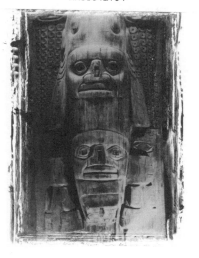

TLINGIT ART

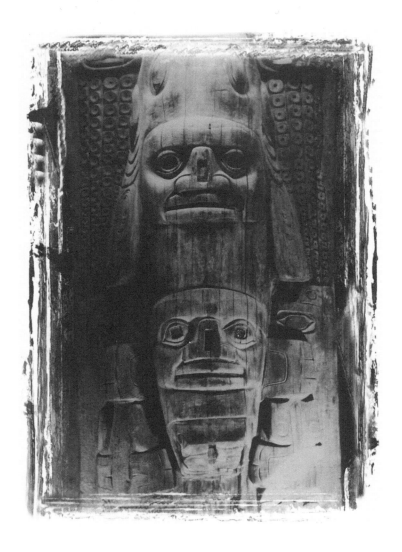

The Dogfish (Mudshark) and Octopus left rear house post of the Stikine River Tlingit Nanyaāyî Clan House which was carved between 1775 and 1790 by Kadjisdu.āx̱ch' II for Chief Shakes III. When his successor Chief Shakes IV moved the village from Kotslit-an to Wrangell the house posts were moved to the new clan house in Wrangell. The house post depicts the head of Dogfish pointing upward and its body and tail arranged below. The head appears to be surrounded by octopus-like tentacles. The dogfish can be recognized by the shape of the creature's mouth, the gill slits behind the mouth, and the pair of dorsal fins. The pair of dorsal fins representations include the carvings of humanlike faces at the base of each fin, and their noses represent the actual fins them-selves. These faces possibly represent the spirit of the Dogfish or perhaps allude to additional characters from the origin story of the dogfish crest. The upside-down figure is said to represent Fog Woman. Apparently there was a similar figure on the opposite side but it has disintegrated.

TLINGIT ART

TOTEM POLES & ART OF THE ALASKAN INDIANS

By

Maria Bolanz

and

Gloria C. Williams

hancock house

ISBN 0-88839-509-4 softcover
ISBN 0-88839-528-0 hardcover
Copyright © 2003 Maria Bolanz and Gloria C. Williams

Cataloging in Publication Data
Bolanz, Maria, 1923–
 Tlingit art

 Includes bibliographical references.
 ISBN 0-88839-528-0 (bound). — ISBN 0-88839-509-4 (pbk.)

 1. Totem poles—Northwest Coast of North America. 2. Tlingit art—
Northwest Coast of North America. 3. Totem poles in art.
I. Williams, Gloria C., 1969– II. Title.
E98.T65B64 2003 730'.8997 C2002-910967-1

Printed in Singapore—AR BOOKBUILDERS

Editors: Lesley Cameron, Yvonne Lund
Production: Bob Canlas, Ingrid Luters
Illustrations: Denise Lausaw
Front cover image: Courtesy of The National Geographic Magazine. NGM 1945 34ii,
W. Langdon Kihn/NGS Image Collection
Back cover image: Left rear house post from X'atgu.hit house of Chief Shakes in
Wrangell. Courtesy Wrangell City Museum
All photographs by the authors unless otherwise credited.

*We acknowledge the financial support of the Government of Canada through the
Book Publishing Industry Development Program (BPIDP) for our publishing activities.*

Published simultaneously in Canada and the United States by

HANCOCK HOUSE PUBLISHERS LTD.
19313 Zero Avenue, Surrey, B.C. V3S 9R9

HANCOCK HOUSE PUBLISHERS
1431 Harrison Avenue, Blaine, WA 98230-5005

(604) 538-1114 Fax (604) 538-2262
(800) 938-1114 Fax (800) 983-2262
Web Site: www.hancockhouse.com *email:* sales@hancockhouse.com

In The Tlingit Way

Dedicated to Awêi' x̲

William M. Williams

A Wolf of the Killer Whale House of the Daq!awe' dî Clan

TABLE OF CONTENTS

ACKNOWLEDGMENTS

The authors wish to recognize the many wonderful Tlingits who over the years have contributed to the material used in this book. Without their inspirational guidance and generous impart this book would never have been possible.

Frank Williams of Tongass

George Stevens of Klukwan

Emma Kyinauk Williams of Tongass

Margaret Stevens of Klukwan

William M. Williams (Awêi' x) of Taku

William Paul of Wrangell

Chief Patsy Henderson of Carcross, Y.T.

Anna Smith of Klukwan

Jimmy Fox (Chief Aanyalahash) of Juneau

Mildred Sparks of Klukwan

Walter Soboleff of Tenakee

Andrew Hope of Sitka

Danny Hanson of Juneau

Herbert Hope of Anchorage

Daisy Fox Hanson of Juneau

Henry Bremner of Yakutat

Elizabeth Nyman of Atlin, B.C.

Frank Peratovich of Klawock

Johnny Jack of Atlin, B.C.

Roy Peratovich of Klawock

Sylvester Jack of Atlin, B.C.

Frank Johnson of Kake

Evelyne Jack of Atlin, B.C.

Al Kahlteen of Sitka

Agnes Johns of Carcross, Y.T

Amy Walker of Angoon

Both of us entered into this project with a different focus. I, Gloria, am half-Tlingit, a Raven of the Dé'citán Clan, and I grew up hearing many of these Tlingit legends. I recall my father, William Williams (to whom this book is dedicated), my great Uncle Danny Hanson, his wife Daisy Fox Hanson, my great aunts Agnes John and Elizabeth Nyman, and my godmother Emma Williams relating them to me. I will never forget my cousin Evelyne Jack, a tribal elder, taking me on her Circle Walk. This is the sacred path one walks and meditates and where one can lose one's self and find one's helping spirit. Our forest trail led to a tent where Evelyne burned herbs in a bowl and moved the vessel about me so that the smoke lingered over my body. Then she carefully scattered the ashes of her burnt offering on the ground and we walked the last arc of the path in silence, until she said, "We closed the circle," then added, "Come tomorrow and I will show you my vision blanket." It was Evelyne and all my relatives who constantly reminded me that I am Tlingit and must be proud of it!

It has always concerned me that fragmented pieces of our culture are dissected and analyzed by the culture theorist, while we the real people stand on the sidelines with our hopes and fears, sorrows and often bitter memories. The general public further tears these fragments apart and lays them open to ridicule, casual interest, and, when politically expedient, uses them as favors on a tray.

The legends cannot be isolated—they are enmeshed within the culture. The role they play in the relationships of moiety, clan, totem poles, and other art objects is so often misunderstood, but so important to understand. None of these have any meaning unless one understands their integrated significance in what we refer to as "The Tlingit Way."

My mother is from outside the culture, but has lived among the Tlingits for the last forty years. Her early background being multicultured has given her a less restrictive lens in viewing the world and other cultures. Experience has taught her you must study and learn the ways and respect them. She says, "It is much like learning a second language. You will always have an accent, but at least you can speak it." Frank and Emma Williams of Tongass were her early guides, my father's family helped her, and to give her status and legitimize her children as tribal members, the Ravenclan Dē'citān adopted her into the Clan.

Dr. Jeff Leer, linguist at the University of Alaska in Fairbanks, and chronicler of my Aunt Elizabeth Nyman's oral history, has always encouraged my mother to write of her experiences. She has often reflected over the advice of the late anthropologist Dr. Philip Drucker who, during their friendship over the years (in Mexico and Alaska) urged her to write her observations. She was further encouraged to do so by Dr. Steve Langdon, professor of Anthropology at the University of Alaska, Anchorage.

After much consideration we made the decision to collaborate on a book, but since neither of us are formal scholars of anthropology or history we had to depend on numerous sources from various libraries, and the help of many individuals, in order to add a more balanced account and a broader prospective to our pool of knowledge.

The master carvers generously gave us their time and attention, and long after the interviews were over they responded to our questions by phone. Nora Rinehart, narrator and interpreter for The Shakes Tribal House in Wrangell, was indispensable. She successfully tackled every request for more information. Carol Brady, granddaughter of Chief Kadishan, shared all the information she had, and became so interested that the family now plans to research his papers at the Smithsonian Institution. Theresa Thiboul, curator at the Wrangell City Museum tirelessly provided us with information, photographs, names and contacts. John Rowan, carver in residence, at the Klawock Public School, personally guided us around the totem park. He identified poles, gave histories, and helped us take the angled photograph shots. Later he answered our desperate questions by phone.

In Ketchikan, Winona Wallace, director of public relations at the Totem Heritage Center gave us carte blanche to explore, question and photograph. The staff made every effort to assist us and left no stone unturned in our tour of the center. Similarly, John Audrey of the Forest Service, our first contact in Ketchikan, located all the parks and how to get there, named the personnel in charge and at times even made the contacts for us! Like all the others he wished us well with our project. Wanda Vandergraft was our logistic sergeant. She arranged our itinerary by plane, ferry and taxi, our lodgings, made contacts for us and personally took us to our destination if there were no other means. She worried about our free time (as if there were any) and invited us to the church she

and Nathan Jackson attend. Thank you, Wanda! At The National Historical Park in Sitka, Gene Griffin, the cultural representative, was our guide, historian and researcher. He was always helpful, answering questions and just talking things over. He is well informed, and shares his knowledge willingly.

Our attention was also directed to the archives in Spain because of the eight very early exploratory voyages by the Spanish to the Northwest Coast and their occupation of the Nootka People in that area. Therefore, we wish to express our great appreciation to Dr. Dolores Higueras Rodriguez, Director of Museo Naval, Madrid, Spain, to Araceli Sanchez Garrido, curator at Museo de America, Madrid, Spain and to Maria Togores, librarian at the General Archives of the West Indies, Seville, Spain. We are very grateful to Dr. Arsenio Rey, professor of Spanish at the University of Alaska in Anchorage for sharing his collection of data on Spain's presence on the Northwest Coast. We also express our gratitude to the museums, universities and libraries in the United States and Canada that responded so helpfully to our requests.

Nora and Richard Dauenhauer's research was an invaluable resource and added a richer dimension to the book. The adaptation of drawings and sketches by our good friend and artist Denise Lausaw was immensely helpful, as were the photographs by Ivan Simonek. Last, but not least, special thanks to Laurie Evans-Dinneen of Ed. Ink for her technical advice and marketing assistance and to Cindy Carl of Executary for her assistance in editing and assembling the final draft for publication.

This book was influenced and produced by many people, and we hope that credit is given to all of those who have helped us. It is, however, especially the Tlingit people we thank, but thank you alone is not enough. One cannot take without sharing, and so a third of the profits from this book will be shared by The Heritage Center in Ketchikan and the Wrangell Museum for use toward workshops conducted by master carvers and other educational programs for students.

TABLE OF ILLUSTRATIONS

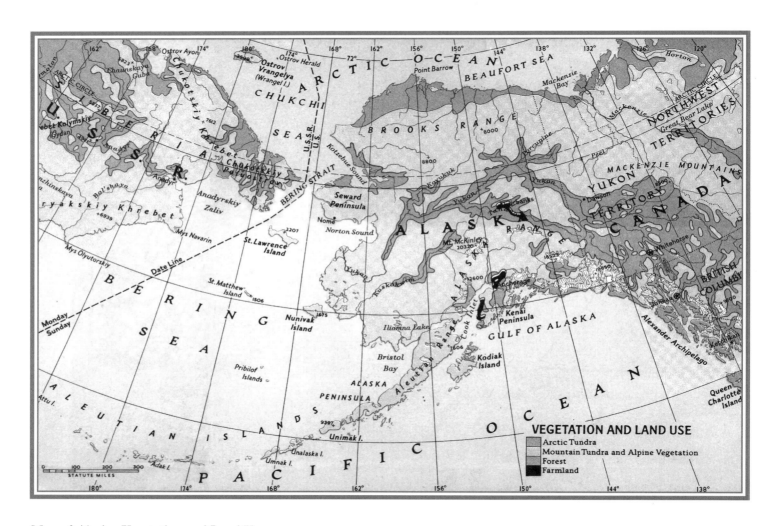

Map of Alaska: Vegetation and Land Use.

Courtesy of National Geographic Text Syndication and Image

Department; Atlas Plate 18: July 1959.

14

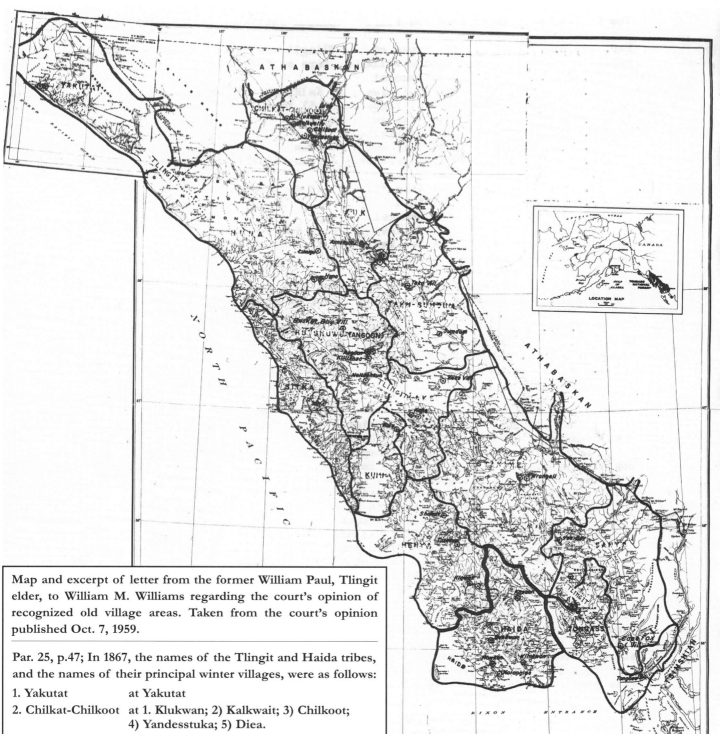

Map and excerpt of letter from the former William Paul, Tlingit elder, to William M. Williams regarding the court's opinion of recognized old village areas. Taken from the court's opinion published Oct. 7, 1959.

Par. 25, p.47; In 1867, the names of the Tlingit and Haida tribes, and the names of their principal winter villages, were as follows:

1. Yakutat at Yakutat
2. Chilkat-Chilkoot at 1. Klukwan; 2) Kalkwait; 3) Chilkoot;
 4) Yandesstuka; 5) Diea.
3. Huna at Huna and Tuxugu
4. Auk at Aynskultu
5. Taku-Sumdum at Taku and at Sumdum
6. Hotsnuwu at Basket Bay; Angoon; Killisnoo;
 Neltushkun
7. Sitka at Sitka
8. Kake at Kake Village and at Kake
9. Kuiu at Kuiu
10. Stikine at Wrangell
11. Henya at Shakan; Tuxekon; Klawock
12. Sasya at Yes Bay; Cape Fox and at Loring
 (they are sometimes called "Cape Fox"
 Indians, also "Saxman" Indians)

This is the area of southeastern Alaska which stretches from Yakutak in the north to the northern border of British Columbia in the south. It is often referred to as the Panhandle of Alaska.

TRADITIONAL TLINGIT COUNTRY

CIRCA LATE NINETEENTH CENTURY

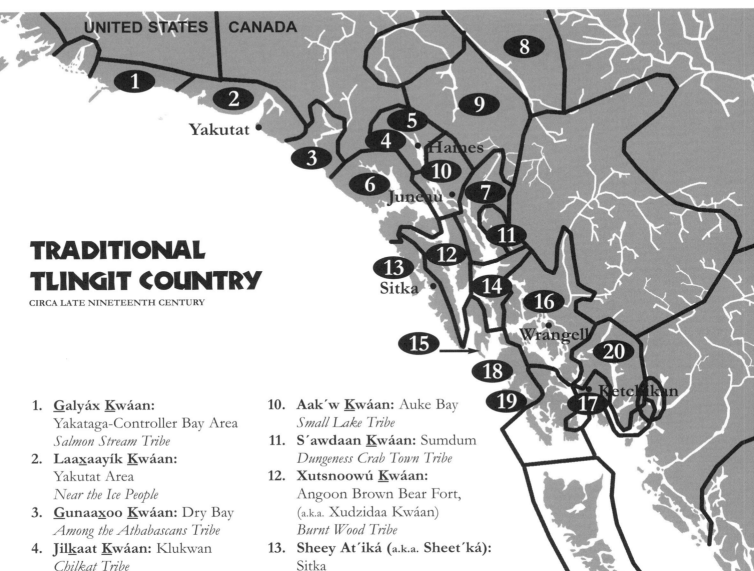

1. **Galyáx Kwáan:**
 Yakataga-Controller Bay Area
 Salmon Stream Tribe
2. **Laaxaayík Kwáan:**
 Yakutat Area
 Near the Ice People
3. **Gunaaxoo Kwáan:** Dry Bay
 Among the Athabascans Tribe
4. **Jilkaat Kwáan:** Klukwan
 Chilkat Tribe
5. **Jilkoot Kwáan:** Haines
 Chilkoot Tribe
6. **Xunaa Kwáan (a.k.a. Káawu):**
 Hoonah
 *Tribe or People from the Direction
 of the Northwind*
7. **T´aaku Kwáan:** Taku
 Geese Flood Upriver Tribe
8. **Deisleen Kwáan:** Teslin
 Big Sinew Tribe
9. **Áa Tlein Kwáan:** Atlin
 Big Lake Tribe

10. **Aak´w Kwáan:** Auke Bay
 Small Lake Tribe
11. **S´awdaan Kwáan:** Sumdum
 Dungeness Crab Town Tribe
12. **Xutsnoowú Kwáan:**
 Angoon Brown Bear Fort,
 (a.k.a. Xudzidaa Kwáan)
 Burnt Wood Tribe
13. **Sheey At´iká (a.k.a. Sheet´ká):**
 Sitka
 Outside Edge of a Branch Tribe
14. **Keex´ Kwáan:** Kake
 *The Opening of the Day (Dawn)
 Tribe (a.k.a. The Town That Never
 Sleeps)*
15. **Kooyu Kwáan:** Kuiu Island
 Stomach Tribe
16. **Shtax´héen Kwáan:**
 Wrangell
 Bitter Water Tribe
17. **Taant´a Kwáan:** Ketchikan
 Sea Lion Tribe

18. **Takjik´aan Kwáan:**
 Prince of Wales
 Coast Town Tribe
19. **Hinyaa Kwáan:**
 Klawock
 Tribe from Across the Water
20. **Sanyaa Kwáan:** Cape Fox
 *Secure in Retreat, Like a Fox
 in its Den/Southeast Tribe*

Adapted from *Traditional Tlingit Country* (poster), second edition revised © 1998.
Courtesy of Andrew Hope III, Chairman of Time Readers, Inc., 1998.

INTRODUCTION

The Tlingit Indians of the Northwest Coast, who carved the poles, revered them as the markings, or, in their own language, Kùtîyà. These majestic cedar columns which include interior house posts, portal entrances and free standing totem poles, are carved with crests of animals, sea creatures, birds, legendary and human figures that reflect the socio-legal validations of a clan and/or historical occurrences within the lineage.

The insignia of the Pacific Northwest Coast cultures is the "Totem Pole." Historically, and continuing to the present time, eight different Indian groups inhabit an area extending from Yakutat Bay in southeastern Alaska to the Straits of Juan de Fuca lying off the north coast of Washington state; they comprise the Nootka, Kwakiutl, Tsimshian, Haida, Bella Coola, Salish, Makah and Tlingit. Within this ethnic grouping, the differences in their distinctive art styles vary from subtle to obvious but always retain an elegance and a balance of form, space and color within a totemic design. While the Tlingits, Haidas and Tsimshians all obtained great mastery in the art of carving cedar poles, it was the Tlingits who carried the tradition to pristine heights in combining realism with symbolism. They are the northernmost Indian group on the Pacific Northwest Coast, and this book focuses on the historical development and the cultural significance of their totem poles, as well as on the artistic interpretation and analysis of their art, and it concludes with the innovations of the modern day Indian artists and carvers. The material is not intended to be a scholarly dissertation, but rather is presented as an accessible document of general interest.

Since art not only reflects a culture in a particular domain at a given moment in time but also mirrors the context of its historical past and its passage toward an unknown future, the background research extended across a wide range of disciplines. It included archeological discoveries made in the development of the art form from the earliest times of Tlingit history in the area of southeastern Alaska, the effect of encoun-

ters with the early European explorers, the Russian occupation, the Territorial American colonial period, the effect of diseases and loss of the Tlingit economic base, the forced enculturation and the strange fascination for the art that has captured the world's imagination. It closes with the cultural rebirth of the Tlingit peoples and their struggle to maintain their unique identity and living patterns against powerful political forces.

The Tlingit people are part of a race of people known as the American Indians and evolved perhaps ten thousand years ago, on the perimeters of an isolated northern part of the Western hemisphere. For the Europeans who sailed to their shores, the independent development of these new world alien cultures offered no frame of reference or any remote historic connections upon which to build a bridge for cultural acceptance. Meetings between the two groups remained a tense affair for many decades. These early explorers, and later missionaries, initiated the recordings and interpretations of Indian customs yet they were unwilling or unable to understand the culture and the significance of its artistic expression. Sadly, during the same era, the Indians themselves did not perceive that, within a relatively brief time, they would never again be permitted to fully experience their own way of life.

When the early Europeans first encountered the carved poles they concluded they were objects of worship, since it was assumed that they were representations of pagan gods and mythical animals; and they called them totem poles. They were not totemic structures, but instead represented heraldic crests that documented both mystical and historical events in the lineage lines of the clans.

The Tlingit dominance of southeastern Alaska and their cultural dynamics began to change when Russia first discovered and then occupied the area. Later, when the final outcome of the victorious colonial powers emerged, the culture was deeply affected by the laws of the United States and Canada, who during their early years of control, endeavored to suppress the Indian culture. Indian lands were taken, the language crushed and the potlatch outlawed. Great amounts of the art work survived because the art was so intriguing and elegant; however, under the guise of heathenism many of the totem poles were destroyed.

Perhaps because they were both so mysterious and audacious standing there in the rain forest, they evoked many different responses from the early foreign visitors: grotesque, aesthetic, heathen, monumental and enigmatic. Later the acquisitions of totem poles would represent a coup for a museum collection, profit for art dealers, and a nemesis for the colonial governments. In the contemporary era they have become the symbol

for Northwest Coast art and culture, and they signify the renaissance of the culture and art of the Northwest Coast.

It is because of their historical relevance to the area that, as authors, we chose to depict totem poles standing in Alaska or in the Northwest Coast area rather than choosing a select group of very old and original poles from the great museums of the world. The idea of national and extended international research was not only unfeasible but delegated the totem poles to the status of dusty artifacts secluded away in distant museums. We became aware that limitations are often a blessing in disguise as we realized that Alaska, which has been the ancestral domain of the Tlingit people for thousands of years and is the cradle of the art tradition, was overlooked. In Alaska, totem poles are not only regarded as historical artifacts, they are a continuing art form and modern poles are found in many areas of the state. Replicas of old poles, carved by modern carvers, stand in many southeastern towns and public buildings. In conjunction with the individual totem poles erected in Alaska, there are nine Totem Parks in the southeastern Alaska area, and many of these parks have master carvers working and exhibiting carving techniques. Totem poles are a living legend in Alaska!

The art tradition has a long history, but the passage of time and early colonial oppression has made it exceedingly difficult to find well-documented historical information regarding the development of totem poles, and the significance of the carvings which involved the legends, clans, lineage, moiety, and the actual events that led up to the raising of the old poles. A few of these original poles remain in Alaska, but most of the existing poles have been either restored or replicated by modern Indians carvers, however all of them stand in the same stately silence as the original Kùtîyà of the past.

Penetrating their silence to disclose the past has involved searching through the shadows of the past by reviving faded memories of the elderly, using sailing ships' logs and the sketches of artists and naturalists on these journeys, military reconnaissance documents, as well as records from Church archives, reports of missionaries and early research of scholars in the field. In addition to this is an examination of the contemporary research of anthropologists, archaeologists, art historians, psychologists, medical personnel in the bush, the dynamic changes in the indigenous society, the resurgence of art, the growing groups of talented artists, carvers and the authors' own experiences and perspectives, one of being Tlingit and the other of living among the Tlingit people for many years. It is hoped that by consolidating all this information in one simple

volume a more balanced account of the culture and the art can be attained, thereby enriching not only the understanding of all the Northwest Coast People, but the significance of their art.

An introduction to the totem poles in Alaska begins with Saxman Park, situated on a knoll magnificently overlooking Tongass Narrows, which combines the past with the present and with master carvers actually working on replicas of old poles. In the same area north of Ketchikan is Totem Bight Park, nested in a pristine coastal forest, and nearby on Prince of Wales Island, a small Tlingit village, is Klawock Park with a carver, John Rowan, in residence. Continuing northward to Angoon, Haines, Klukwan and Anchorage are other parks with clan houses, totem poles and carvers diligently carving in workshops. In addition, apart from the totem pole theme, other objects are depicted throughout these pages to portray the Tlingit use of art in daily life. Artistic expression was such a compelling force in the Tlingit world that it was reflected in all aspects of Tlingit life.

The symbolic art of the Tlingits has at last come into its own again in the land where it was created and is being revived by the descendants of the original artists, carvers and primary owners of the original poles. In attempting to understand the culture and its transition, and to comprehend the art that mirrors it, one should contemplate what Edmond Carpenter has so eloquently stated in his 1973 book, *The Far North: 2000 Years of Eskimo and Indian Art*:

> The art offers no windows facing in. A detachable observer may possess them, even know them but he will never experience them. Only the person who avails himself of their methods, aims at their goals, assumes their sensory profile, can enter into these realities. For others, the visible forms remain mere trophies, loot displayed in a pirate's wardroom. Some may exploit them as an exotic variation of our own art; they are the plagiarists. Others too sensitive for such imperialism, yet unable to encounter this art on their own terms, will find them vaguely unsatisfying. They will be bored. They will have come not merely to study man, but in hopes of experiencing man they will fail to encounter him. That will not be because he is absent. He is here waiting to greet us within his home.

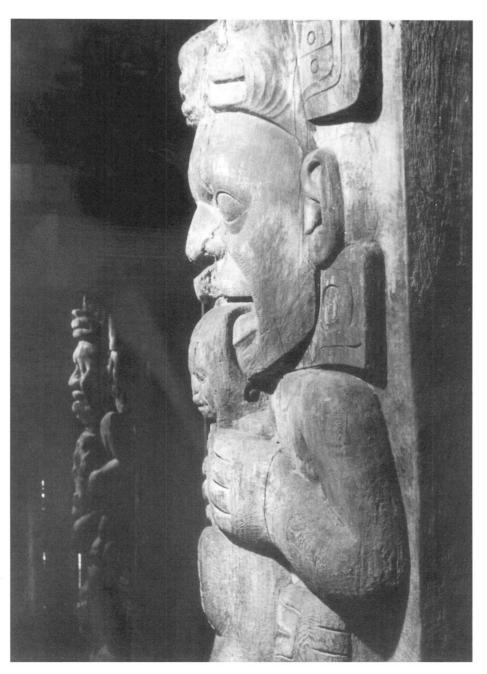

Ixt or Shaman's House Post. From Chief Shakes House in Wrangell

This house post stood to the right front house doorway of the Nanaā.yî House and was carved by Kadjisdu.āxch II between 1775 and 1790 for Chief Shakes III. The Shaman is depicted wearing his headdress of the dogfish. The wide mouth of the dogfish is above the man's forehead, with gill slits on either side of its mouth. The pectoral fins and asymmetrical tail of the dogfish are carved in relief above and below the man's ears. The use of the dogfish crest on the headdress illustrates that the shaman is an ancestor of the house lineage group. The hair of the shaman's Yéik spirit seems to protrude from the shaman's mouth as if it were a part of him. The Yéik spirit or shaman's helper lies on the shaman's chest and is carved with characteristics of the masks used by Tlingit shaman. The body of the yéik lies between the shaman's knees and hands. The yéik is standing on the head of a sea lion, whose pectoral fins protrude to the sides from behind the shaman's legs. The head of a dogfish issues from the mouth of the sea lion. Courtesy of Wrangell City Museum, Wrangell, Alaska

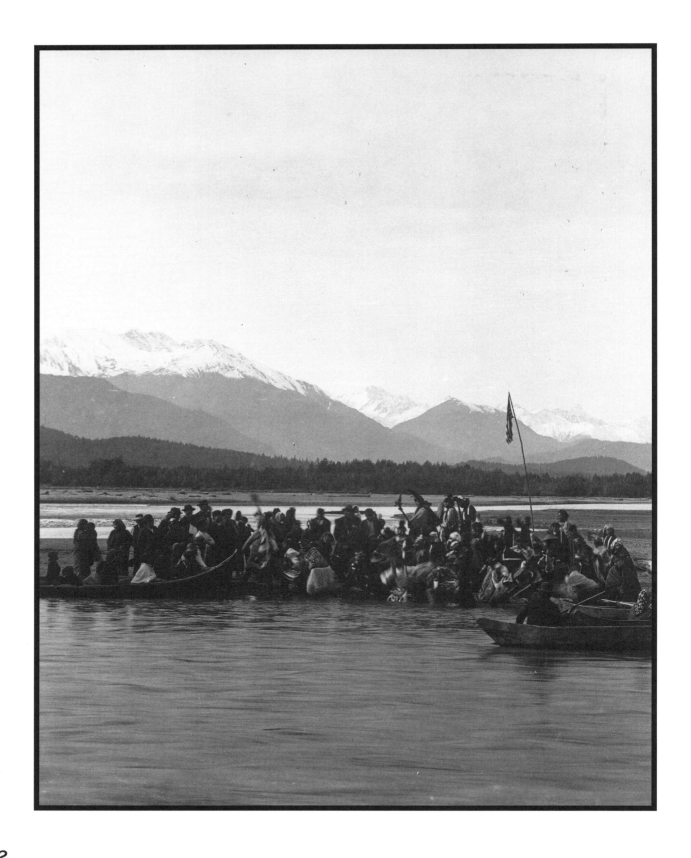

THE TLINGITS AND THEIR HISTORY

THE PACIFIC NORTHWEST IS ENDOWED WITH ABUNDANT RAINfall and warmed by the Japanese current that flows off the Western coast of the Alexander Archipelago; the terrain is composed of hidden glaciers lying within heavily forested mountains that slope directly to the sea. The mountains protect the area from the subarctic climate of Canada and northern Alaska and the warm, moist air from the sea produces a mild climate creating a lush temperate rain forest. Southeastern Alaska, known as the panhandle, is an area of the Northwest Coast. The land is thick with spruce, red and yellow cedar, hemlock, alder, and fir, and a dense undergrowth of ferns, devil's club, moss, salal, labrador tea, Angoon berry, fireweed, and wild cabbage. The vegetation is canopied in the shadows of sunken mountain valleys and deep narrow inlets, or fjords, that penetrate far into the base of the mountains. Four major waterways carve their way to the sea: the Chilkat river in the north, the Taku river in the Juneau area, the Stikine river in the south and the Portland Canal on the boundary between Alaska and British Columbia.

The area is endowed with an easy and accessible food supply. On land there are moose, deer, elk, bear, and goat; ducks, geese, grouse and ptarmigan are abundant, as well as many edible plants, plant roots and berries. All this is combined with a sea full of shellfish, salmon, candlefish, codfish, halibut, whale, seals, and edible marine plants, such as sea kelp and seaweed.

Presented with endless resources of food and a mild climate, the Tlingits developed a complex society based on status and lineage, wealth,

They were, perhaps some of the most expert boat builders in North America. The boats varied between 12 and 75 feet in length and were not only seaworthy— they were works of art.

Opposite: **People arriving for potlatch at Chilkat.**

Photo: Alaska State Library, Winter and Pond Collection PCA 87-43

23

People out of the foam... mastered the sea in huge canoes.

family honor and clan respect. The culture was steeped in protocol and ritual activities that consisted of great oratory, elaborate dances and lengthy songs. The participants wore elaborate garments and beautifully carved wooden masks representing mythological beings and legendary figures. The rituals were carried out to the tempo of the drums, and were often accompanied by the clan chorus, who sang the traditional songs for each particular event. The effect was both dramatic and transcendental.

Tlingit legend tells of the Salmon Eaters clan, a people who sailed out of the sea foam from a Siberian Island and crossed the Bering Sea, using the Aleutian chain of islands and protected coastal islands as stepping stones until they reached the Nass River in British Columbia. The journey was so long and arduous that the people changed languages many times by the time they reached the Nass River, where they were called *people out of the foam*. Upon reaching Alaska the group began splitting and redefining and merging with other groups for many years until they became solidified into a branch of one ethnic linguistic group (NaDene) calling themselves Tlingits or *The People*. "Legends have groups traveling down the Skeena River in northern British Columbia and migrating by boat northward into southeast Alaska. Songs and dances enact another exodus over coastal mountains and down river valleys to the coast" (Langdon, 1993: 70).

The past is also revealed by archeological evidence; a site discovered on Prince of Wales Island and dated 9,700 B.P., was occupied by an unknown group, possibly proto-Northwest Coast people who settled there and then spread out to other areas.

At the time of contact during the eighteenth century, the Tlingits

**Carved wooden halibut hook,
with iron barb and short length
of twisted spruce root line.**

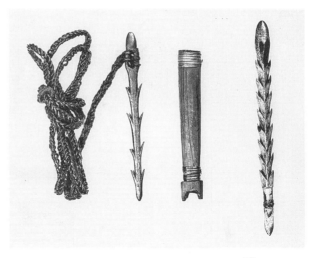

Harpoons.

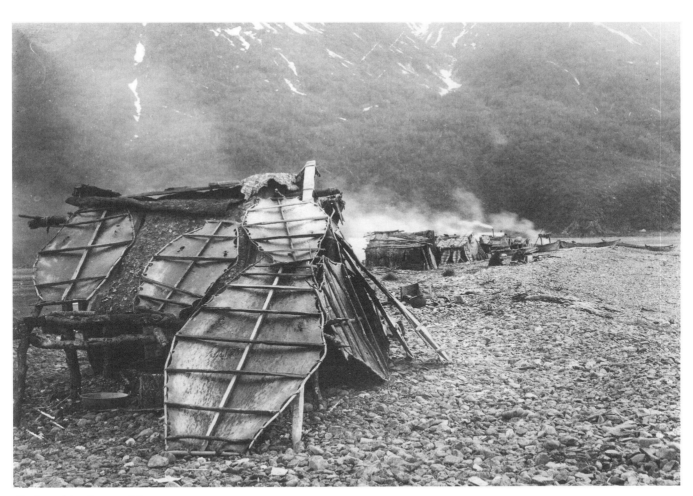

Curing skins by smoking.

consisted of a loose confederation of eighteen tribal entities, or *kwans*, stretching from Portland Canal in the south to as far north as Eyak, north of Yakutat and south of the Copper River Delta, eastward along the Taku River to Atlin, British Columbia and further northeast in Yukon Territory to the village of Teslin, which is situated on a point of land at the confluence of Nisutlin River and Teslin Lake. The people mastered the sea in huge canoes and with equal ease adapted to the land. It could be said that they became one with the sea and the land—reminiscent of other Alaska Native indigenous groups who were, and continue to be, noted for their unique adaptations to the specific area they inhabit. Large areas of the land and the coastal waters were marked and defined, creating a strong concept of territory and ownership. Each clan had their own fishing and hunting areas that implied the rights of production of the lands and their responsibility to share its rich abundance within the framework of the clan system.

SOCIAL ORGANIZATION

Tlingit society was organized into two large groups or moieties—the Raven and the Wolf. In the northern area of the Northwest Coast the designation of Wolf becomes the Eagle. There is some confusion regarding this change, and some anthropologists theorize that the Eagle crest came from intermarriage with Haidas or Tsimshians. Under each moiety were numerous clans, and within each village there were, and continue to be, a number of different clan house groups. The master of a clan house was called Hít s'àtí, and sometimes was referred to as a subclan chief. There was not an overall ranking clan chief above the Hít s'àtí since, as George Emmons (1991: 24) explains, "each subclan was more or less an independent body regulating house groups could have a quasi chief or representative enabling them to unite on issues. In a dichotomous sense it was clans of the opposite moiety that exerted substantial influence; due to the strength of biological relationships, and affinal ties, they could express or withhold consensus and cooperation with their opposites."

These strong influences existed due to an important basic aspect of Tlingit society. It was matrilineal, by which lineage was legalized through the mother's blood line, and the inheritance of status, clan and property came directly from the mother. Because of this marriage custom, affirmation or consensus was often required of the clan of the opposite moi-

ety. Each individual was required to marry his opposite moiety. Thus a Raven always marries a Wolf/Eagle which, as stated previously, were subdivided into clans, and the clans further broken down into house groups. A representation (Swanton, 1908: 399-404) of the some 20 or more clans under each moiety would include:

Raven (or Crow)
Gānaxa'dî (People of the Ga-nax)
Dā'citān (Beaver People)
Te`nedî (Bark House People)
K!uxîne'dî (Martin People)
Tak^uane`dî (Winter People)

Wolf (or Eagle)
Kā`gwantān (Burnt House)
Daql!awe'dî (Killer Whale)
Xél qoan (People of Foam)
Yenyé'dî (Hemlock People)
Nāste'dî (People of the Nass)

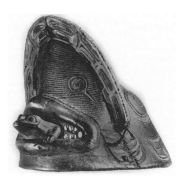

Shark war helmet of the Nanyāa'yî Clan.

Using the first two clans as an example of the further division into house groups:

Gānaxa'dî Clan
Whale House
Frog House
Starfish House
Looking Out House
Kā′gwantān Clan
Grizzly-Bear House
Kats!s House
Drum House
Halibut House

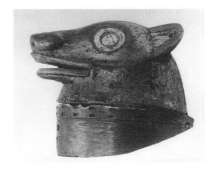

Bear war helmet of the Kā`gwantān Clan.

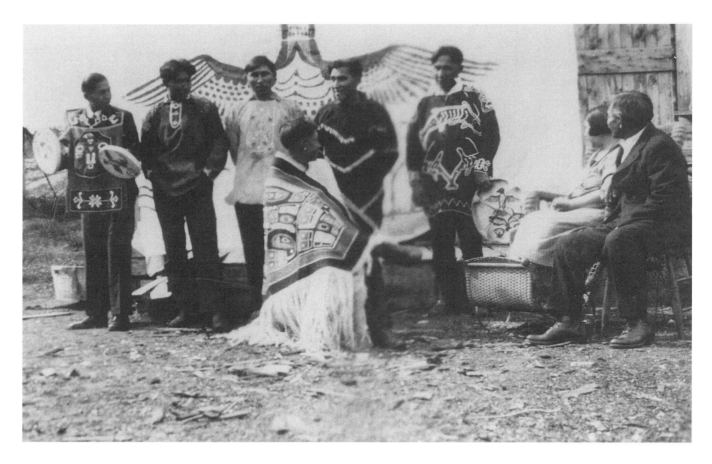

A ceremonial event to raise status. Photo taken at Billy Williams' home in Atlin, BC, circa 1925.

Each village contained members of both moieties and several or more clans under each moiety (depending on the size of the village) with members tracing their lineage from their mothers. Therefore a Tlingit of the Tongass tribe (an area near Ketchikan) might be a Raven belonging to the Gānaxa'dî clan and a member of the Starfish House, while another Tlingit in the same village could be Wolf, belonging to the Kā´gwantān clan and a member of the Xúts!hit or Grizzly Bear House. Individual Tlingit names indicated the moiety, clan house group, and geographical area.

Every clan had a history of its origin; each sublineage group had particular oral lineage histories. The respective house chief (Hít s'àtí) acted as guardian for these treasures, and represented the house group politically. Both clan and sub clan celebrated the legendary history through oratory, songs, dances and the carved poles, houseposts and house panels. The origin stories were incorporated into a social framework of lineage, status, clan history, and the crests were carved or painted on tribal objects as outward expressions that redefined the events. While moiety was an important designation, the power rested within the clans and the house groups who owned major crests (Khà shuká) that were lavishly displayed everywhere on crest hats, house fronts, ceremo-

nial hats, ritual clothing, totem poles, bent wood boxes, jewelry, and household items. As with all property, it was possible to sell, bequeath, bestow and lose or win in war. "The comparison might be drawn between the crest and European heraldic quartering or in the American sense to the cattle brand that the Western rancher burns not only on his animals to establish legal ownership but on the gate post of his corral, the wing of his chaps, on the jamb of his house and all sorts of places because it is his brand and he likes it" (Drucker, 1995: 190).

The society was composed of three status levels that Westerners might identify as aristocrats, commoners, and slaves. Membership in each group (except slaves) was dependent on heredity while status was in part based on heredity and specific feats or actions of the individual. An individual could never change clan or moiety but could attempt to elevate the status. The individuals with the highest status were, of course, the hereditary aristocracy who had a great deal of wealth (Nâtxh) and were highly esteemed. These individuals inherited status and maintained their status and respect in the community by increasing their power and wealth through effective leadership and marriage to a high-ranking person. They hosted ceremonial feasts (*potlatches*) for special occasions, and often distributed great amounts of goods and property to the respective opposite clan or clans. It should be borne in mind that these distributions actually resembled social and legal contracts and tribal validations. "The potlatch was not a struggle over material wealth but over symbolic capital, reputation, prestige, and honor" (Kan, 1989: 247).

Each of the sub clans had a Hít s'àtí who was viewed as the primary custodian for the holdings of the group, both material and non-material. These included the dwelling place, ceremonial regalia, songs, crests, dances, names, hunting and fishing areas, as well as controlling of feuds and protecting the honor and position of the group. The wealth possessed by prominent leaders was not personal, but was regarded as tribal assets. "Chief's power was more moral than real, since the group constituted the governing body. He presided over them in council and represented them in dealing with outsiders; but he governed largely through their consent" (Emmons, 1991: 391).

Slaves were obtained by capture in war or through debt or purchase. They had no rights and could be slain in a ritual killing at a potlatch, but they could also be set free. A shaman, although belonging to a specific clan, held a certain mobility within the cultural mesh and was viewed more as a separate part of the society since he had a very specialized role.

In family life, Tlingit men raised their own sons until they were twelve

Art was everywhere, as shown by these wooden combs, war club and stone-bladed dagger.

years of age, at which time discipline and training would be taken over by an uncle, a ranking brother of the boy's mother. At that time the boys would go to live with their mother's brother, who would carry out with more objectivity a difficult regimen of training than a natural father would not or could not provide, a practice known as the *avunculate*.

The husband might take his wife to his father's clan house to live, but it was her clan crest and lineage line that she proudly brought with her and that her children would bear. It was not a reduction in the father's role, but rather a shift in it. Within their legal system it was held sacrosanct. The estate of a deceased man would go to the eldest son of his sister or, if there was no nephew, to a younger brother of the deceased, but never to his own children. The entire socio-legal system was the reverse of Western tradition. This, in conjunction with their so called animism, shamanism, and anthropomorphism and combined with the illusive line of distinction that existed between the Indians and their universe, set them apart from traditional Christian thought and was very disconcerting to the Western mind, and, therefore, thwarted their understanding of the Indians.

"The great fault of all ethics hitherto has been that they only believed in themselves. This is particularly true in Western Christian traditions. Their material universe is man centered. Nature, in so far as it is noticed, is only a convenience or a temptation with no positive value" (Bates, 1960: 254). This contradiction allowed the Americans and Europeans to value only the tribal art and to completely dismiss the people's beliefs and the culture that produced it.

The culture of lineage-rights tradition, with its rich mythology and ceremonies, was expressed in the medium of art. This included wood-carvings, paintings, blanket weaving, basket weaving, and the working of copper and silver. Art was everywhere: on totem poles, canoes, paddles, house fronts, wooden storage boxes, serving bowls, eating utensils, fishing hooks, facial paintings, dancing staffs, drums, garments, and tools.

Tlingits were remarkably adept at working with wood and weaving the soft durable mountain goat wool, combining it with the inner bark of red and yellow cedar for weaving into blankets and clothing. "In their carving and painting of wood the Tlingits achieved their highest expression of their aesthetic genius" (Carpenter, 1973: 169). With such rich traditions, the Tlingit needed no written language. Their history books and legacy of beliefs are in the highly stylized patterns and designs, which today we admire and struggle to interpret.

The Tlingit tradition, as in all Northwest Coast cultures, expressed their legendary histories and validations of the social and legal systems in forms of art, and this was a completely new concept for the Europeans and Americans. Sadly, the symbolic forms used in the artistic narration's were not appreciated and often held in contempt; and so explanations of details from informants, who could have provided it, were neither solicited nor willingly offered by the people themselves. In contemporary times the designs are neither completely understood nor fully interpreted. Nevertheless, the art and the genius are greatly admired, and artifacts are avidly sought after and collected by connoisseurs of art.

The essence of the Tlingit spirit world, daily life and historical interpretations were amalgamated into artistic designs that they chose to paint, weave, and carve. "Red cedar in particular may be seen as the *sine qua non* of the Northwest Coast art and architecture, and responds to the carver's tools in a way that has made it justly famous" (Carpenter, 1973: 165).

The art of story telling and oratory was used in conjunction with their ceremonial rituals; and few modern statesmen or orators could equal them in oratory. They were eloquent and dramatic, and the moment the speaker's staff was raised the group became quiet and transfixed on the words of the speaker. Even the most unrefined of traders spoke in awe of Indian "*talking*."

The Tlingit believed that somewhere in the mystical beginnings all living things shared the world as equals and lived in mutual understanding; animals, birds and fishes all had a spirit essence, and were, like humans, reincarnated after death. Tlingits noted that each creature was specifically gifted in a way that mankind was not; and all things were admired for these differences. In such a balanced universe, it naturally developed that people claimed descent either from supernatural beings or from actual birds, animals, and fish. "The people developed and inherited certain symbols as reminders of early history such as, a ceremonial hat, a mask, a dance, a legend of their origins and zealously guarded them as inheritance" (Hawthorne, 1956: 18). According to Tlingits it all began in the distant past, as long ago as time itself; and so that this history will not be forgotten, the stories are repeated over and over, again and again.

THE LEGENDS OF THE RAVEN AND THE NASS RIVER

Many legends of the Raven and the Nass River were documented by John Swanton, who interviewed Tlingits in Sitka and Wrangell in 1904. Swanton had the legends published in 1909, giving non-Indians access to these wonderful stories.

The mythological Raven at the head of Nass River became their cultural hero, and in the very beginning he created man from the leaves of a tree, and because leaves die in the fall, Raven said, "man will also die." It was in the area of the Nass River where the Tlingits first acquired their most powerful crests. The Nass River figures in early Tlingit folklore and "in the traditional history of their more powerful clans there is a clear recollection of a Nass River exodus from the interior of British Columbia" (Carpenter, 1973: 166). It was at Nass River that the great young Raven Yēl released light on the world. A powerful chief who lived in the area had the box containing light, and Raven planned to obtain the box. He turned himself into a pine needle and floated on the creek, and when the chief's daughter came to drink she swallowed the pine needle and became pregnant. When her time was completed she bore her child, and because the chief loved his daughter, he loved his grandson; and would do anything to please him and make him happy.

One day the child spied the box containing light. He cried out for it, and the chief gave him the box to play with. Immediately Raven seized the box and started to fly out of the smoke hole in the roof. The chief seized the Raven by his white tail feathers up—until that time the Raven had been a white-feathered bird—and held on to him for an instant in the smoke of the fire; and in that very moment Raven turned black. At last he pulled away crying "Ga." He opened the box as he flew away, and the sun and the moon and the stars fell out and went into their places in the sky. It is said that the release of the light frightened the people, especially those that ridiculed the Raven, and some ran into the woods while others ran in terror into the sea.

Those who ran to the sea were transformed into aquatic mammals, the ones who fled to the forest became animals and those who climbed the mountains became birds. Only the people who had gone unclad in their human state, and not mocked the Raven remained as they were "and consequently these remaining Tlingits adapted their first crests in honor of their transformed kinsmen" (Carpenter, 1973: 167).

Raven continued on his journey and along the way he met a man named Ganùk, who was the keeper of all the fresh water. Raven was curious, and formed a plan to meet Ganùk.

As they were talking Ganùk asked Raven, "When were you born?" Raven replied, "I was born before the world began."

This puzzled Ganùk greatly; so Raven sent him outside to ponder over it. While Ganùk was gone, Raven stole the fresh water. He carried it off in his mouth, and he made the Stikine, Taku, Chilkat, Alsek, and Copper Rivers, and all other large rivers. The small drops of water that fell from his mouth became the salmon creeks, and these he filled with salmon and trout; and he placed an old woman at the head of all salmon creeks. That is why the salmon go up the creeks to spawn. He put the tides in order by placing a woman in charge of their rising and falling, and he gave her a servant, the mink. He also made the world as it now stands on the strong foreleg of a beaver. The old woman underneath attends to the world, and when she is hungry she shakes it, and the people must put grease in the fire for her. Raven appointed a hollow tree eastward of Sitka as the place where the sun would turn back.

He made the west wind and said to it, "You shall be my son's daughter, for no matter how hard you blow you shall hurt no one." And he made the north wind, and a house for it with the sides all hanging with ice, and placed the house on top of a mountain in the north. He created the soft south wind that melts the snow, and the high wind of the east that carries rain. He took some red cedar bark and a white stone, the kind that is found on beaches, and he put fire into them so there would be fire forever all over the world.

Raven said to the land otter, "You will live on water as well as land, and whenever a canoe capsizes with people in it, you will save them, and make them one of your people." Thus it is when people who have been taken away by land otters and return home they become shaman, and therefore it is through the land otter that shaman first became known. It is said that shaman can see one another by means of the Land Otter Spirit; whereas, ordinary people cannot.

It is told that while Raven was traveling, he rocked his canoe on the water just outside Sitka, and caused great waves that still occur there. He sent an invitation to the Killer Whale Chief and ate with him under the sea. He noted they seemed to live on hair seal meat, fat and oil, and the chief was named Gonaquade't. He visited the Fish People, the Land Otter People, the Goose People, and the Porcupine People, and learned many things from them. In his travels he met a sculpin, who claimed to be older

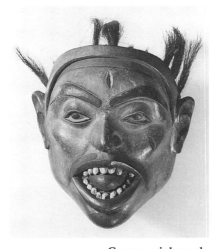

Ceremonial mask.

Photo: Canadian Museum of Civilization

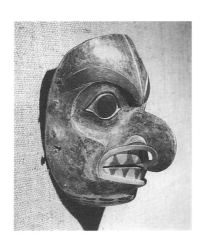

Above: **Tlingit Hawk mask.**

Photo: Field Museum of Natural History, Chicago

Below: **Shaman's drumstick and daggers.**

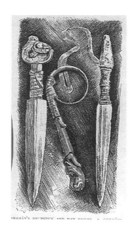

than Raven, so he placed him in the sky where he is known as Pleiades. He said to the Lugan, a bird that lives far out on the ocean, "You will live far out on the ocean on the lonely rocks. You will seldom be seen ashore." And to the eagle he said, "You will be very powerful, and fly above all other birds. Your eye sight will be without equal." Then he put the talons on the eagle. Eagle feathers and down were considered very sacred symbols.

The Raven was also a very sly fellow, and because of this, he played many tricks on people, as well as on animals. Once he was walking along a beach near an abandoned fish camp and he saw a huge salmon jumping in the sea. Immediately he was filled with a desire to eat the salmon, but had no way to catch it. Suddenly he spied a piece of jade on the ground and thought "Aha, I have a plan!"

The Raven called out to the Salmon saying, "Do you know what this green stone is saying to you? It is saying 'you thing with the ugly back. You thing with the filthy gills, come ashore'." And as the salmon came ashore to fight the stone, the Raven struck it and killed it with a wooden club, thus, because Raven made jade talk to salmon, people have since made stone axes, picks and spears of jade.

There was a great flood with the waters rising up and covering some of the mountains. The people and animals fled to the highest peaks. Raven hung on to a cloud until the water receded. He knew for certain the waters were receding when he flew over the sea and found a piece of kelp. The animals and people began coming down the mountain; but some of the people who returned were turned to stone by the Raven.

It was after the flood that Raven's mother died, and he said, "My mother is dead. I am going to drum and sing to praise her." And he gave a feast in her honor, and danced at the feast with the chilkat blanket owned by Gonaquade't.

The great young Raven, Yēl as the Tlingits call him, is comparable with figures in many tribal societies where the cultural hero is the trickster figure—for example, the coyote legends of the Southwestern Indians in the United States. "The trickster is a forerunner of the savior, and is at once a God, a man and an animal. He symbolizes the aspect of our own nature which is ready to bring us down when we get inflated, or to humanize us when we become pompous. The major psychological function of the trickster figure is to make it possible for us to gain a sense of proportion of ourselves. He is the satirist par excellence" (Singer, 1972: 289).

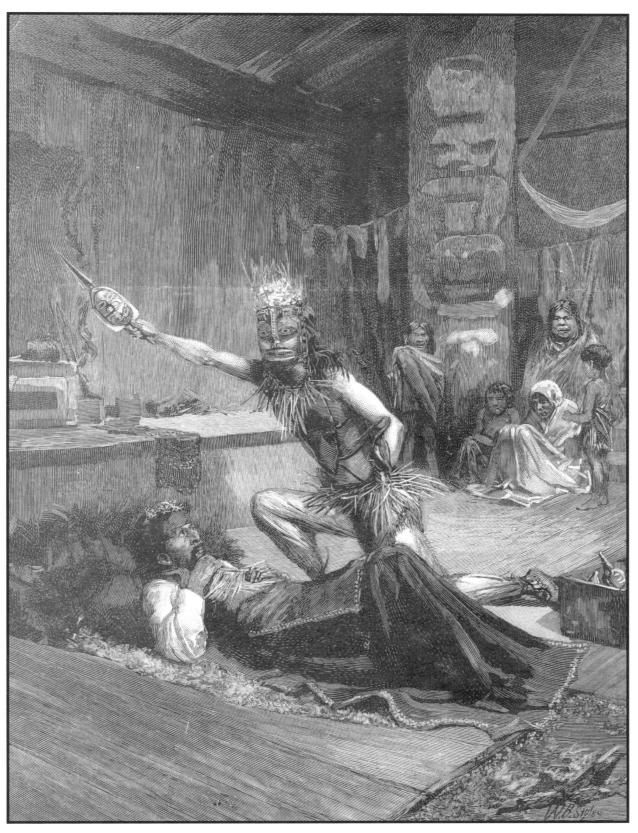

Tlingit shaman treating his patient

Shaman's headdress of bear claws.

Photo: Field Museum of Natural History, Chicago

THE TRANSCENDENTAL LINK BETWEEN THE TANGIBLE AND THE INTANGIBLE

Art was the expression of the metaphysical world. For the Tlingits, art, history and the legendary past, in addition to living patterns, were all one and the same, and thus were so intricately knit together that to loosen one would be to unravel the cultural fabric, causing it to disintegrate. In a sense there was no end or beginning of art, and no separation of it from daily living and the mythical past. The ceremonies employing the opposite moiety to erect houses and totem poles, to initiate persons into the secret societies and even pierce the lips and ears of their children represented a legal validation and a historical record. The combination of tribal validation and the use of the crest (Khà shuká) in the ceremony was an outward confirmation of their esoteric world.

It was the Ixt, the shaman, and his Yéik, spirit (his supernatural power or powers), who was called upon as a prophet and healer to act as the bridge between the spirit world and the tangible world. "He chose a life of dedication to the world of non-corporeal reality; and was moved to do so for some psychic or spiritual and manifestation of a particular quality of his being that set him apart from other members of society. He had to prepare for his vocation by undergoing arduous periods of isolation and personal sacrifice taking onto himself the suffering of his people and living through them" (Singer, 1972: 32). And if he failed in finding his guardian spirit, and failed in his psychological combat with the forces he had to conquer, he died!

The mysticism penetrated throughout the society through the use of meditation, the expanding of awareness and realization through the use of spirit guides and the belief in the reincarnation of souls. Fasting and bathing in icy waters and switching the body with bundles of faggots and nettles—even self-mutilations—were done to purify the aura of human sensuality and acquire superhuman powers, and enhance the telepathic means of communication and the interpretation of visions. In a world that was so greatly imbued with the transcendental and supernatural it was only natural that trances, taboos, amulets, the casting of spells, and bewitchment became a part of the cultural life.

Witches could curse people, it was thought, and so they were greatly feared. It was believed that they could complicate the lives of certain individuals or the group by spells and curses. Witches were not shaman and were seldom, if ever, members of the nobility. Generally they were members of other castes. The society dealt very harshly with suspected witches. There were three types of shaman who practiced Yāk (medicine). The Ixt shaman, who were both healers and prophets, practiced for the benefit of the people. The He'oyk practiced good or bad medicine and the Nuk'satie was a master of bad medicine. The latter two might be referred to as sorcerers or wizards.

The Indians endowed nature with spirit life, such as spirit of the earth, spirit of the air, spirit of the sea, and spirit of glaciers. Each shaman had his own spirits, usually five to eight, and each spirit had his particular song. The shaman entered into his spiritual combat wearing one of his Yéik guardian spirit masks. He began the ritual by beating his shaman sticks and singing one of his spirit's songs; then as the drums beat at a faster tempo he began to dance. During the dance he gestured with an elaborately carved rattle and passed into another dimension to contact his helping spirits, who in turn would lead him deeper into other realms. He returned after this journey with the means to heal or prophesy the future. He fasted and abstained from sexual encounters for a long period, and because he obtained power from his hair it was never cut or combed. He was called on to treat the sick, advise war parties, and predict the future. One of the great shaman spirits was Unseeable who, it was said, was the chief of all shaman spirits. He wore a tall hat and sat in the middle of a canoe with bowman and sternman. These three were much like the three Fates of Greek mythology.

Westerners have accused the shaman of being a sinister magician, a charlatan, a mental aberrant and a shrewd opportunist, but even the most cynical observer has been amazed at his powers. Cultural dimensions lock individuals into pattern grids that shut out other realities, and often blind one's objectivity in viewing other cultures, thus preventing a rational analysis and balanced view of other societies. If one pauses to ask "Has anyone seen an angel?" No one will answer. This is in spite of the fact that angels dominate Western beliefs and are seen in the finest paintings in the world's greatest museums.

In the material world, the carved red cedar poles were not only legal writ but a narrative link to the metaphysical world. The totem crests usually depicted mystical animals from the spirit world (past or present) and

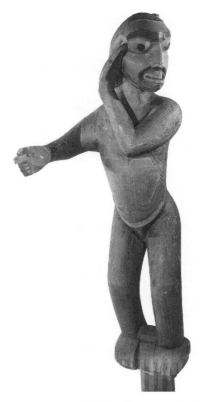

Chilkat shaman witch spirit wand.

Photo: Field Museum of Natural History, Chicago

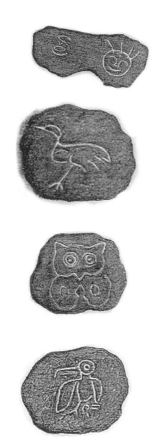

Petroglyphs—carvings on rocks. These are still found in abundance on beaches in Wrangell, Alaska. Their origins are unknown.

Photo: Maria Bolanz

actual animals represented with human qualities which, it was believed, they could manifest. A kind of fluidity of form existed whereby man and animals interchanged form and generated important events and/or changes in the clan or subhouse history. "For the Indian believed the legendary encounters with spirits and monsters were an actual historic event, and as much part of the natural order of the universe as was man himself" (Drucker, 1958: 191).

Margaret Lantis, an anthropologist, suggested in a lecture at the Anchorage Art Museum at the opening of the exhibit 'Our Way of Making Prayer' in 1996 that, rather than totemism, it is closer to a type of animalism since Tlingit society is based on an organizing principle of animal crests as symbolic origins of the various clans. These form cohesive relationships by building kinship groups, clans and moieties based on both existing and mythological animals to represent man's relationship in the natural world. The logic afforded by the use of clan crests give a meaningful expression to the systems, concepts, and categories derived from experiences imposed by the surrounding world.

This was explored by Jenness (1943: 540):

> We know what animals do, what are the needs of the beaver, the bear and the salmon, and other creatures; because long ago men married them and acquired this knowledge from their animal wives. Today the priests say we lie but we know better. The white man has been in this country only a short time and knows very little about animals; but we have lived here thousand of years and were taught long ago by the animals themselves. The white men write everything so that it will not be forgotten, but our ancestors married the animals and learned their ways and passed the knowledge from one generation to another.

The beauty of their logic enabled them to intimately understand their environment and to survive and thrive in it. They carefully classified plants into edible, non-edible, and medicinal; they analyzed the plants of the sea, and the manner and habits of the fish and mammals of the sea. They studied the stars, and expertly navigated by them; their knowledge of geography was meticulous and thorough. They were weavers of fine textiles and elegant blankets; their language is expressive and highly complicated. They were, perhaps, some of the most expert boat builders in

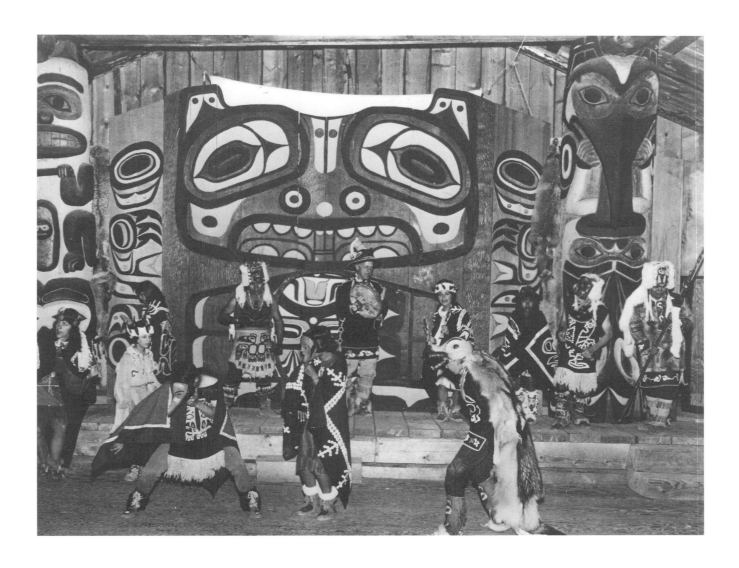

North America. The boats varied between 12 and 75 feet in length and were not only seaworthy—they were works of art. Their knowledge of engineering and construction was unrivaled in house building.

The Tlingit clan ḥouses, or wooden tribal houses, were an elegant feat of engineering. The dwelling places were quite large—often wider than forty-five feet and longer than thirty feet—and were solidly constructed without joints, standing for many years. The wood work was both an architectural and an aesthetic wonder. The house was not only a dwelling, but a representation of the lineage line and contained the tribal wealth of blankets and coppers. The four supporting house posts, or gars, were carved with historical events of the history of the group and their crests, which were their privilege to use. No house could exist without tribal validation in the form of a ceremonial feast. It was this ritual in its multiplicity of forms that created the cultural adhesive.

A modern representation of a ceremonial feast with Chilkat dancers from Port Chilkoot, Alaska.

Photo: Alaska Dept. of Economic Development

THE CEREMONIAL FEAST KHU.ÎX' (POTLATCH)

Khu. îx´ is the general name for a ceremonial feast meaning the *inviting*, and it was a complicated system of legal validation and distribution of property and a transfer of wealth and titles with corresponding obligations required of the recipients.

The significance and meaning of the potlatch, because of the colonial powers' limited understanding of it, was blown up as a circus and focused on as "a gigantic bloody savage farce of killing slaves and burying them beneath the totem pole at the feast" (Wherry, 1964: 100). The entire potlatch celebration and ceremony was reduced to this one simple exaggeration. Probably no one custom of the Northwest Coast Indians has been so misunderstood and taken out of context. A comparison of crosscultural misunderstanding might be drawn of the Aztec Indians in what is now Mexico, who upon viewing the ritual of holy communion practiced by the Conquistadors, drew the conclusion that it was a kind of cannabalistic ritual in which they created their God out of bread and wine and then ate him! The name "Potlatch" itself is a misnomer, and in reality is a corruption from a Nootka phrase *Patshatla*, meaning "giving," and adapted into the Chinook jargon, a traders' jargon that was used on the Northwest Coast. The Tlingits themselves never used the term since each feast was named for the type of event it was to represent—mortuary, memorial, the dedication of a clan house, and later on, in the nineteenth century, the public validation of important events. The Khu.îx', or ceremonial inviting, was an integral part of the raising of a totem pole.

The respect for one's ancestors, honor for the dead and the belief in reincarnation are major threads that run through Tlingit culture. John Swanton, an early ethnographer in the field, observed that "the erecting of a house or a totem pole and the secret societies' performances, feasts and distributions of property which accompanied it, were all undertaken for the sake of the dead members of the clan; every blanket that was given away and the food offering that was put into the fire were in honor of their ancestors" (Swanton, 1908: 435). These gestures offer an example of ideology molding social responsibility since reincarnation meant rebirth into the tribe, so indirectly homage was being rendered to all the living members of the tribe. The Khu.îx' (ceremonial inviting) was

extremely formal. Invitations were sent out in different ways. For example, an invitation might consist of the ceremonial crest hat of the inviting chief being carried to each clan house in order to announce the event, a messenger might appear and announce the event with a special song composed for the occasion, while another announcement might be in the form of a ritual dance.

The Khu.îx', or potlatch, was the bonding for the social structure; the keystone that underpinned the culture. The event validated status and property, and served as the axis around which the social grouping of lineage and clan revolved. The concept of the ceremonial/inviting was the legal affirmation to right and privilege. It was the lineage group that would work together to amass property and act as a group host to opposite clan or clans (one never hosted one's own group).

The Hít s'àtí, or chief, was the principal figure at a ceremonial/inviting, since he was custodian of the group's wealth. He directed the labor, assembled the property and collected contributions from his clan, arranged the amassing of goods to be given away, and acted as host for the event, but it "was a major clan group activity which served to maintain the sense of membership and to further the solidarity of the group" (Spencer and Jenning, 1940: 190). It was the tribal way of establishing and maintaining a stable relationship between local segments and the other extended villages. A chief would announce the event to be celebrated and request the support of his clan in other extended villages. Upon receiving their affirmation of support the chief outlined the time, selected the groups to invite, directed the labor, assembled the property and collected contributions from his kinsmen. The lineage of his wife/wives, as well as, the lineage of the wife/wives of the deceased chief and their clans' recognition and acceptance of the feast was required—this was a factor in promoting social stability between intermarriage lineage lines. The chief's matrilineal kinsmen were the hosts at the event and all members of his group shared in the proceedings and received public acknowledgement on receiving names, titles, and inherited property. It benefitted all members of his household to offer their assistance, and the chief could always count on their support.

"Proud and haughty behavior, subtle references to one's descent, titles, privileges and one's use of valued lineage names and crests were carried out with pretended indifference to the property amassed" (Spencer and Jenning, 1940: 191). Property was given away to guests, and offered to the deceased members of a clan by throwing objects or food into the fire or simply broken like a copper. This was carried out with an elegant

disdain to indicate a wealth so vast that these losses did not matter. The gift giving was the basis of showing respect to the invited clans of the opposite moiety, and carried with it an act of bonding, which in return required some form of reciprocation at some future time. The acknowledgement and partaking at the feast of the opposite moiety were the quasi-legal structures that strengthened the economic ties and reaffirmed social integration of the group. Hierarchical precepts and rigid protocol offered built-in provisions to control the rivalry.

THE NEW TRIBAL HOUSE INVITING

One of the most important ceremonial invitings of the Tlingit was the one for the newly built tribal house. The house was so implicated with rank and title, so massive in architecture and size and so involved with gigantic expenditures, planning and construction, as well as, representing the symbolic origin of the group with the carved house posts and portal entrance posts, that its importance cannot be overstated. It was built by the Hít s' àtí, with the consensus of his clan, and the chief had to support all the workers while they were building the house. The new house and the associated house posts, the assumption of titles of the deceased chief, all required public validation through the ceremonial inviting. In other words, the new Hít s' àtí legally claimed his inheritance and right to his position as titular head and in doing so raised the esteem of his group by the potlatch.

INVITING FOR A HIGH RANKING PERSON'S DEATH RITUAL

Equally important was the potlatch given for a death of an important person, Yù at kùtìk. This was carried out in stages and involved ceremonial rites that concluded, at least a year later, with the mortuary feast and the raising of the mortuary pole (Q'do Ke dî). The corpse would be displayed dressed in his finest ceremonial clothing, and his face painted with the death sign of his moiety; the wake would last four to eight days, and the mourning songs and chants continued day and night. The grieving family and friends cut their hair, blackened their faces, and lamented their loss. At the end of the wake the body was removed through a hole in the roof then cremated. In pre-contact times a slave or slaves could be killed to attend his master in his journey. The bones would be placed in a painted wooden box (Khà dàkèdî). All these formalities were tended to by the opposite moiety. On the eve of the potlatch the formal *smoke feast* was held. All details were carefully planned "to ensure this the aristocracy, and the guardians of the matrilineal group of the

Hít s' àtí had to involve themselves significantly in the planning and execution of the funeral" (Kan, 1989: 166). Condolence speeches were given, "the crying songs" were sung, and some of the deceased's possessions were distributed along with names and titles. Meanwhile behind the scenes the major shifts the death may have caused in the power structure were being pondered and evaluated.

Forty days later it was assumed the deceased had completed his journey on the spirit trail and had reached the land of the dead. This was a very dangerous journey for the spirit trail was infested with grizzly bears, monsters, and harmful forces. This was the time for the Forty Day Observance. It was a feast of joy and filled with speeches of loving remembrance of the deceased.

A year or two later the mortuary feast was held and the box of ashes was transferred to the back of a totem pole that had been carved for the occasion. In the event of a chief's death, this marked the final transfer of the inheritance (khà nêx'i) and the end of any moiety conflict that might have arisen during the change in power within the lineage, and confirmed the assumption of the heir to the role of chief. The mortuary potlatch marked the transfer of titles and names and privileges, and was full of praise and homage for the deceased. This was carried out in the same manner as the other types of *invitings*, although conducted for its own specific reason. Unique to this potlatch were the very sad mourning songs by the host and hostess, the people would shed tears and gradually the songs would become happier.

THE COMMEMORATIVE INVITING

The third important ceremonial inviting was the memorial or commemoration feast (Khà dàtíyí), sometimes referred to as the anniversary feast. Some scholars regard the mortuary and memorial feast and their corresponding totem poles as one and the same, except that the memorial pole contains no burial remains. "The totem pole set up at this feast was in memory of the deceased, yet it reflected equal honor on his successor," (Emmons, 1991: 193). The successor assumed the titles and needed to validate his status and worthiness to bear the crests, titles and names that were a part of the position he had assumed along with the control of the property/wealth of the house. In honor of his ancestor one or more slaves could be killed. All heirlooms and crests were displayed and gifts were given. It was his prerogative to bestow new titles and names to ranking members of his group, and to acknowledge and honor individual names already acquired by other members of the group. Names were

important clan possessions as they indicated family history, rank, and lineage. "Each family had a series of titular names, the use of which was strictly observed. They could be inherited or acquired by the association with some important event or received during a potlatch to elevate the person's status within the tribe" (Inveraity, 1950: 25). During his life an individual may have several names—his name at birth and a name acquired for a specific deed, such as booty in war. The name, just the word itself, had such significance and meaning that it revealed the family, rank, clan, area and event. Names could be acquired out of the lineage, even from a foreign group as a gift. "All qualities and special privileges belonging to the original owner of the name were acquired by the new owner" (Inveraity, 1950: 24).

Historically these events were quite magnificent. Invitations were sent out months in advance. At the appropriate time the guests would arrive in huge carved canoes with slaves at the paddles and actors in carved masks prepared to enact a clan story. Dancers in costume, song leaders with carved staffs and a chorus dressed as mythological animals chanted to the drum beat as the canoes moved through the water. Others came by land, dressed in their finest blankets and crest hats with their faces painted according to clan and rank, and announced their arrival by singing songs that had been composed for the occasion. The chief's representatives greeted them at the beach and everyone received a gift. They waited there for their formal invitations to enter the tribal house.

During the ritual, the chief wore a chilkat blanket, a ceremonial robe of woven mountain goat hair and red cedar bark, his crest hat, which might be trimmed with ermine skins that hung to the ground, and he sat in the rear area of the house—considered to be the place of honor—with his wife, who wore a button blanket, abalone shell earrings that could be seen across the Nass River, bone bracelets, and in contact times, gold bracelets that encircled her forearms to her elbows. The ranking nephew would sit either in front or behind the chief, depending on the nature of the feast, while selected members of the chief's clan also occupied the rear area of the house. Other members of his clan stood in the front at the entrance of the clan house to greet the guests as they arrived and usher them in. The opposite moiety entered singing their entrance song (Ne xae shí), followed by the procession song (Yà na át da'shìyí) as they walked to their places at the feast. The master of ceremonies (Nà'kâni) welcomed them in Gunāh khâ ah etî, the special oratory language with high pitch meaning speaking around the fire, reserved for the *invitings*. The guests were seated with the opposite moieties facing one another in two long rows that extended from the entrance

to the formal area; in the rear of the clan house the chief sat with his family, solemnly watching his guests arrive while appearing indifferent to the vast amounts of wealth he had collected.

Speeches, drumming, and dancing filled the intervals. At the appropriate moment the spirit dance was begun, and as they danced, eagle down scattered from their headbands signifying friendship and welcome. As the food was being served, the chorus, composed of clan sisters, sang directed by the song leader who used the dance staff to beat the tempo on the floor.

Some members of the chief's clan sat quietly, observing with great dignity the proceedings, looking out for a possible breech of etiquette or an accident in protocol. These were considered unforgivable errors. The following day the gift giving (At ta,ùx'ú) would take place with the host's moiety giving the gifts to their opposite moiety. One's own moiety was known as *my friend* and one of the opposite moiety was spoken of as *my outside shell*.

Lavish events were discussed and remembered for years. Great quantities of food, including rare and unusual foods, were important for the event. Food was considered wealth, and lavish quantities were served in huge carved dishes—one was three feet long! Canoes were filled with food to be given away. Affirmation of status required an investment in the form of blankets, boxes of eulachon oil, seaweed, berries, furs, weapons, moose and deer skins, carved vessels and boxes, and above all, the highly prized copper, since all major potlatches required one. They could be given away or broken, and were carried by servants or slaves on these occasions, and on these occasions often beaten as a gong. Coppers (Tinâ) were of small intrinsic value, but were valued as high as 10,000 blankets, and when they changed hands they were valued according to the last amount paid for them. "The potlatch was conducted very seriously replete with drama; elaborate oratory and protocol, amidst the display of vast amounts of property, ceremonial dress, elaborate etiquette and great dignity accompanied by a strong sense of pride and honor" (Spencer and Jenning, 1940: 192).

The ramifications of the potlatch and the raising of the totem pole that accompanied it were not only powerful symbols to the Indians of the Northwest Coast but to the colonial governments as well, for they did not fail to recognize it as one of the major cores of the indigenous culture, along with their lands and language. The land they had taken without title, and the languages could be crushed by the boarding schools, but the threat of the potlatch had to be crushed *in situ*. Canada chose to outlaw it by the Indian Act of 1884, while the Federal and Territorial governments in Alaska did not actually legally ban it, but behaved as if they had, and

severely discouraged the practice. Both governments chose to enforce their policies through the churches and the regional boarding schools. Canada later felt obliged to use direct law enforcement, including fines, prison sentences, and confiscation of potlatch property. Alaska's policy was indirectly strengthened by the action taken by Canada and it was able to continue enforcing its position through the churches and boarding schools without enacting a law. Officially the policy was the complete assimilation of the Indians into Western culture, and the remaining barrier was the potlatch! Presented to the public with less coercive wording it was spoken of as immoral, degrading, spreading disease in group gatherings, pauperizing the people by draining their assets and leading to prostitution in order to pay for the potlatch.

The missionaries accepted the challenge. They chose to come to a remote part of the world, to live in isolation from family and friends, and to relinquish frequent contact with their homeland in order bring Christianity to the natives of Alaska. "They opened stores to obtain the things they needed, and they offered cheap trade goods, medicines, tools and could offer expertise in technology, especially sawmilling. They were opponents of disruptive forces, especially liquor" (Cole and Chaikin, 1990: 55).

Rightly and wrongly the clergy and layworkers helped the Indians understand and accept the new land laws and the resource developments that were occurring and greatly impacting on the indigenous people. As the very foundation of the Indians' existence broke away from under their feet the churches offered them a new way of life, the Christian Way, to begin again. By the turn of the century many Tlingits had become Christians, and were agreeing to abandon the potlatch and destroy their totem poles. Governor Brady considered the potlatch the most abhorrent of all the Indian customs and promised the Tlingit Christians of Sitka that he would expunge the potlatch from Alaska.

"In 1904 native groups gathered in the territorial capital of Sitka for a potlatch, the last of its kinds given by the Sitka Tlingits. Governor Brady hosted the ceremony at which a Tlingit chief came forth to renounce their old customs and present the governor with a raven hat said to be from the eighteenth century" (Cole and Chaikin, 1990: 59). Hoonah and Yakutat refused to yield, and continued to hold potlatches for some time.

Some Indian agents were more sympathetic to the Indians and attempted to ignore the situation when they could. "Feeling that the potlatch was neither Government nor departmental property; but entirely the results of their own labor, and that at least some of goods disposed of went to the needy among them" (Cole and Chaikin, 1990: 64). Many of

the elders said they would rather die than relinquish the potlatch, and reminded the Government that it was like the Fourth of July, Christmas, and anniversary celebrations. As a result, for fifty years the Canadian Tlingits, Haidas, Tsimshians, and Kwakiutl fought many legal battles, including test cases and imprisonment to continue to hold potlatches.

The more rigid Canadian officials, such as Superintendent Scott, continued the battle declaring that "the potlatch are attended by prolonged idleness and a waste of time by ill-advised and wanton giving away of property and by immorality" (Cole and Chaikin, 1990: 133). The more lenient agents were under a great deal of pressure from their superiors and were forced to change, leave the service, or retire. Meanwhile, agents such as DeBeck, who "wanted to make them do what I know is best for them" (Cole and Chaikin, 1990: 179), remained in the system. The Indians and the Colonial governments were at war on the Northwest Coast!

The Kwakiutls were the most conservative and never ceased fighting, partly because their marriage customs and secret societies were also declared illegal. George Hunt, Dr. Boas' informant, was arrested for illegally participating in a secret society ritual where supposedly human remains were eaten (the corpse was said to have been dead for two years). Willie Seaweed, a famous Kwakiutl carver, continued to make dance masks for potlatches until 1940. Some of his finest masks were made during this period.

The anthropologists, who had done field work among the Northwest Coast groups, actively protested against the Canadian law and the attitude of Alaska. John Swanton argued that since the Indians were not permitted to take part in civic and political activities the potlatch was their only source of pleasure during the long winter months. Peter Macnair, of the Royal British Columbia Museum, wrote, "The law tore away most of the traditional social fabric. It was enforced to persecute native people and not to prosecute the potlatch" (Macnair: 514). Boas wrote, "The results would be havoc as would be created by the destruction of white man's cheques, drafts and other forms of credit and cause complete demoralization of their business system" (Boas, 1992), Sapier, the director of the Ottawa National Museum bluntly stated, "It seems to me high time that the white men realized that they are not doing the Indian much of a favor by converting them into inferior replicas of themselves" (Sapier, personal correspondence, 1915). Newcumbe feared, "With all their custom birth, marriage, family life and death suddenly destroyed they would become lost, listless and indifferent" (Newcumbe, personal correspondence to Sapier, 1915).

The pressure continued. At a potlatch in Alert Bay the goods were confiscated, and several hundred items, such as coppers, masks and crest hats were sold to George Heye for American Museum of Indian Art-Heye Foundation in New York, the Ottawa National Museum and the Royal Museum of Toronto. The latter two later returned the items to the Indian people.

In the crusade against the potlatch no notice was ever taken of the sordid and tragic practices occurring in the government boarding schools and mission schools, which Alaska continues to ignore, and only Canada now is acknowledging the child abuse and sexual exploitation of both male and female students.

It was not until 1934 when MacKenzie King and his liberal party took office that the sanctions were lifted against the potlatch. The law was finally removed from the statutes in 1951 and Alaska reduced its resistance to the custom about the same time. There was a consequent resurgence of the potlatch and carving of totem poles beginning in 1960.

As a *cause célèbre* of the colonizing powers, probably no custom of the Pacific Northwest Coast Indians was so exploited by ridicule, distortion and misrepresentation in order to demean the solidarity of the Indian society as the *inviting*. As a result of this policy, most existing poles were chopped down or burned.

THEORIES ON THE ORIGINS OF TOTEM POLES

While the destruction of the totem poles is well documented, the origin, development and historical dating is still debated among scholars. The questions and answers on the origin of the totem poles are often just as enigmatic and mysterious as the highly stylized designs and split form designs of the Kùtîyà (markings). Is their actual origin documented in the maze of explorers' accounts? Did the Indians stealthily conceal the totem poles from them? Are they a fairly recent phenomenon that reached its golden age between 1800 and 1880, and then succumbed to acculturation or are they the development of a very ancient tradition? Perhaps more importantly, are they only relics of the past or are they still a part of a vital cultural heritage?

The answers to these questions rely upon written accounts of early explorers and fur traders, archeological discoveries, the legends of the

Northwest Coast people, and detailed analysis by art historians regarding the progression and development of the art form and the Tlingits' use of tribal art in their modern society

The written history of Alaska begins with the eastward expansion of Russia and the second expedition of Vitus Bering and his discovery of the coast of Alaska in 1741. Bering commanded the *St. Peter* and Chirikov commanded the *St. Paul*. The ships separated during a storm, and Chirikov became the first European to encounter the Tlingits at Salisbury Sound. A reconnaissance group that went out from his ship did not return and a subsequent search party also did not return. No one knows whether the Tlingits killed them or they were swamped and drowned.

As a result of the Vitus Bering expedition Russia claimed most of what is now Alaska by the right of discovery, and began to build an active trade in furs using the Aleuts as both hunters and middlemen in dealing with other native groups. In 1783 the Russian fur trading company began expanding from Kodiak to the mainland in the direction of Southeastern Alaska. This was the beginning of the Russian-Tlingit contact. During the next decade, following their advances in the area, no mention was made of totem poles until they founded a settlement at what is now Sitka, and their records mention encountering free standing poles. In 1802 the Tlingits attacked the fort, burned it, and massacred all but two Russians.

> In 1805 Alexander Baranof, general manager of the Russian-American company and Governor of Russian America, returned with the flotilla of 300 bidarkas manned by 800 Aleuts and two small ships on which there were 120 Russsian and aided by the guns of warship Neva destroyed the Tlingit village and burned the totem poles. (Hullyu, 1970: 126)

The Russian presence was not an isolated phenomenon on the Northwest Coast, and other European nations, lured by the abundance of furs and a possible Northwest Passage, took considerable interest in the area. Spain, which had already established a strong presence in the New World, maintained a wary eye toward foreign activity on the Northwest Coast and continued vigilance was combined with a keen interest in searching for the fabled Northwest Passage. As a result, from 1774 into the first quarter of the nineteenth century, Spain sent eight expeditions from México to explore the Northwest Coast. Six of these expeditions reached Alaska, and well-documented accounts exist of the

voyages. In 1774 the Spanish viceroy in México, Fray Antonio de Bucareli, sent Juan Pérez in command of the frigate *El Santiago* with Francisco Maurelle as pilot to explore the area. They reached Dall Island, discovered what is now Forrester Island, surveyed and described the land of the Kagani Haida, and after a rest in Bucareli Bay returned to México. A year later, two ships were sent from San Blas, México, to continue explorations. Juan Pérez was in command of the *Santiago* and Bruno Hecate was the pilot; the second boat, *La Señora*, was under the command of Don Francisco Bodega y Quadra with Francisco Mourelle as the pilot. In July 1775 six sailors went out in a canoe for water and were ambushed and killed by the Indians. For this reason the point of land was named Punta de los Mártires, or Martyrs' Point. The two boats became separated during a storm. The *Santiago* returned to San Blas, while the *Señora* continued on, reaching what is now Sitka. Slightly north of Sitka they went ashore for water and saw a crudely constructed shelter with a parapet of trees for defense. They planted a cross on shore and took possession in the name of Spain calling it Puerto de los Remedios, now Salisbury Sound. They noted that the river was full of fish. The date was 18 August, and so we can assume this was a fishing campsite and not a village. Maurelle charted Cabo del Engaño (Cape Edgecumbe) and Ensenada de Susto (Sitka Sound). Both names were given by Bodega y Quadra, and were later changed by Captain Cook. They made no mention of totem poles on this journey.

Captain Cook, sailing on a British expedition in 1778, mentions the expertise of the Northwest Coast Indians in working with wood, but did not mention totem poles. He noted sighting the area of Sitka Sound and seeing villages, but continued on northward passing Mount Saint Elias.

In 1779, on orders from the Méxican viceroy, another expedition was sent northward under the command of Ignacio de Arteaga. He sailed with two ships, the *Nuestra Señora del Rosario* under his command and the frigate *Virgen de los Remedios* under the command of Lt. Bodega y Quadra with Ensign Mourelle acting as pilot for the third time. They reached Bucareli Bay on the west side of Prince of Wales Island and explored the area for two months. No mention was made of freestanding totem poles in their detailed accounts on the southern Tlingits. They ventured as far as the Copper River Delta site of the most northern Tlingit Village of Eyak, crossed Prince William Sound and entered into Cook Inlet—the site of modern day Anchorage.

In 1785 Comte de Perouse sailed with two ships, the *Astrolade* and *Boussole* from France, on a scientific expedition around the world. They sighted the coast of Alaska and landed at Lituya Bay where they stayed for six weeks among the Tlingit. La Perouse gives interesting and animated accounts of the Tlingits in this area. He notes they were in possession of iron, copper, hatchets, beads, and what Perouse refers to as carved poles. "While reports of interior house posts are common in the eighteenth century, the large free standing poles were unusual. Only at Dadans on the Queen Charlottes and Lituya Bay are there early reports of such sculptures" (Cole and Darling, 1990: 132). The expedition met with a terrible misfortune when 24 of his crew drowned while taking soundings in an inlet passage.

Captain Dixon, sailing under the British flag in 1787, described Native art and carved figures as a type of hieroglyphics, noting a certain elegance. In the same year an American seaman, John Bartlett, sailing on the *Gustaves Adolphus*, described and sketched a portal entry pole at a Haida village in the Queen Charlotte Islands. He described it as being in the shape of a man's head with the passage through his teeth. He estimated the pole to be forty-five feet high.

Spain was now alarmed by the Perouse voyage, fearing greater French presence in the area and the possibility of a Russian advance southward. They had become aware that the Empress Catherine planned to send an expedition to occupy Nootka Sound to thwart the English presence. In 1788 the Méxican Viceroy sent two ships to the Northwest Coast, the *Princesa* commanded by Alférez Estevan and the *San Carlos* commanded by José Martínez, to meet with the Russians and inform them of the Spanish plans to establish a outpost at Nootka Bay on Vancouver Island. In spite of foreign opposition, Spain established the post and occupied the area from 1789 to 1793. While there they collected excellent data on the Nootka and made many excellent drawings showing the interior of the house with carved house posts. Much of this information is now to be found in the Museo Naval in Madrid, Spain.

The Alejandro Malaspina expedition sailed from Cádiz, Spain on 29 July 1789 to continue the search for the Northwest Passage and explore the Northwest Coast of America, and then follow the route of the Spanish galleons to the Philippines. Malaspina was in command of the flagship *Descubierta* and José Bustamante y Guerra in command of the accompanying vessel *La Atrevida*. This was the fifth Spanish voyage to the Northwest Coast. In late June 1791 they approached Port Mulgrave, now known as Yakutat, and were met by two canoe loads of Tlingit men who

came along the side of the ship singing. "They swayed back and forth, dropped their oars as they clapped bands in rhythm to their songs and led the two ships to Port Mulgrave" (Rey, 1996: 54).

The expedition spent about ten days there, some of them in rather precarious circumstances as there were some difficult moments with the Indians. Several times they were forced to threaten harm to the Indian hostages if peace was not restored. (All foreign ships practiced keeping a few Indians on the ships to be used as hostages should the situation arise.) Always on guard, they did manage to trade, communicate, and make some interesting observations.

The diaries of Tomás de Suria (who was held captive in the chief's house for a brief time) and Captain Esteban Tova contain many interesting details of Indian life. An entry in Malaspina's diary dated June 1791 mentions their first encounter with a grave at Puerto Mulgrave.

> We came upon the grave of an individual, who the Indians said was killed in their last war. The grave was indicated by a small pole that had been dug in the ground. A woven grass mat covered the grave, and was held down by rocks. The Indians showed great reluctance about getting close to the area, and indicated by signals and signs that we should not go near it either. We took it to mean they were afraid we would interrupt a peaceful sleep. (Malaspina, 1885: 308)

One pauses to wonder if the Spaniards were not mistaken, and it was the new grave of a shaman or some other person about which there was great controversy. A few days later Malaspina, Suria, and Captain Tova came upon another burial site. They were walking along the banks of a river, and found what they described as an old sepulcher. Malaspina gave the following description.

> There were posts and beams that encircled a large room covered with a roof probably to offer protection from inclement winters. Four Indians were gathering berries nearby; but they did not intrude upon us. We occupied ourselves a long time studying the burial objects, and desired to take some of them, but feared that the nearby Indians would not look favorably on it. We experienced a strange admiration for the place, and a haunting respect for the people who had created it. Finally we offered pres-

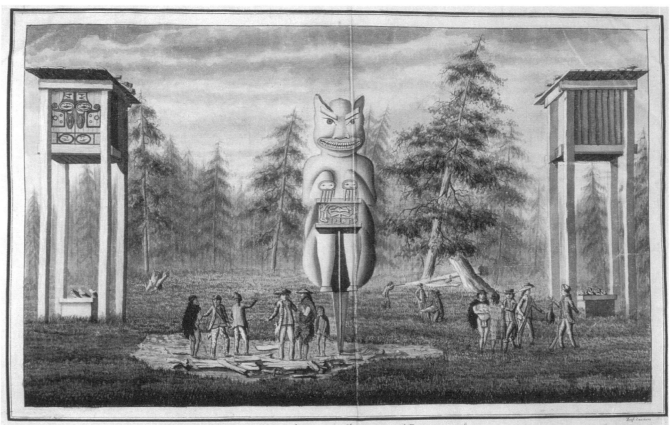

Pira, y Sepulcros de la Familia del actual *An Kau* en el Puerto *Mulgrave*

**From Malaspina's voyage
"Viaje Aldrededor del Mundo"
1791; Yakutat. Drawing by José
Cordero. A.M.N. 1726/50 2926.**

Courtesy of El Museo Naval, Madrid, Spain

ents to the men, and seeing that they were content with our presents, I took out a box from the old sepulcher as a specimen for the Royal Cabinet in Madrid. It was adorned with sea shells and inside was a smaller box in which were burned bones wrapped in a cloth along with dust. I understood from the Indians that this tomb was for ruling family. (Malaspina, 1885: 313)

José Cardero, the ship's other artist, made a drawing of this. Suria, also, described the site as, "Two large square boxes raised about 2 1/2 yards off the ground and held up by four pillars, also perfectly square. Of these large boxes the one on the left had several designs on the frontispiece, and other signs whose meanings we ignored at the foot of the large boxes (at ground level)" (Rey, 1993: 73).

On 5 July, one of the officers was dismantling the observatory set up on the land when some difficulty arose with the Indians over the theft of ships' maps and navigational instruments. Malaspina had to fire a cannon without the ball to frighten them into returning the articles. Peace was made, and in celebration the Tlingits came out to the ships

dancing and singing, incorporating the name of the ship *Atrevida* in their songs. Later during the event, the chief, to whom the Spaniards referred to as Ankau, led them to the third sepulcher of his family, and Malaspina wrote of it in detail.

> We do not know whether the colossal monster which occupies the foreground is an idol or merely a frightful record of the destructive nature of death. Its height is not less than ten and one half feet. In a casket which lay beneath its claws or hands was a bowl shaped basket, and in it was a European type of hat, shells and a piece of board. The whole thing was of pine wood and the ornaments on the caskets were of shell embedded in the same wood. The coloring was red ochre with the exception of the teeth, claws and the upper part of the sepulchral deposits were baskets, one greater than the other, containing calcified bones. The monster's significance was unknown. It faced eastward and some of the Naturales (natives) that accompanied us said his name was 'Inkitchetch'. Hairs hung from the ends of both high posts, and the boxes were carved with strange symbols. There was a shelf with circular rings above the two lateral posts. We had no doubt of the burning of corpses. Around the figure we saw three or four trenches, the size of a man, covered with stone, boards and coals were obviously used to make a fire. (Malaspina, 1885: 313) (Sketch by José Cardero is seen on pages 53 & 74.)

The *Atrevida* sailed to the nearby Pineda Island leaving the other ship, the *Descubierta*, in Puerto Mulgrave. There Malaspina noted "We saw again the absolutely same kind of sepulchers as in Puerto Mulgrave" (Malaspina, 1885: 319). Dr. de Laguna acknowledged, "I believe that the Bear and Killerwhale grave monuments seen by Malaspina were associated with the Té'q e'dî. This Tlingit clan was recognized as having originated among the Tongass, and members had moved north to Sitka and eventually to Yakutat. It is reasonable to suppose that the leading aristocrats of that clan were of Tongass descent and that the immigrants had brought to Yakutat the typically Tlingit heraldry and the totem pole" (Emmons, 1991: 195).

During the time of Malaspina's voyage Spain was experiencing international challenges regarding its settlement at Nootka. France was unable to assist Spain because of the impending French revolution, but felt compelled to have at least a presence there. Captain Etienne Marchand sailed from Marseilles in 1791 on the *Solide*, and spent some time near Sitka in 1792, writing some of the finest accounts of the Northwest Coast at that time. "Indeed, Marchand's voyage because of the publicity given it by his four volume work was better known than any of the other expeditions that preceded it" (Hully, 1970: 110).

Captain Vancouver, sailing on a British expedition in the southern area of the Northwest Coast in 1793, reported standing totem poles in front of houses with painted house fronts" (Hully, 1970: 324). Almost a decade later, in 1805, Russian Captain Urey Lesiansky arrived in Sitka on the *Neva* and wrote: "The bodies are burned and the ashes and bones are placed on or in a pillar that has different painted figures on it according to the wealth of the deceased. On taking possession of our new settlement we destroyed, at least, a hundred of them" (Lisiansky, 1914: 200).

The voyage of Juan Pérez in 1774 marks the beginning of the presence of foreign sailing ships in the area. English, French, Russian, American, and Spanish explorers and traders all give detailed accounts of their findings. Many stayed on board ship or stayed near their land-based fortifications. Vancouver, exploring in late 1795, met a hostile reception, and averted trouble by making a hasty retreat. After the Russian occupation and subjugation of the Tlingits in 1805 they continued to be on guard against further attacks. The French ship *Bordelaise*, commanded by Captain de Roquefeuil, was anchored in 1815 on the east side of Prince of Wales Island when it was attacked by the Tlingits. Twenty of his Aleut guides (contracted from the Russians) were killed, and he barely escaped with his life. "The early European explorers and traders on the Northwest Coast of America were united in their testimony as to the warlike character of the Tlingits. They described the natives as courageous, daring, alert and never without their arms in readiness for instant use" (de Laguna, 1972: 101).

The caution of the early explorers is therefore not surprising. They were wary, always on guard, took care never to go far from the shore—and if they did, it was always in groups with ship's cannons well aimed at the landing site—and used hostages when there was trouble. The Russians kept to their forts and left the dangers of Indian contact to their Aleut slaves.

Drucker makes the point that, due to the danger of the hostile Tlingits, the ships' captains did not send crew members far from the ships to explore the area; and furthermore they rarely saw the winter villages (permanent villages) where the totem poles would be standing. He therefore concludes that "Northwest Coast art, and the carving of totem poles themselves antedated all European influences. Presumably the first iron used was obtained from some Asiatic source long before the entry of Europeans or Russians into the North Pacific" (Drucker, 1958: 597).

The ensuing period of early explorations and fur trade introduced new technology, material, and ideas that certainly affected the culture and art. Studies by Wike and Drucker, however, indicate that it was less disruptive to Indian life than previously believed, and was therefore not the disaster it was thought to be. Although the Indians were certainly caught up in the web of international commerce, they did have some control over the situation and could direct the change, inasmuch as they could decide whether or not to accept European goods as they certainly knew how to live without them. Conversely, the ships were halfway around the world and had to depend on the Indians for fresh food. The Europeans had ships laden with cargo that had to be traded in order to obtain the furs and fresh food they wanted, but the Indians had the controlling hand when it came to negotiations. There was always the chance that the Indians would refuse to trade and the ships' captains did not relish the loss of returning their cargos of iron, copper, cloth blankets, and beads to Europe. The Indians were not oblivious to this and were very wily traders, often playing the English, French, Spanish, and Americans against one another. "Although the fur trade clearly brought change to Indian society, it was a change that the Indians directed and therefore their culture remained intact" (Cole and Darling: 119).

The shattering of the Northwest Coast cultures was due to white colonization and settlement that occurred after 1840, causing the entire social order to be engulfed in a multiplicity of overwhelming events. Cataclysmic epidemics eroded old lineage lines, creating a void until new segments developed and encoded the old mores. "Before the arrival of the European in 1774 as many as 200,000 Native Americans inhabited the Northwest Coast culture area, making it one of the most densely populated nonagricultural regions of the world. Within 100 years the aboriginal population had declined by over 80 percent" (Boyd, 1774-1874: 134).

The epidemics came in waves. Smallpox struck first in 1775 and reoccurred in 1836, followed by epidemics of measles and venereal disease. The diseases greatly decimated the population and shattered lineage lines.

The people desperately needed to redefine and confirm their status in order to validate their position within the social group that remained. The United States purchase of Alaska in 1867 was another change that greatly affected the native people. The American occupation and subjugation further disrupted the economic values, and the religious conversion changed the entire dimensions of their once tightly structured society and belief system. They were further victimized and exploited by the federal troops who had been sent to protect the law of the United States government and the newly-arriving settlers. The Tlingits grasped desperately for ways and means to protect their domain and very existence, almost as aliens, in the increasing Western presence. No sooner had they made a tenuous adjustment than they were struck again. The third epidemic, Spanish influenza in 1918-19, killed thousands of native people and was followed by a massive tuberculosis outbreak that began in 1940 and was not fully contained until 1975. Suicides, mental disorders, and alcoholism occurred due to stress.

It was an endless struggle to survive, let alone maintain a cultural identity. The changes in the sculptured totem poles reflect the suffering of the people and their struggle to retain a psychic balance.

Dancers at Potlatch at Chilkat.
Photo: Alaska State Library, Winter and Pond
Collection PCA 87-20

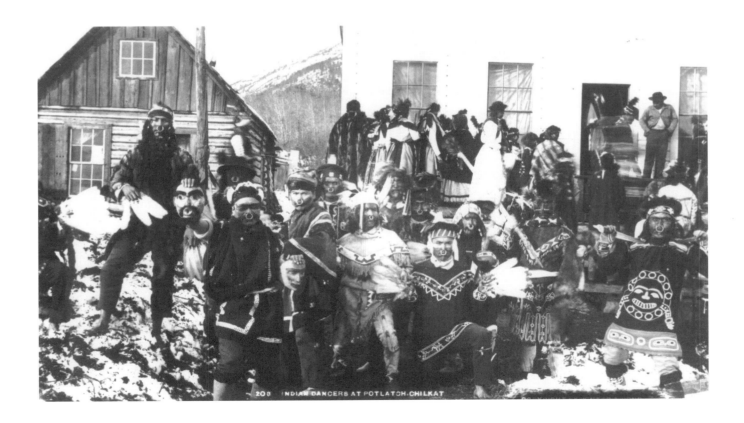

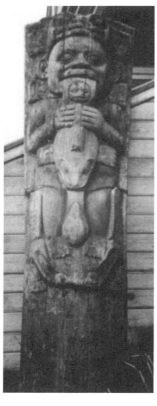
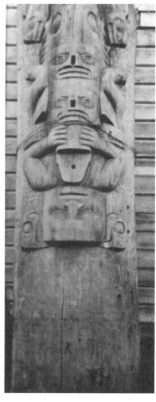
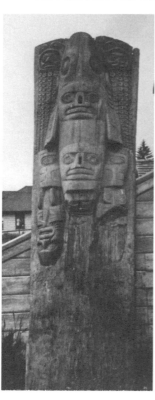
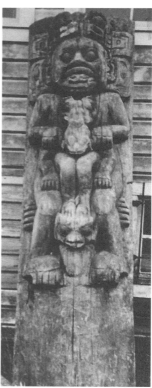

58

PRE-CONTACT STYLES OF TOTEM POLES

DESPITE THE INCREASING NUMBER OF **E**UROPEAN EXPLORERS, the Russian occupation, and the introduction of Western technology between 1750 and 1820, the Tlingit people managed to maintain their stability; and were able to control what they wanted to accept or reject into their way of life. They lived in the clan houses, maintained tribal reciprocity, and sustained a balance amidst the changing economic condition of trading fur pelts for European goods.

The clan system continued to exert its great control through consensus of the clan house group. The strength of the clan house group lay not only in its historical lineage significance, but also in the bond of respect and honor within the group. This esteem is something the Tlingits never lost, and in modern times they continue to honor it and carve it in red cedar.

The early anthropologists and art collectors, who viewed the clan houses, were in awe of them and the treasures they contained. The Spanish, during their occupation of Nootka (1789-93), wrote detailed accounts of the houses' interiors and made numerous drawings of the house posts. The drawings can now be found in the archives of El Museo Naval in Madrid. Modern researchers and artists continue to be fascinated by them, studying and analyzing the clan houses and carved house posts. Most Northwest Coast scholars are of the opinion that freestanding totem poles derived originally from carved interior house posts and the exterior portal entry posts, and then evolved into the larger and more numerous columns as they gained access to European tools.

This theory was further strengthened by the discovery of an ancient Makah village, dating back to 1450 A.D., near the present Makah area on the Olympic Peninsula in the state of Washington. When it was excavated in 1974

Opposite: **The four original house posts from the Nanyaā'yî House of Chief Shakes II in Wrangell. Clockwise from top left: 1) The I**x**t or Shaman Post which stood at the front to the right of the entrance. 2) A similar I**x**t Post which stood to the left of the entrance. 3) The Salmon Post which stood at the rear left. 4). The Dogfish (mudshark) post which stood at the rear to the right of the entrance.**

Photo: P91.11.60, Courtesy of the Wrangell City Museum, Wrangell, Alaska

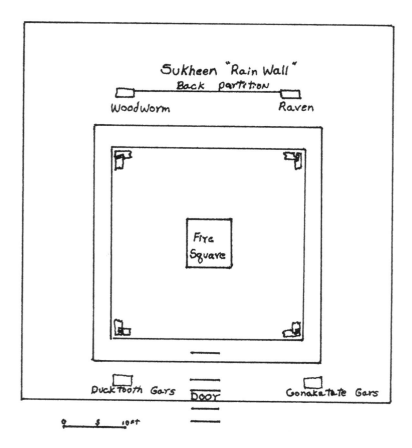

Sukheen "Rain Wall"
Back partition

Woodworm Raven

Fire Square

Duck Tooth Gars Gonakatate Gars

Door

0 5 10 ft

Ground Floor Plan of the Whale House. Lt. George Emmons, *The Whale House of the Chilkat*, 1916. Anthropological Papers of the American Museum of Natural History. V. 19, pt. p. 21, fig. 5.

Courtesy of the American Museum of Natural History.

they found huge planks used in its construction, as well as carved house posts.

The importance of the clan house and its architectural posts cannot be ignored in any study of totem poles. They are a legacy of the past, a stimulus for modern carvers and a haunting reminder of the battle for Tlingit art. Only seventeen original house posts of the early Historic Period remain in Alaska; all other posts and totem poles of this era were destroyed or removed from the area by museums and private collectors. However, there remain in Alaska four house posts, in good condition, from the Whale House in Klukwan, three house posts from the Wolf House and three posts from the Eagle Nest house in Sitka are on loan to Sitka National Historic Park, four original posts from Chief Shakes' House are in the Wrangell City Museum and two Wrangell Frog House posts are displayed in Shakes' House.

No mortuary or memorial poles remain in Alaska from the early historic period; thus, in order to present a chronological understanding of the sequence of the development of totem poles, this book features photographs and drawings. Additionally, a few totem poles from later in the early classic period (1820-65) have been included because they are representative of freestanding poles of the early historical period. Artistically, however, they are from a later tradition. In the same manner, a few early and late classic period totem poles from different lineage lines in Wrangell are presented in this section because they portray in a contemporary setting a situation that is reminiscent of how totem poles once stood in villages. Wrangell reflects the great historic lineages, dynasties and clan houses that existed in Yakutat, Klukwan, Kake Sitka, Angoon and other Tlingit villages. Chief Shakes Island and the restored Nanyaā'yî clan house represent the dynasty of seven Chief Shakes and span the recorded history of the art tradition from 1750 until the present time. The site also includes replicas of poles from other great clan houses that are now

vanished from Wrangell. Several of these, although later poles, are presented in this chapter in order to convey an idea of the other old clan houses and their totem poles, and their importance in the original community. Shakes' Island Historical Park aptly illustrates this.

THE CLAN HOUSE

An unparalleled example of a tribal house and its carved Hít yìgâs'i (house posts) is the Whale House in Klukwan described in detail by Lt. Emmons in 1885. His account is not only excellently done, it is also significant because of the current importance in the art world of the art contents of the house. "The Whale House was built in 1835. It represents the best type of Tlingit architecture: a broad, low building, of heavy hewn spruce timbers, carefully united through groove, tenon, and mortise to support each other without extraneous fastening" (Emmons, 1916: 19). His sketch can be seen on page 60.

In an abridged account of the Whale House, according to Emmons the communal house, as described by him in *The Whale House of the Chilkat* (1916), faced the river frontage and was 49 feet 10 inches wide and 53 foot long. Four interior posts supported the roof structure. There were two large roof beams made from adzed tree trunks, two feet in diameter that ran the length of the house. Crossbeams were placed on these roof beams and these in turn supported two additional longitudinal beams close to the center of the house. A smoke hole in the ceiling provided light and ventilation. There were platform areas for sleeping or bedrooms for the different families that occupied the house. A large space dominated the central area and in its center was the fire square, or cooking area. On the posterior corners of this space were two carved posts nine feet high and two and a half feet in diameter. The left was the Woodworm house post (Hít yìgâs'i) and the right was the Raven Hít yìgâs'i. Similarly, in the anterior area were two other house posts, the one on the left was the Duck-toolh post and the one on the right was the Gonaquade't post. The heavy longitudinal beams that supported the roof structure rested on these four posts.

The private apartment of the house chief occupied the central portion of the upper rear platform, and was partitioned off in front by a screen of thin native split red cedar planks of varying widths, neatly fitted vertically and sewn together with switches of spruceroot, then

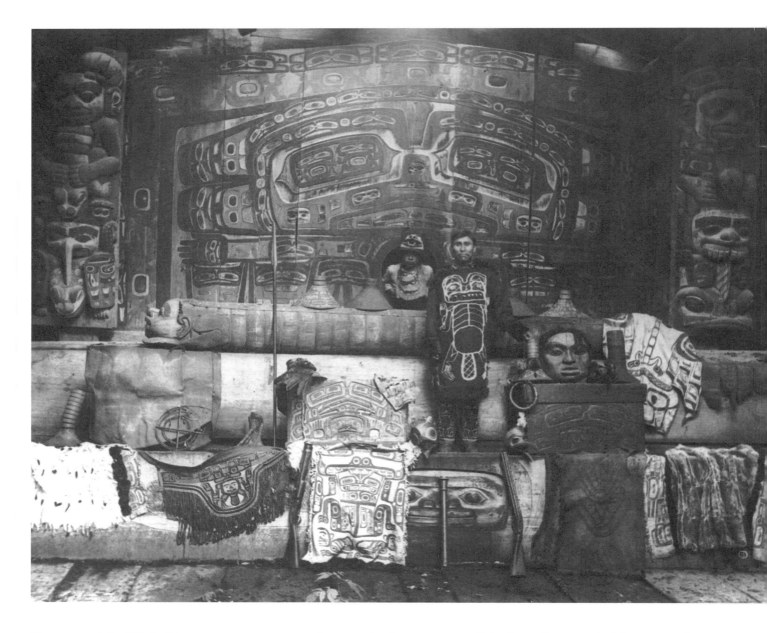

**Rear area of the Whale House.
The Woodworm Hít yìgâs'i is on
the left, the Rain Screen in front
and the Raven Hít yìgâs'i on the
right of the Whale House. These
house posts were carved by
Kadjisdu.āxch' II between 1800
and 1820. Klukwan, Alaska.**

Photo: Winter & Pond collection, photograph
#PCA 87-013. Alaska State Library & Archives;
Juneau, Alaska.

countersunk to make it appear a solid piece. It extended between the
two rear carved posts and was twenty feet long by nine and a half feet
high. The front surface was smoothed with dogfish skin, and the screen
was elaborately carved in low relief and painted to represent the rain
spirit, symbolized by a great central figure with outstretched arms,
while the small crouching figures in the border around the sides and
top, known as "raindrop splash up," representing the splashes of the
falling raindrops after striking the ground. The whole partition was
called 'Sukheen' or rain wall screen.

When Emmons saw the Whale House in decay in 1885, he dated the
house posts at 1835; but using current data, artist Steven Brown, assistant

curator of Native American Art at the Seattle Museum of Art, believes the posts were carved between 1800 and 1820. Chief Xetsuwu, a Raven of the Gānaxa'dî clan, built the house in an effort to strengthen the deteriorating social order of his people. It was called the Whale House to honor an old crest associated with the Whale clan.

Chief Xetsuwu summoned the greatest carver of the time, Kadjisdu.āxch' II who lived in the village of Kasitlaan, commonly called old Wrangell, where he had carved the interior house posts for the house of Ka-shisk, Chief Shakes III, around 1775. The carver's reputation was known outside of the Tlingits, among the Haida and Tsimshian nations, and later became celebrated in the Western art world. His works have whetted appetites for over one hundred years since the first outsiders saw the Whale House and viewed its monumental carvings. For his work, according to Emmons, he was paid 10 slaves, 50 dressed moose skins and a number of chilkat blankets. "Nearly 200 years old, the totems and rain screen are regarded as the pinnacles of the golden age of Northwest Coast Indian art, a time when carving flourished with the introduction of metal tools. Collectors and museums have prized the Whale House artifacts for their unparalleled artistry" (Enge, 1993).

LEGENDARY HISTORY DEPICTED ON THE HÍT YÌGÂS'I (POSTS) OF THE WHALE HOUSE

WOODWORM POST

The Hít yìgâs'i, or carved post on the left as one gazed at the Sukheen "Rain Wall Screen," was the Woodworm Post. It is one of the crests of a branch of the Gānaxa'dî clan that migrated north from Prince of Wales Island north to Klukwan (mother town) in the early mystical beginnings of Tlingit history. In sorrow, remorse and bitterness they severed their ties with their village and hunting grounds and journeyed far to the north, bewildered and disconsolate, on a lonely trail that would take them many, many years and hundreds of miles from their beginnings and their memories. The Woodworm Post tells the story of the dominant carved figure that represents a girl holding a woodworm in front of her body. On top

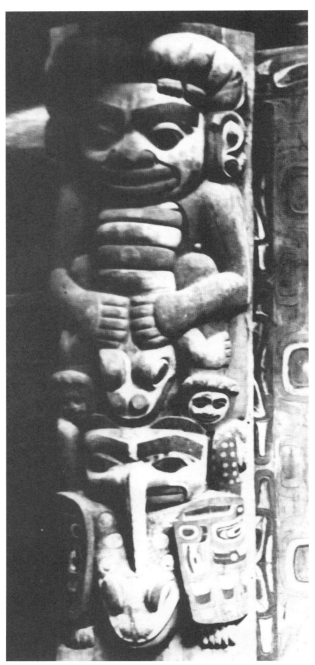

**Tlúkwx-aas-a-Gaas'
"Woodworm Post".**

of her head are two woodworms that form her ears. Beneath the woodworm that she is holding is a crane with a frog upside down on its beak. The post represents the tree in which the woodworm once lived. Presumably such trees rise out of a swamp, where frogs abound, and branch to the sky beckoning cranes to light on their branches. It tells a strange tragedy of early times near Prince of Wales Island when a chief's daughter found a woodworm in the forest and wrapped it in a blanket and took it home. She kept it in her room, or compartment, where she was alone, for she was beginning her menses, and tradition was that young women were kept in seclusion for a period of time. She gave the worm food, but it refused to eat; so she offered it her breast and it suckled greedily. It began to grow rapidly and in a brief time it became as large as a man. She grew very fond of this strange creature and spent all her time fondling the woodworm, and singing to it. The chief and his wife, because of her strange behavior, spied on her. They were horrified to see this huge woodworm. They entered her quarters and begged her to find another pet. Soon the village people became aware of the strange situation, and they became afraid of the giant creature for they feared it would eat all their food supply. It was decided that the woodworm would have to be destroyed, but the horrified girl refused to listen to their pleas and clung to her pet.

One night she called out to her mother, "Mother, bring me my martin skin robe."

The mother replied cunningly, "Ah, but you must first finish sewing it."

Upon realizing she needed to complete her martin skin robe, she rose and left her room, leaving the woodworm asleep and unattended. While she was gone the men seized sharp spears and rushed in, stabbing at the woodworm; but it would not die easily and fought desperately for its life. She heard the terrible noises of spears ripping through flesh and striking the wooden planks, and she ran to her quarters and saw them slashing at the woodworm. She screamed, "You are killing my child! You are killing my child!" as her parents tried to restrain her.

After the slaying of the woodworm she was very sad, and could not be comforted. Night and day she sang this song until she died of grief.

I am blamed for bringing you up,
and now they have got me away from you.
Now they have killed you, at last my child,
But you will be claimed by a great clan. (Paul, 1944: 48)

In bewilderment and despair, her family fled Prince of Wales Island and migrated north. Many generations later, descendants of this family became very powerful and were entitled to use this as a family crest in commemoration of the event.

Sadly, perhaps, the Woodworm Post is not only a history of a past social upheaval but also a haunting prophesy of the present conflict of the Gānaxa'dî clan and the Whale House people.

RAVEN POST

The Raven Post (see photo page 148) stood on the right of the Rain Screen adjacent to the Woodworm Post. According to Emmons it tells the story of the capture of T'á, "The King Salmon." The top figure is the Raven in human form. Coming out of the mouth of Raven is a bird form called "Telling Lies Raven" which symbolizes the lies Raven told to the little birds in this story. The Raven holds a head by its ears, and protruding from the head is a blade-like tongue representing a jade adze. At the bottom is the head of T'á "The King Salmon."

GUNAKADEIT POST

The Gunakadeit Post (see photo page 148) stood at the right of the doorway beside the Duck-toolh (Dukt! ū.L!) Post. According to Emmons the post represents an episode from the adventures of Raven and the famous sea creature Gunakadeit (Gonaquade't). The main creature is Gunakadeit holding a whale he caught by its flippers with its tail in his mouth In the blow hole of the whale is the face of the Raven. The figure of the woman on the whale's back is the sea monster's Tlingit wife. At the very top of post is one of Gunakadeit' s children holding a hawk (a crest symbol of the whale House). The female children of the sea monster became the old women who live at the headwaters of every stream and are responsible for the yearly return of the salmon.

Dukt! ū.L! Hít yìgâs'i of
the Whale House Klukwan.
Carved by Kadjisdu.āx̱ch' II
between 1800 and 1820.
Klukwan, Alaska. Totem
Poles of Tlingit Indians:
PN 1627.

Photo: Royal British Columbia Museum;
Victoria, B.C.

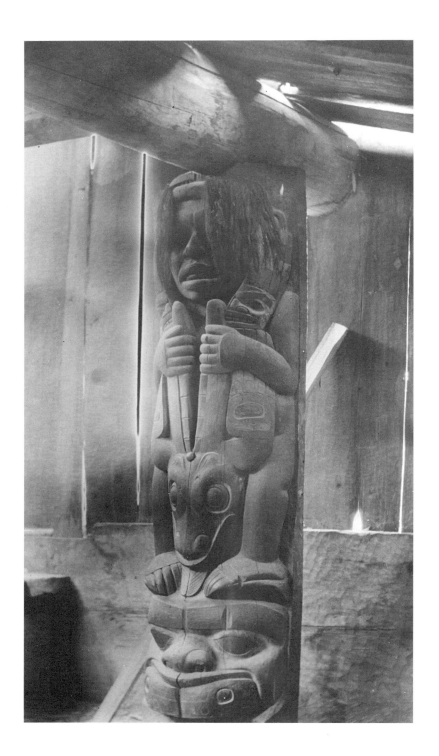

DUKT! ū.L! POST

At the front of the house, on the left side of the portal entry, was the Dukt! ū.L! post, another crest of the Gānaxa'dî. The event depicted is supposed to have occurred in old Tuxekan on Prince of Wales Island. The main figure is Dukt! ū.L!, wearing a kind of wreath about his head and in the act of tearing apart a sea lion with his bare hands. Originally the figure of the man had human hair which was not to enhance the man, but to honor one of their respected dead. Dukt! ū.L! (Dark-skin,) as he was called, was a nephew of the chief Gal-wet, who was very strict about training the hunters. He was also one of three nephews of a former chief who had been killed by the sea lions The nephews were expected to avenge his death and Dukt! ū.L!'s brothers would bathe every morning in the sea for strength and then whip each other with switches until their blood ran. Dukt! ū.L! never joined them, and was considered a very lazy and cowardly fellow who slept all day while the others trained. He never bathed and always seemed to be covered with ashes, hence his name Dark-skin. However, he was only pretending, and while the others bathed for strength during the day, he would sleep; but at night he would steal out and do the same things the others did. He would sit so long in the icy waters that he had to crawl back to the fire and lie in the ashes to warm himself. In the morning as the others left they would kick him and insult him, and call him Dark-skin as he lay there blackened by the ashes. He covered his head and said nothing. One night as he was bathing for strength, he saw a short thick man. The man said, "I am strength. I am the strength of the Northwind; and I have come to help you." He bade Dark-skin to wrestle with him and promised, "I will come every night, and we will wrestle until you are able to throw me."

As he grew stronger he was very careful when he wrestled in the Chief's house that he did not show his increasing strength. He always let the young boys throw him, and the people laughed and mocked him; but he said nothing. Only the elder wife of the chief was kind to him and defended him. She had taken pity on him and would try to soothe him when the others taunted him.

It was not long before he was able to throw the Northwind, and the Northwind said, "as a final test of your strength you must pull that young spruce tree out of the ground."

Dark-skin grasped it with only one hand and pulled it free. He held the tree root and all, before the Northwind.

The old Whale House at Klukwan. It was built between 1800 and 1835. This photo was taken in 1890 when the house was in decay.

Photo: Alaska State Library, Winter and Pond Collection, PC 87-09

"You are ready," said the Northwind.

During the next few days the two nephews prepared to set out on the rigorous sea lion hunt. Dark-skin told the chief's wife that he was going even though no one had asked him. So she prepared food for him and gave him clean garments and hair ornaments to wear. As the canoe was pulling away, he ran down to the beach and jumped in it. They all laughed and joked that they could use him to bail out the water.

They traveled to the precipitous rocks where the sea lions lived. The waves were so great that it was very difficult to beach the canoe. The two nephews jumped out of the canoe as a wave lifted it on the shore. They began killing sea lions almost immediately, and rushed upon the creatures as they attempted to dive off the rocks into the whirling surf. The two nephews slipped on the rocks, and as they did, a bull caught them and threw them up in the air, and they fell, smashing against the rocks.

Those in the canoe became frightened, and sea spray filled their canoe with water. Dark-skin turned to them and calmly said, "I am the man that twisted the tree." He spoke as high caste Indians spoke in those days, and they all listened to him. He told them how to land the canoe, and they did as they were told. He leaped out of the boat and began killing sea lions by hitting their heads together and stepping on them, and the two biggest sea lions he split in two. After they had killed all the sea lions they could carry, the others loaded the canoes and pushed off, leaving Dark-skin behind. Left alone, Dark-skin pondered what to do. Finally he covered himself in the sea lion skins they had not taken and laid down to sleep.

A black duck swam near him and said, "I have come after you. I have been sent for you."

He closed his eyes, and let the duck carry him away on his back. When he opened his eyes he was in a very fine house, the house of the sea lions, and the sea lions appeared very human to him, and he got on very well with them. The young son of the chief sea lion had a serious spear wound; a part of the spear was still in his foot. Dark-skin pulled it out and took care of the child's festering wounds. The chief was so grateful that he offered Dark-skin anything he wanted.

Dark-skin paused and then said, "I would like the box that calls the winds. The box that hangs there on the rafter. You call the winds to it like you call a dog."

The sea lion chief said "Go and take the box. It is yours. Get in the box."

He did as as the chief said, and quite suddenly he was far out on the sea. He called to the box, "Send me the wind that will blow me to shore." Within the day he landed near his village, and carrying the box he walked toward his home wearing a wreath of braided sea lion intestines on his head. The wife of the dead chief was very happy to see him, but the people who had been cruel to him were much ashamed.

"But," he thought to himself, "Had I not humbled myself, they might not have been cruel." So he overlooked it; but some of them still ran into the forest, while others rejoiced to see him.

In 1889 Yeilgooxu (his English name was George Shotridge) House Master, or Hít s'àtí, attempted to rebuild the Whale House, but it was destroyed in a mudslide in 1913 before being completed. In 1938 the heirs rebuilt the Whale House on a concrete foundation to protect its artifacts—the famed four house posts and the rain screen that had intrigued the art world for the last century. They are eloquently described by Aldona Jonaitis, an art historian and expert on Tlingit, formerly curator at the American Museum and now curator at the University Museum at Fairbanks. "I personally think the screen and the four posts are the singular most extraordinary art works in all the Northwest Coast. They are so beautiful, so well documented, so masterfully carved and exquisitely painted. There's an elegance and refinement that is breath taking. These are very important art works. They are not only treasures of the Chilkat, but they are treasures of all Native Alaskans, and treasures of the world" (Enge, 1993).

The Cannibal Giant post, situated
next to the Frog House post.
Originally it stood on the left of
the inner entrance of the Frog
House and a Brown Bear post
stood on the right of it. Carver
and date, as well as the ultimate
fate of the two posts, unknown.

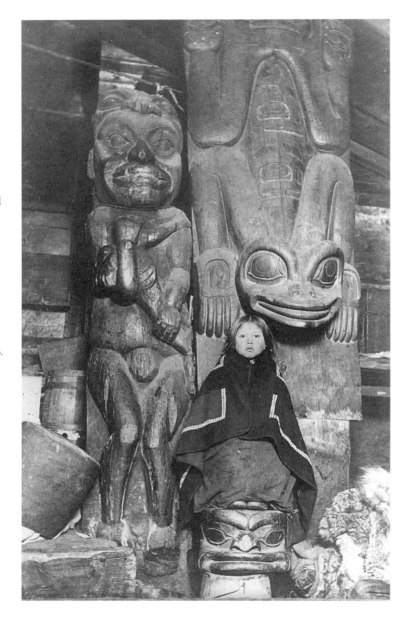

The last five remaining tribal houses, in varying states of condition in Klukwan are the Valley House, the Raven House, the Looking Out House, the Frog House, and the Whale House. Of these, the Frog House had treasures equal to the Whale House, and its contents were sold several years prior to the attempted sale of the Whale House artifacts. Now vanished from Alaska are the two house portal entry posts and the interior house posts of the Frog House.

FROG HOUSE ENTRY PORTAL GÂS' (POSTS)

THE CANNIBAL GIANT INTERIOR ENTRY POST

The interior entrance of the Frog House at Klukwan had two portal posts eight to ten feet high. The post on the left was the Brown Bear Friend Post, a clan crest. The one on the right was the Cannibal Giant holding a dead tormented child that is half frog, the House clan crest. It dates from the late historic or early classic era.

The giant cannibal terrorized the Tlingits and they were unable to destroy it because of its great strength and tough skin that nothing could penetrate. It ate their fish supply then began to eat the people. The community realized that something had to be done, so they banded together and searched the mountain areas for the cannibal's community house. They finally found it and dug a huge pit as they did to trap grizzly bears. Then they put a strong sinew net in the bottom and camouflaged the huge pit. One of the bravest men was sent to the monster's house to draw him out and lead him to the trap. He shouted insults at the giant, baiting him and challenging his strength. The monster, raging with anger, left his house and chased after the man, who quickly skirted the pit, but the giant fell in and was trapped in the sinew like a victim in a spider's web. He realized that the people were going to kill him and he cried out, "I can never be slain. No one has the power to destroy me. I will always continue to plague you."

They burned him, and to make certain he was completely destroyed, they kept the fire going for four days and nights. After it had cooled they stirred the ashes in the pit with long poles to see if any traces of the monster remained. As they stirred the embers sparks flew up and became mosquitoes, which at once began to swarm on the people. They realized in horror that he could never be destroyed, but would only change into

Káts!s Exterior Portal Entry. This copy of the original pole was done by Nathan Jacks about 1988. It stands in Saxman Park, Saxman, Alaska.

Photo: Maria Bolanz

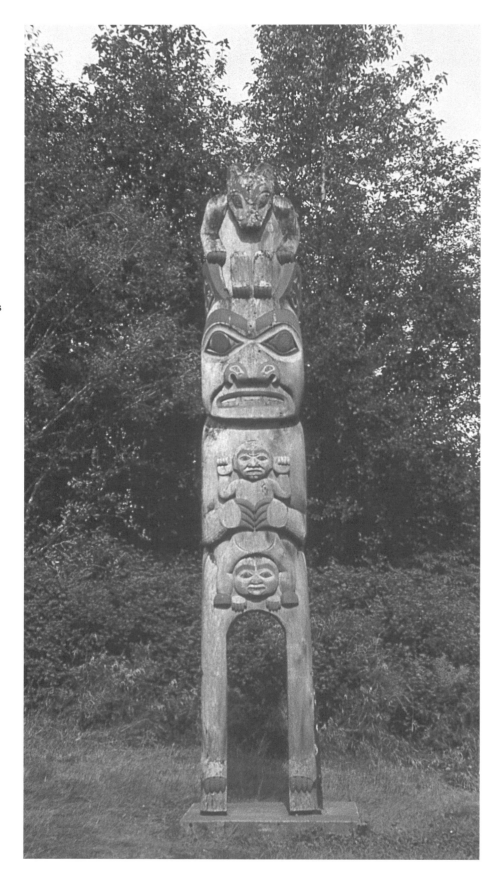

another form and would continue to plague them forever. The Indians fed the statue of the monster daily, showing respect for his power and hoping to gain favor and good fortune.

Symbolically the legend may imply, as Richard and Nora Dauenhauer note in their book *Haa Shuká*, that revenge often creates unfathomable consequences.

KATS!S HOUSE EXTERIOR PORTAL ENTRY POST

An example of an entrance pole serving as an exterior ornamental entry or doorway as the house front pole is the Kats!s Pole, which belongs to the people of the Kats!s house of Angoon and Tongass who, in turn, are members of the Ká'gwantán clan of the Wolf Phratry. The pole was originally a part of the entrance of a house at Village Island around 1848; however it has since been replicated by Nathan Jackson, and stands in Saxman Totem Park in an exhibit with other poles, most of which are restored poles.

Legend tells of a young Tlingit hunter who belonged to the Kā'gwantān and lived at Sitka. One day while hunting, he became separated from his party and, alone, he followed bear signs along the wet bank of a stream. These signs led him to a cave where he saw a female bear. When she saw him and that he was armed, she grew afraid. He did not kill her but became strangely enchanted with her and followed her into the den. She returned his feeling and was inexorably drawn to him. She begged him to stay with her, and he did. As they talked, the bear's mate returned unexpectedly. He cried out as he approached the cave, "I smell man," and he entered fearful that his mate had been slain or carried away. He was relieved when he found her quietly occupied with her tasks.

"I smell man," he warned.

"You only smell him because one was hunting near here."

"But it smells like he is here."

"No, my husband you are mistaken," and she went on with her tasks. She had hidden the man beneath a pile of rocks and sticks and bade him stay there until her husband left. Soon after that the male bear did leave, and she hastened to the man and beckoned for him to come out. They embraced in mortal fashion, and began to plan what they should do if they desired to remain together. Just as they had resolved what to do, the male bear returned and growled again, "Why do I smell man more strongly than before?"

"It's nothing," she said.

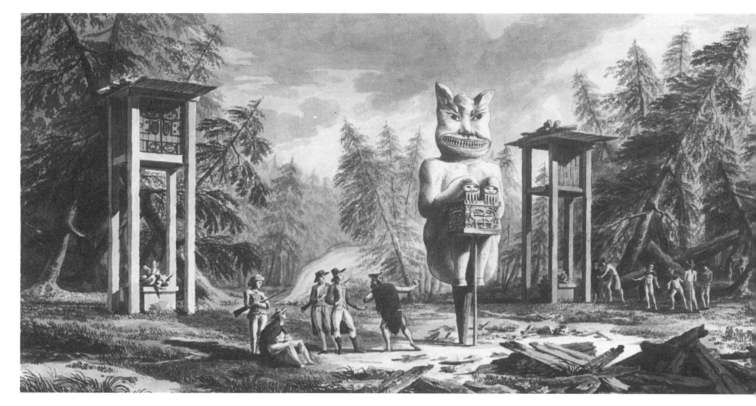

Drawing of Mortuary Pole at Yakutat in 1791. Carver and date unknown. The only information is Dr. de Laguna's theory that they are Bear and Killerwhale monuments associated with the Te`q èdî clan of Tongass descent. From Malaspina's voyage "*Viaje Aldrededor del Mundo* " 1791; Yakutat. Drawing by José Cordero. A.M.N. 1726/50 2926.

But he was not so easily satisfied this time, and began to hunt about the den. The female said nothing but waited until he grew tried of searching and lay down to sleep. As he lay sleeping, she and the young hunter killed him.

Sometime after that a party searching for the young man came across his canoe. Since it was not broken and they could find no trace of him, they assumed that he had been devoured by some wild beast and returned to the village with the sad news. His family and his young wife cut their hair and blackened their faces and went into mourning for him. Meanwhile Kats!s and the she bear lived happily together in the cave, and with the passing of time two cubs were born to them.

One day the young man thought of his village and his family, who were probably still in mourning for him. So he said to the bear and their two cubs that he was going to visit his people, and tell them that he was well and happy, and that they need not mourn for him. "As soon as I comfort them, I will return," he said.

He returned and stayed a brief time among his people, and they rejoiced to see him again, even his wife at whom he would not look. He told them that he was living in the forest and they must not ask why, but

that he was happy and well cared for. They were so pleased to see him that they would not ask any questions, fearing they might anger him and he would never return to the village again. One night, as he told them he would, he disappeared quietly and by dawn the next day landed on the beach near his cave. His two cubs saw him land and rushed playfully down to the beach to meet him. They climbed all over him, licking him and calling to their mother to hurry.

As time went by they lived more happily together than ever before; and the cubs grew to a good size. The man would hunt for seal and sea lions, and when he returned the cubs would jump all over him and help him carry the freshly butchered chunks of meat out of the canoe to their mother. They spent that summer eating berries in the forest and catching salmon from the streams; as fall approached they prepared to return to their den. It was just before winter snows came that Kats!s spoke of returning to his clan house and taking a final farewell of his family. They seemed saddened by this; but walked down to the beach with him and helped him push his canoe off into the water. They gazed after him a long time as he rowed out of the channel.

In his village there was much rejoicing over his return, and everyone came to greet him except his wife, whom they hoped he would ask for. But he did not, and she walked silently in the shadows concealing her sorrow and herself from further humiliation. One day he came upon her and gazed at her beauty and sensed her sadness. He grasped her in his arms as she embraced him, and he carried her away. The wind and the leaves and the rain carried this message back to the bears.

It was with great sadness for all, including himself, when Kats!s bade his final farewell to his people. He left at dawn and rowed all day across the water until he reached his cave. As he approached, he scanned the shore for his young cubs and the she-bear; but he did not see them. He beached his canoe, expecting the cubs to come bounding out at any minute; but they did not. So he walked across the sandy beach towards his cave vainly seeking them. Then over in the goose tongue grass, he saw the ears of the two cubs sticking up, he called to them, but there was no answer; so he called again. Still no answer, only the sight of their ears in the fluttering goose tongue grass. He thought in play they were hiding from him, so he walked toward them calling out affectionately. As he reached the edge of the grass they leaped upon him and tore his body to shreds.

Drawing of a Mortuary Pole at Hoonah of "Wants-to-be-higher-than-the-other-animals."

Drawing by John Swanton (Swanton, 1908: 431).

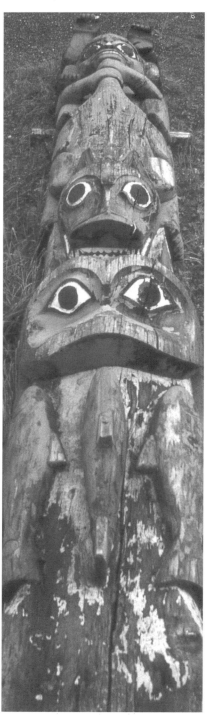

The Sockeye Salmon Mortuary Pole. This replica of the original was carved circa 1938 by Walter Ketah of Klawock in connection with the C.C.C. restoration project. Klawock Totem Park, Klawock, Alaska.

MORTUARY POLES

Standing apart from the village were the mortuary poles. The important dead were cremated and their ashes placed in a niche in the back of the pole, with the only exception being the shaman, who were not cremated but buried in small grave houses. The less important members of the community were cremated and buried in smaller houses. Mortuary poles bore the crests that were the lineage of the deceased chief and, in a sense, the property of the house group.

BEAR AND KILLERWHALE MORTUARY POST

The mortuary pole seen at Yakutat in 1791 by the Spanish explorer Malaspina, described in Chapter 1 and depicted on pages 53 and 74, is probably the oldest mortuary pole recorded. Unfortunately not enough information is available to explain the meaning of the carvings.

WANTS-TO-BE-HIGHER-THAN-OTHER-ANIMALS MORTUARY POST

An example of a grave post surmounted by a grave box in Hoonah is shown in a sketch done in 1881 by Dr. Krause. According to Swanton it was erected for a chief whose name meant "Wants to be higher-than-the-other-animals" and who died by violence. Originally on top of the box was a figure of the dead man's head painted half red and half black. The box that contained the ashes had the face of Gonaquade't (a mythological hero who could change shapes and become a sea monster) painted on it. The dancing hat with sea lion bristles came from him. The hole in the lower portion represents the path by which the highest heaven is reached, and the human figure above is the being who is supposed to keep watch over it; and the markings on or about the opening represent the faces of grizzly bears. Bears infested the spirit road! The soul of a living person was called "what feels," and after death the soul was called "the shadow." There were different heavens for the way in which people died; but one of the highest heavens was reserved for a person who died by violence. Access was by ladder through a single hole.

SOCKEYE SALMON MORTUARY POLE

A mortuary column of a chief of the Wolf Phratry who owned a sockeye salmon stream at Tuxekan can be seen at Klawock Totem Park. A bear is on top of the pole and represents the tribal house owning this rich

salmon stream. Below the bear is the figure representing the titular head of the house restraining his fellow tribe members, represented by the wolf, from being too greedy and over fishing the salmon stream. On the lower part of the pole are salmon swimming into the spawning stream. At the bottom are salmon caught in a fish trap. According to Garfield, when the Raven clan was erecting the pole, a rope broke, putting the men in the direct path of the falling pole. "The owner stepped in front of the pole and stopped it to save them from injury. He suffered a crushed leg, but saved his clansmen from paying for injuries to the opposite moiety and from the disgrace of an accident which would have marred the value of the pole" (Garfield, 1948: 111). Unfortunately, the replica of the pole fell again; this time in 1997, due to a windstorm. It was photographed where it lay in the park waiting recarving. The original was early classic period.

The importance of the mythology and the reverence with which the mortuary poles were regarded cannot be treated lightly. The myths were a vital source to the structure of the society and were displayed in a ritualistic sense on their monuments for the dead. Nietzsche, the German philosopher, meaningfully concluded: "That myth imparts an idea of the universe and presents its conception not intellectually as consciousness does, but indirectly in the sequence of events, actions and sufferings. That kind or style of thinking is actually the particular essence of each system of myth and varies according to the underlying conception by which each civilization envisions its place in the universe" (Progoff, 1973: 216).

Mortuary poles and corresponding legends, therefore, could never be understood or tolerated by the colonizing Russian and Americans since they were antipathetic to Christian beliefs. Up until recent times their significance and beauty have not been acknowledged; and old poles have laid unnamed, unmarked and weathered to a silver grey in the forest; some have totally rotted away, while others, fortunately, have found their way to museums around the world.

Still others, as in Kake, were burned or chopped down by well meaning missionaries with the approval of newly Christianized elders. They were considered pagan idols and health hazards because of the charred bones they contained.

The village of Angoon had their mortuary poles destroyed in the shelling by the U.S. Navy in the late nineteenth century, and the Russians, according to Urey Lisiansky, burned them or chopped them all down in Sitka. As a result there are few old original mortuary poles standing in Alaska.

Chief Ebbit's Memorial Pole.
This is an original pole carved
circa 1892. It has had
restorations over time. The
carver is unknown. Saxman
Totem Park, Saxman, Alaska.

Photo: Clark James Mishler

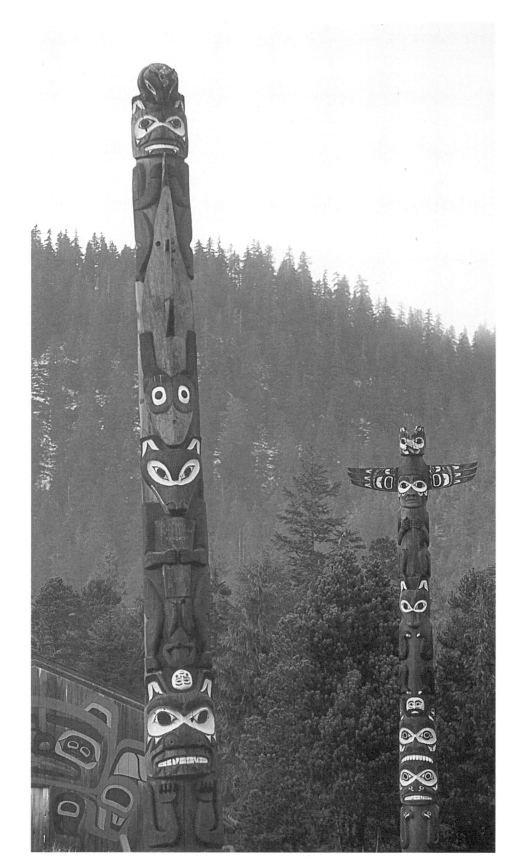

Chief Kahl-teen Memorial Pole.
Replica of the original done by
Steve Brown and Wayne Price in
1987. Kik.setti Totem Park,
Wrangell, Alaska.

Photo: Alaskan Images; photographer
Ivan Simonek of Wrangell, Alaska.

MEMORIAL POLES

A memorial pole was erected by the heir of the deceased chief as a part of the process of assuming ascendancy to the office. There are many scholars who regard memorial poles as a type of mortuary pole. The memorial pole, however, did not contain the ashes or bones of the previous chief. Its erection was accompanied by a feast given by a chief in honor of his deceased ancestors. All heirlooms, regalia, and crests were displayed and one or two slaves could be sacrificed. Gifts were given, and the host became entitled to assume the name of an important ancestor. In the precontact times it was a prerogative only of the nobility to display their lineage and crests and crucial event in their hereditary lines of descent.

CHIEF EBBITS' MEMORIAL POLE

A restored memorial pole dedicated to Chief Ebbits stands at Saxman Park near Ketchikan, Alaska. It stands near the original site of Tongass village and is called the Dogfish (Mudshark) Pole of Chief Ebbits. It is a late-nineteenth-century pole but is an excellent representation of the early classic memorial poles. Surmounting the pole is a bear, a major crest of the Wolf moiety of Chief Ebbits. Beneath the bear is the figure of a man holding the tail of a dogfish, another crest. Beneath the dogfish is a wolf holding an ancient copper shield, and below that is a human figure upside down, and at the base of the pole is another bear. The wolf holding the tail of the dogfish is said to represent the Wolf moiety members.

Coppers were pieces of unsmelted copper hammered into the shape of a shield and decorated with a crest. They often had the quality of an heirloom and were quite valuable, representing wealth in terms of many blankets or twenty or more slaves. They were named individually and could range to three feet in height (they were valued for their height) and a foot wide. Occasionally a copper would be deliberately broken at a potlatch in a display of, or in deference to, wealth or nailed to a mortuary pole.

The upside down figure is a record of an unpaid debt to Ebbits and his heirs. The bears at the base of the pole are again a lineage crest. A plaque with an inscription (rare on totem poles) reads "In memory of Ebbits, head Chief of Tongass January 11, 1892." It is said that he was over one hundred years old when he died. "Chief Ebbits assumed the name of John Jacob Astor's captain as a compliment to the fur trader, who visited the area in 1802 and 1809. According to tradition he was entertained by the wealthy Tongass chief, and the two men exchanged

courtesies and gifts, and sealed their friendship by an exchange of names"
(Garfield and Forrest, 1948: 50).

CHIEF KAHL-TEEN MEMORIAL POLE

The memorial pole erected by the heirs of Chief Kahl-teen stood before
the Sun House, the clan house of the Kîksa'dî Clan of the Raven moiety
of Wrangell. The pole was erected in 1885, and was popularly referred to
as "The Kik.setti Pole." The original no longer exists, nor does the Sun
House. However, the site is now Kik.setti Totem Park, a small but elegant
park with four replicas of original poles from the Wrangell area. The
Wrangell Cultural Heritage Committee began the restoration project in
1987. Steve Brown and Wayne Price carved the poles, using, at the request
of the descendants of original owners, painstaking precision to carve the
poles without the aid of power tools.

The top figure on the Kiksa'dî pole is the spirit of the Person-of-the-
Glacier. Beneath it is the Frog, a major clan crest of the Kiksa'dîs. Further
down is the Old Raven and his son the Young Raven. At the base is the
Killisnoo Beaver and on top of the chest of the beaver is another frog.

The frog represents an incident in the distant past that occurred when
a man and his wife were crossing the mouth of a bay and became lost in
dense fog. Out of the fog came a powerful voice saying over and over,
"We have captured a man." As the fog lifted they saw that the resounding
voice came from a small frog. The wife took the frog to the village and
treated it like a child. Finally she placed it in a secluded lake and left it
there. From then on the woman and her descendants have claimed the
frog as their crest.

The beaver represents the legend, also from the past, of a chief from
Killisnoo (Angoon) who captured a beaver and kept it as a pet. He gave
the animal much attention, and his clansmen grew jealous of the beaver
and threatened to kill it. The beaver appealed to the chief for protection,
but the chief refused. The beaver composed songs to evoke the aid of a
spirit. He went into a pond, and began to dig under the village. As he dug
he became a giant.

One day he went out in the forest and made a spear; then he hid it in
a hollow tree. Some hunters discovered the beautiful spear perfectly
made, and were curious when they found fresh shavings in the forest and
traced them to the pond. They took the spear to their village but could
find no one there who had made it. The beaver kept saying that he made
it but no one believed him, and the chief laughed at him. The beaver
seized the spear and ran it through the chief, and then killed the other

Original Eagle (left) and Lq!aua'k! (right) Poles as they stood in front of Chief Kadishan's house in Wrangell.

Photo: Alaskan Images; photographer Ivan Simonek of Wrangell, Alaska.

men as they rushed at him. Then he slapped his tail against the earth so hard that the earth shook violently. The beaver jumped into his pond as the village caved into the deep tunnels he had burrowed. Those who remained took the beaver as a crest.

It is said that Kiksa' dî people derived their name from Kicks Bay, a place where they first stopped on their migration from the Nass River to the Stikine River. An interesting aspect of this totem is its cross-cultural sense. "In the record of probate proceedings in the estate of Kakl-teen, the widow waived her rights to the house in consideration of certain debts having been assumed by Willis Hoagland, the lineal chieftain, and further consideration of having a totem erected to the honor of my husband and his gens" (Keithahn, 1963: 48).

Not only has the Sun House vanished from the Stikine area, the other eight great clan houses have also disappeared through time. Kotslitan (old Wrangell) was once a powerful Tlingit stronghold, and reportedly had over 2,000 inhabitants. Edward Keithahn (1940) produced a comprehensive study of the Tlingits and Chief Shakes' dynasty that documents the early history and the later colonial periods. Now only the Q!A' tgu hît House or Shark (Dogfish) House of the Nanyaā yî remains. It is better known as Chief Shakes' House, and stands on Shakes Island which is on the National Register as an historic monument site. The Wrangell Cooperative Association (IRA Council) is custodian of this land held in trust by the federal government for Indian people.

Chief Shakes' tribal house was restored during the same period as the eight totem poles surrounding it. The Chief lived in the house until his death in 1916 and his wife also lived there until her death in 1935. The restoration was completed in 1940 and in June of the same year a great potlatch was held in commemoration of the event. "The central theme of the potlatch was accession to chieftanship of Kudanake to Chief Shakes VII. He was 76 at the time, and several thousand people came, including Indian leaders from all Southeastern communities, prominent Alaskans and officials from the United States and Canada. All were anxious to pay homage to Shakes VII the last of Nanyaā yî chief born prior to the purchase of Alaska" (Keithahn, 1963: 7).

The Eagle and Sun poles were specially carved by William Ukas and erected for the occasion. The Eagle (Na-chee-su-na) stands at the entrance to Shakes Island; the Sun Totem (a replica of a pole from the Sun House) stands at the rear of Shakes Island. It is said to take a week to relate all the details of its crests' narratives.

In Chief Shakes' House are superb replicas of the original house posts carved in 1985 by master carvers Steve Brown, Will Burkhart and Wayne Price. The four original house posts were carved by Kadjisdu.āx̱ch II circa 1775 when he was a young artist (the same carver who years later carved the Whale House posts in Klukwan). They are now in the Wrangell City Museum and definitely worth looking at. Displayed in Chief Shakes Clan House are also two original Frog House Posts from the now vanished Sun House. They were carved circa 1835.

Wrangell is, indeed, a crown jewel in the Land of Totems, and such a historical setting is a fitting place for the Kadishan poles. Two memorial poles belonging to the family of Chief Kadishan of Wrangell were erected in the late Russian or early American period. Replicas of these poles carved by William Ukas around 1939 now stand on Shakes Island. The original poles probably dated from 1865 to 1870, the latest part of the early classic period in Alaska.

The Lq!aya'k! pole stands with a companion Eagle pole which is also a very interesting pole. The eagle on top of it holds two coppers (some say a crest of Tsimshian origin), and below the eagle are Gonaqade't, a frog crest, and a sand-hill crane. This pole was a copy of a very valuable and honored Haida dancing crane. Both poles stood in front of the Kāsq!ague'dî Clan House of the Raven moiety. The Lq!aya'k Pole is considered a memorial pole and was erected by Kadishan's older brother, who was the chief to honor his family lineage. He died at an early age, and upon his death Chief Kadishan assumed his brother's title of Hít s'atî.

The companion Eagle pole briefly mentioned here is said to be the older of the two poles, and to have been erected in honor of an uncle. There is some confusion among the present heirs regarding this crest on a pole in front of what was a Raven moiety clan House. Another puzzling question that arises is how did the Kāsq!ague'dî clan or their chief obtain the rights to use the Haida dancing cane. It could be a situation similar to the title "We Shakes" which was a part of the spoils of battle conferred on a Nanyaā'yî Clan or their chief upon victory in a war against the Niska Indians of British Columbia. The name means the splash that a killer whale's tail makes when it enters the water. The Niska also relinquished their use of the Killer Whale crest and bestowed it on the Wrangell Nanyaā'yî , and as a result created the Shakes dynasty of the Nanyaā'yî of Wrangell. The gravesite of Chief Shakes V is just off Case Avenue in Wrangell and is adorned with two Killer Whale crests.

The Kadishan's family was also a prominent family in the Stikine area. They reigned during the time of Russian rule and through the transfer of power to the United States. The dilemma of balancing Indian sovereignty against foreign domination fell on these able statesmen's shoulders. The last Chief Kadishan was a great orator and a consummate authority on Tlingit history. In early 1910 he was the principal informant for Dr. John Swanton, ethnographer for the Smithsonian Institute. Among Dr. Swanton's papers is a fine description of the Lq!aya' k! pole:

> Memorial Pole
> "At the top of the pole is Nas-ca'kî-yēl (Raven-at-the-of-Nass-River), represented by a man wearing a raven crest hat. On his breast is the Raven (Yel); below is another being, Lakitcina, wearing his hat and the red snapper coat which he used to murder his children. Underneath him is the frog emblem of the Kiksa'di, and at the bottom is the thunderbird who represents a crest of Lq!aya'k!."
> (Swanton, 1908: 434)

The story of Lq!aya'k! states he was born at Sitka. His father was Lakitcina, a cruel man who hated all humans. It was said he inherited the fire spirit of his father and the wolf blood of his grandmother, who was an actual wolf. He wore a coat made from the skin of red codfish. The fins were so arranged on the front of the coat that they formed saw-like teeth up and down his breast. He would kill people by ripping them open, and he even killed his own children. The fire spirit came to his wife, and told her to cover her children with ashes from the fires so they would look like puppies. When Lakitcina was gone, she brushed the ashes off, and they appeared as children again. Three of their children had survived—two boys and one girl.

When his two sons, Kq!aya'k and Lq!aya'k, were of age, they killed their father to avenge his evil ways. Later Kq!aya'k (the older brother) killed a monster that was troubling Sitka. He learned of a charmed salmon spear that a man had at Yakutat, and he wanted it to accompany the charmed halibut hook of his father. He slew the man and obtained the spear. The brothers were told never to look upon their sister's face, so she wore a head covering that hid her face and held her head down.

The brothers had many adventures from Yakutat and Sitka. On their way back to Wrangell they were crossing the Stikine River when the water was low but the current still swift and treacherous. The brothers looked

back with concern at their sister. She glanced up at them for reassurance. They saw her face and turned to stone. The rocks can be seen to this day on the Stikine River.

The last figure on the pole is the Thunderbird, who lives high in the mountains and spills water and causes rain when he is upset.

When the Tlingits were traveling in their canoes on the Stikine River they sang the "Song of the Rocks" as they rowed past them to pay honor to the brothers and their sister. Every legend and every totem pole had its own music and particular song. Dr. Walter Soboleff, a Tlingit elder, when interviewed, stated: "And when the people are telling a legend or an incident there is time to sing; at one point in the legend, incident or totem pole raising there is a time for the music that goes with it. We say in Tlingit Ada'suitoo the music that surrounds these things. It had its own identity. It was like a big opera. The music had its own essence and power. There was special music used by the shaman and this music would be dependent upon who his spirit helpers were. The Ixt man always did his own singing" Williams, 1996: 585).

Dr. de Laguna mentions, "When the tribal house was completed a song was sung. It was just like the commissioning of a naval vessel to assume its place in the fleet" (de Laguna, 1972: 610). All of the early ship captains also speak of the Tlingits' constant use of song. When approaching the ships they came out in their canoes singing; and when boarding to trade they sang and danced at least an hour before trading. When another Indian group approached a different village, they were greeted by song (either friendly or hostile). They in turn had to respond in song to state their intentions. Malaspina witnessed such an event when the Yakutat people, fearful of strange canoes in the bay, asked the Spaniards for help; but the approaching canoes began singing a hymn of peace, and the situation was resolved. Suria further noted that when some difficulty arose or there was trouble in the village they would sing all afternoon and well into the night.

POST-CONTACT CHANGES IN TOTEM POLES

THE CHANGES IN THE STRUCTURE OF THE SOCIETY THAT BEGAN slowly in 1800 proceeded to increase rapidly after 1840 during the intense culture stress of colonialism, and these changes, in conjunction with the severe demographic decline, were reflected in the artistic expression. The cedar monuments erected during this era reveal the multi-faceted changes that happened during this century.

Major losses occurred with the deaths of many members within the intelligentsia, and fragmented the lineage lines of the artists who dominated the classical style, determined the ascetic values and controlled the formal aspects of the art. The decimation continued to erode lineage lines further, thus affecting the solidarity that controlled the rigid procedures that decreed who of high status was eligible to commission a totem pole and circumscribed the occasions for such events.

These factors precipitated changes in the traditional school of carving, the conservative rules accompanying the expression of the art form and the inherent restrictions that permitted only a selective few to learn the carving techniques. Like the samurai, it was a formal code of rank, obedience, and honor, with the addition of genius, that maintained the art, sustained the expression, and distinguished master carvers of the hallowed tradition.

These changes created an opportunity for those left to carry on the tradition to initiate more freedom in the executions of the designs with the new carving tools, and to expand the technique further within the medium of cedar sculpture. Since they were living in a time of change, they ventured to introduce their styles in the art without the sanctions or resistance from the old hierarchy. Art historians regard 1820 to 1865 as the

Opposite page: **The Land Otter Woman, or Koos-da-Shan, Pole. The pole no longer exists, and the original carver is unknown. This old photograph of the pole was taken in Wrangell, Alaska.**

Photo: Wrangell City Museum, p. 80, 12.284.002, Neg. No. 0318.

87

early classic period of the art. The carvers were motivated, not only by the desire to change and the opportunity to accomplish it, but were driven by a kind of dramatic intensity to capture its essence within their time. There are those who refer to this as the golden age of the art.

The late classic period, from 1865 to 1920, coincides with the United States' purchase of Alaska in 1867. It was not until 1884 that Congress passed the First Organic Act, which created a civil and judicial district with a temporary capital in Sitka. However, the civil administration was denied the means either to inspect or enforce the laws, and education was left to the churches. The gold rush began in 1898, and the main route to Dawson in Yukon Territory was through the Dyea Pass in Tlingit country, which caused the population in the area to increase to 63,000. Obviously, this intrusion of so many transient gold seekers caused many problems, and with a stressed territorial government, there was little protection for the indigenous people.

The artistic expression was caught up in this upheaval that intensified the existing sociocultural problems and caused further disruptions within the lineage lines. This placed an even greater strain on the Indians' struggle to maintain their way of life and it became necessary to define the positions of the new chiefs and nobles, who were not from the old lines of descent, by potlatches and totem poles. Memorial and mortuary poles (now often grave markers) became common for individuals who could afford them. They developed poles that varied from the classical models, and with European tools they were able to make taller poles and a greater number of them. There were victory poles, shame or humiliation poles, poles to dignify a name or an event, and poles to validate any important occurrence. "This does not mean that there was a mass production with influential people erecting poles like match sticks" (Wherry, 1964: 34). The significance lay in the types of poles and the status of the people who *could* erect them and, as in any changing culture, the *nouveau riche* wished to display their wealth.

Another element contributing to this situation was the Indians' covert defiance of the restrictive colonial government's brutal stance against the potlatch. The totem pole and potlatch are so ritually interwoven in the culture, that by increasing the kinds of totem poles they subtly strengthened the potlatch.

Apart from what scant controls they could create for themselves, they were engulfed by inundating forces. The epidemics continued. They were not citizens of the United States and therefore legally could not file mining claims, and thus share economic gain from the discovery of gold.

Christianity was taking a firmer hold, mainly through the education process (see Chapter IV) and would not allow the student to speak their languages in boarding schools. In more subtle ways,. Indians' names were changed by the Indian agents and the missionaries to create new identities—forbidding the use of the Indian name (even in its English translation), the name that literally defined an Indian's family, status, and lineage within the clan, effectively reducing him/her to a non-person.

The previous generation of carvers had remained deeply rooted in their traditional society and the esoteric beliefs of their ancestors. The Canadian and U.S. colonial governments exerted great efforts to destroy these links, which contributed further to the dismantling of the social order of the Tlingit people. The carvers had little guidance from the old masters. They had to resist government pressure and were forced to carve guardedly when making carvings for the clans, although they could carve freely for museums or collectors. Consequently, during these times there were a number of conceptual innovations in the form line and a masterful kind of simplification in the carving. They were creative, inventive, and often portrayed a feeling of urgency in their art as if their time were running out.

The changes that occurred in the art were not so much a departure from the past as a new reflection of it, as they strove to preserve the tradition's aesthetic strengths and values. There was never any intention to deny the past, but only to redefine it within the dimensions of their present restrictions. As always, the now slender thread of lineage and tradition continued to prevail, and the art retained the traditional elegance, the richness of the formline design, and the universal drama of man's place in the world.

MORTUARY POLES IN TRANSITION

MORTUARY POLE FOR THE PARENTS OF A REIGNING CHIEF

Gonaquade't Pole

This late-nineteenth-century pole of the late classic period is called the Gonaquade't Pole. The original was erected by Chief Shakes VI to hold the ashes of his parents. The dual aspect of the pole is a departure from the old tradition. The present pole was replicated by Charlie Ukas and

stands in front of Chief Shakes' community house. On this totem squats the image of a man with a double-crest whale hat on his head. The man is Gonaquade't, a name he gained on becoming a sea monster.

Gonaquade't was a monster that lived in the sea and he features in many Tlingit legends. This is the tale of the young man who encountered and trapped the monster. The monster seemed to have died so the man skinned it and wore the skin. The young man was a rather worthless fellow and a great gambler, who quite naturally had problems with his mother-in-law. He finally had to move away from the clan house and live in a hut near a lagoon behind the village. This is how he came in contact with Gonaquade't and decided to capture him. He spliced tree roots together to make strong fishing lines and constructed a hoist of hemlock trees. When he finally landed Gonaquade't, he hung the monster on the hoist in order to skin him. Curiously, he studied the skin, claws and all, and decided to put it on. Then, without thinking, he jumped into the water. Amazingly, he discovered that he could swim under the water for long periods of time without any problems. He told his wife of his new discovery and begged her to keep it secret.

Later, when the village was suffering from a famine, the man would leave salmon and halibut for his mother-in-law. The woman claimed she was a shaman, and when she found a whale at the door, she proclaimed she was a great shaman and demanded the village honor her as such. The young man and his wife were amused at her arrogance.

He had warned his wife that he must always return to the lake at dawn before the ravens called. One morning he failed to heed the call of the ravens, and was not seen again in the village. The villagers finally sent out a search party, and he was found lying on the beach between two whales. He was dead but still wearing the skin of Gonaquade't. The villagers thought the monster had swallowed him, so they prepared his body for cremation and cast the skin that enveloped him back into the lagoon.

The widow would go there every night to weep for the loss of her husband. One night, like the sound of rippling water, she heard Gonaquade't call out to her. "Come, my wife! Come with me! Get on my back. Hold on tight!" She did, and he took her to his home under the water. Whenever people see Gonaquade't and his wife and children, it is always a great occasion, and they will be richly endowed.

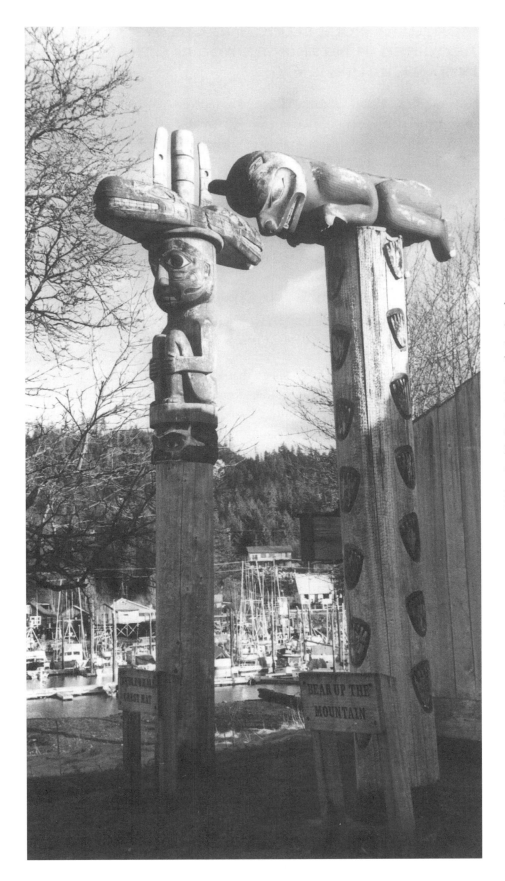

The Mortuary Pole Gonaquade't.
Charlie Ukas carved a replica of
the original pole. Shakes Island,
Wrangell, Alaska. It stands to the
side of the Grizzly Bear
Mortuary Post that held the
ashes of the younger brother of
Chief Shakes VI. A grizzly bear
led the Nanaā'yî to the safety of
a mountain top during a flood.

Photo: Alaskan Images; photographer
Ivan Simonek, Wrangell, Alaska.

MORTUARY POLE DEPICTING CRESTS ACQUIRED IN INTERMARRIAGE IN OTHER INDIAN GROUPS

Raven-Finned Blackfish or Killer Whale Pole

In Klawock Park there is a mortuary pole of the late classic period called the Raven-Finned Blackfish or Killer Whale Pole. This replica of the original was carved by Israel Shotridge in 1990. The pole depicts a blackfish diving. On the top of its long dorsal fin, which forms the body of the pole, is the Raven. The crest originally came from the Haida Indians but, through intermarriage, it became a part of Tlingit legend.

The pole stands in Klawock Totem Park and belonged to a man of the Wolf moiety, and in a niche at the back of the pole was placed the box containing his ashes. Killer Whale was a very prized crest because even though it was small, it attacked and killed larger whales. It was supposed to give strength to those whose privilege it was to use this crest.

The story tells of some men who were hunting seal when a school of blackfish appeared and chased the seals into an inlet. The hunters followed the seals and began to spear many of them. One man speared a blackfish and threw it in his canoe along with the seal. Instantly more blackfish appeared and surrounded his canoe, and they spoke about killing him in retaliation for spearing the young child of the chief of the blackfish people. One of them spoke up and said the only way he could spare his life was by paying for killing the child.

The hunter had very little with him except his canoe, his weapons, and a bit of food. He gave them his food and they asked for more. All he had left were his weapons and his canoe. His sealing spear with a bone point had been handed down in his family for many generations from uncle to nephew, for he had come from a line of hunters, and his spear had a great history. The chief of the blackfish appeared; he had a long dorsal fin on top of which sat a raven. The chief began by speaking to the hunter saying, "Only by giving us your seal spear can you make restitution for the life of my child and thereby redeem yourself. We know how great your bone pointed spear is, and something that great can pay for the taking of the life of my child." The hunter had no choice but to throw his spear into the water to the chief.

Alone, with only his canoe, he thought he would surely starve, but then the blackfish sent him food in the form of seals, halibut, salmon, and clams. He was finally able to reach his village, and he told the people the story of the blackfish people and their chief's demands. His family had a pole carved to commemorate the event and gave a potlatch to validate the taking of the Killer Whale crest as a part of their lineage line for all of their descendants to use.

92

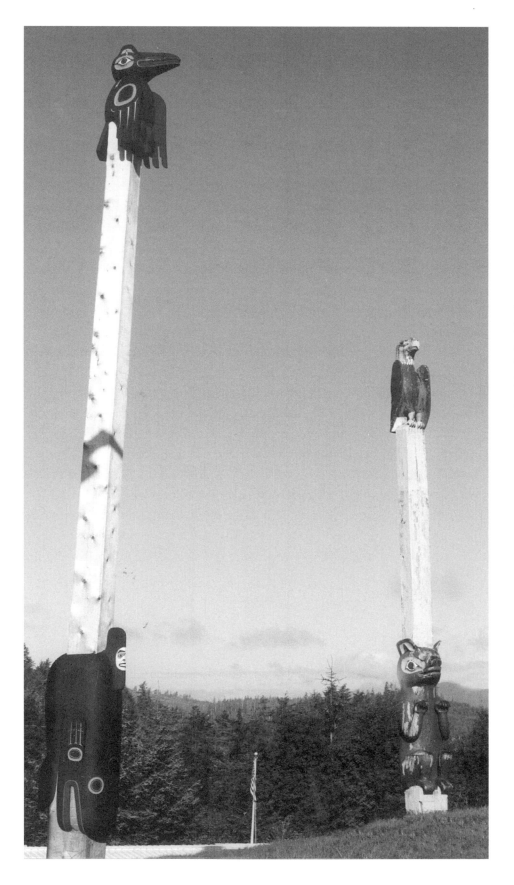

The Mortuary Pole Raven-Finned Blackfish. This replica of the original pole was carved by Israel Shotridge in 1991. Klawock Totem Park.

Photo: Prince of Whales Photography, #JMG001, Craig, Alaska.

GRAVE MARKERS

Sun Raven Pole

Mortuary Pole/Grave Marker Sun Raven Pole. Charlie Brown replicated the pole in 1938. Saxman Totem Park, Saxman, Alaska. This pole is in decay, and at the time of this writing, Israel Shotridge is carving a new Sun Raven Pole.

This pole, located in Saxman Park, is a copy of a grave marker erected in 1902. According to Garfield, the original was carved by a famous carver, Nawiski, for a woman of the Raven moiety belonging to the Starfish House. A replica of the original was done by Charlie Brown in 1938. The pole was originally set up on Pennock for the woman's two sons. It relates the story of a Raven's mother and how she feared for him after he stole the box of daylight. She gave her son to a crane, who said, "I will raise him and make him strong like me. He will stand in the cold water in the summer and in the winter." Raven grew strong, and when he became a man, he attempted to return to his village and see his mother, but her brother still harbored terrible hatred toward him. His uncle made many attempts on his life, and the final attempt to drown him in the rising tide caused Raven to flee. The waters continued to rise, so the Raven put on a sandpiper's skin and flew up to the sun.

Some say he married the Sun's daughter and stayed there until the flood subsided in the world. This is depicted at the top of the pole with the Raven figure with wings outstretched and a halo of the sun about his head. On his breast are three figures of the children of the sun. Below the children is the round head of the Fog Woman, whom it is said that Raven also married. She had a special hat that always provided food from the sea. This abundance is indicated by three figures of salmon on either side of the Raven and underneath the Fog Woman. At the bottom of the pole is a frog, representing Raven's trip when the frog took him to the bottom of the sea.

Indian graves, Fort Wrangle, Alaska 1887.

Photo: Oregon Historical Society, N334.

The grave of Chief Shakes V in Wrangell, Alaska.

Photo: Wrangell City Museum, Wrangell, Alaska

The Mortuary Pole/Grave Marker Man With Crest Hat. Charlie Brown carved a copy of the original in 1936. In 1995 his nephew, Israel Shotridge replicated the aging pole. Mud Bight Totem Park, Ketchikan, Alaska.

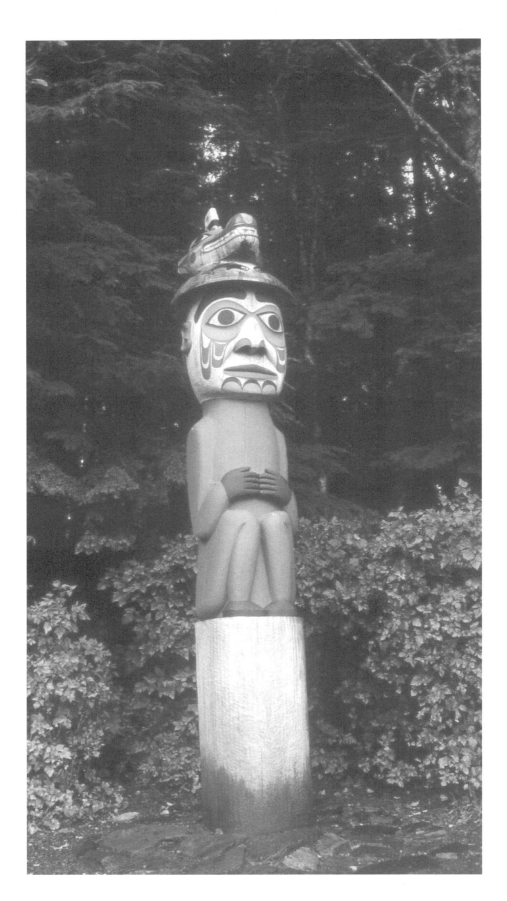

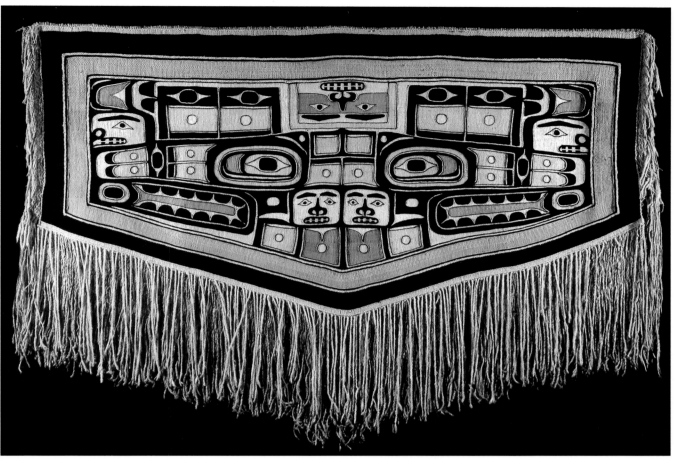

A Chilkat blanket is a ceremonial garment woven out of mountain goat hair and red cedar bark. The Killer Whale blanket pictured above was inherited by William Williams (father of Gloria Williams) from his mother Clara Johnson Williams of the DaqL!awe dî Clan. Since his children were of the Raven Moiety and not of the Wolf Moiety, according to Tlingit law they could not rightfully use the blanket, but according to Alaska law they inherited it. The family wanted the blanket to be seen and admired by many people but still remain within Tlingit hands. It was sold to Sealaska Corporation and is exhibited in a glass case in the boardroom of their corporate offices in Juneau. At right is William M. Williams (Awêi' x̱) wearing the blanket in a photo taken circa 1980.

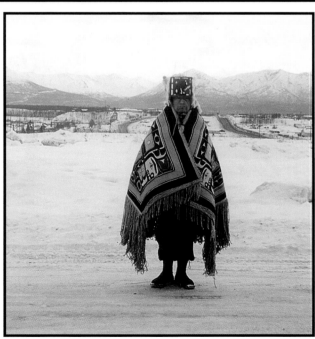

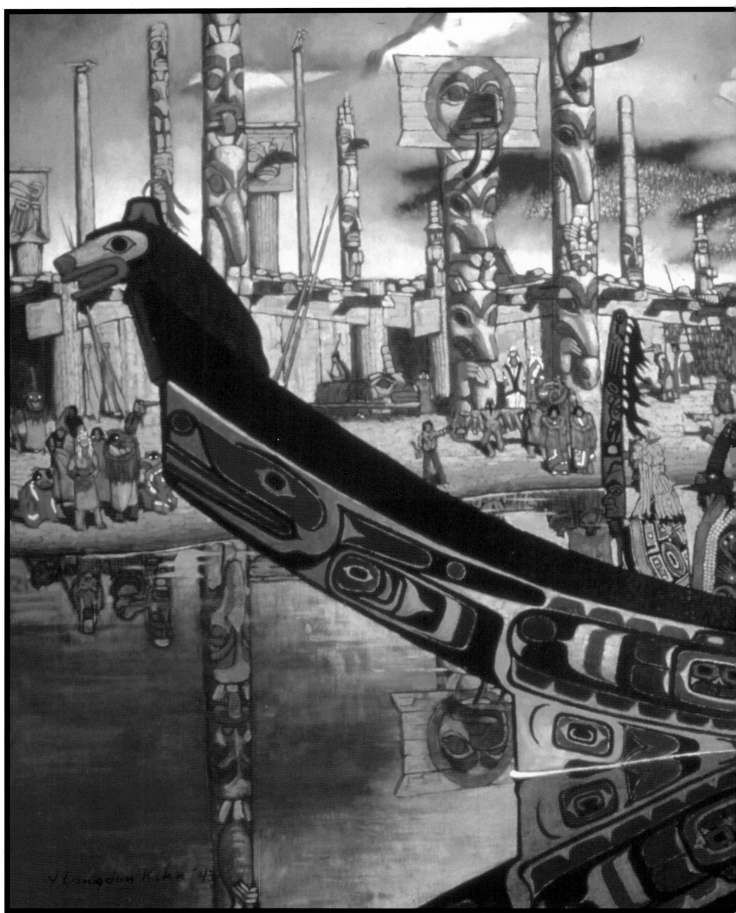

Actors in Masks and Slaves at Paddles, Celebrants Arrive for a Potlatch.

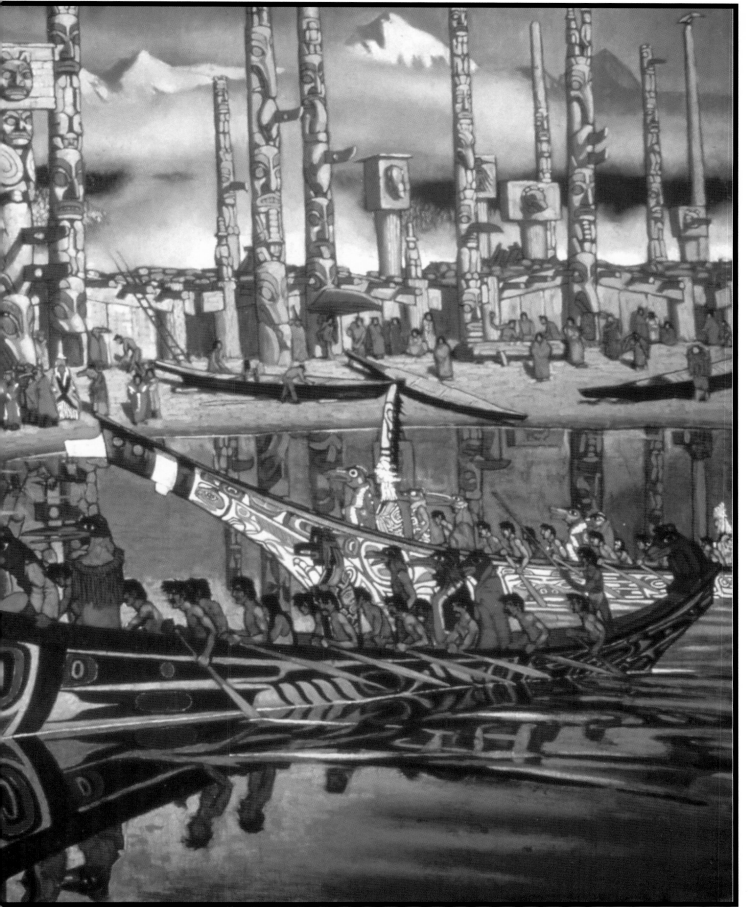

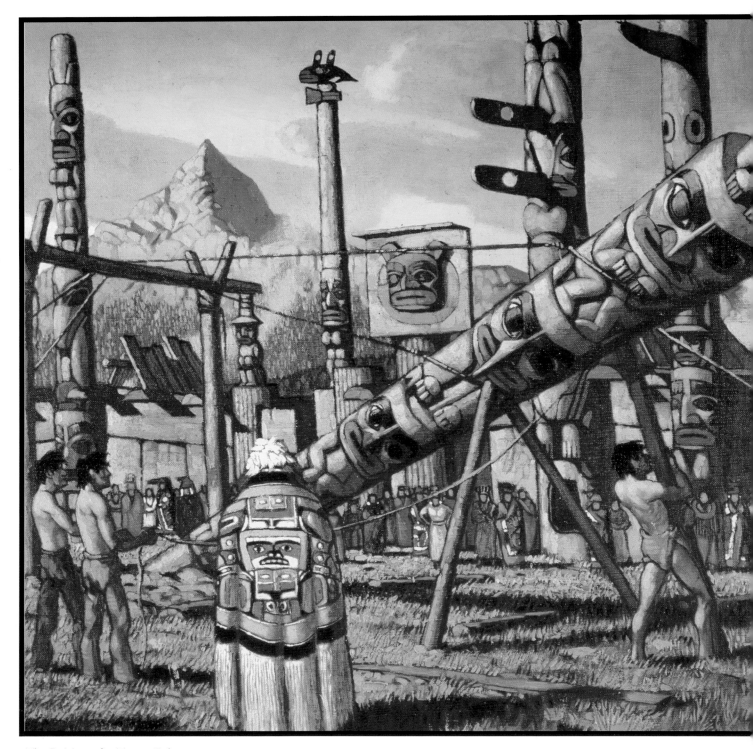

The Raising of a Totem Pole.
Courtesy of the National Geographic Magazine, N 1945 34 ii; W. Langdon KIHN/NGS image collection

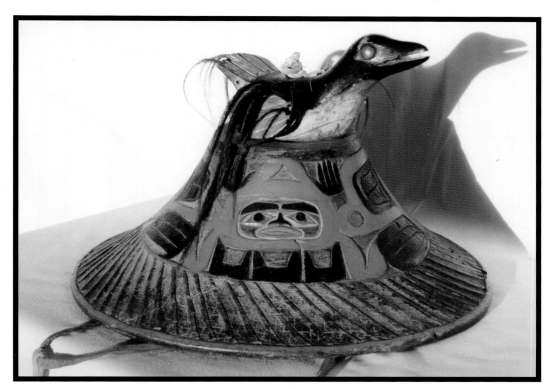

Murrelet Crest Hat. When the crest hat is worn the murrelet on the top moves about with the motion of the person's body (See page 187).

Courtesy Williams Albecker Hít s'ati Chilkoot Grizzly Bear House of the Kā´gwantān Clan of the Eagle Moiety in Haines, Alaska

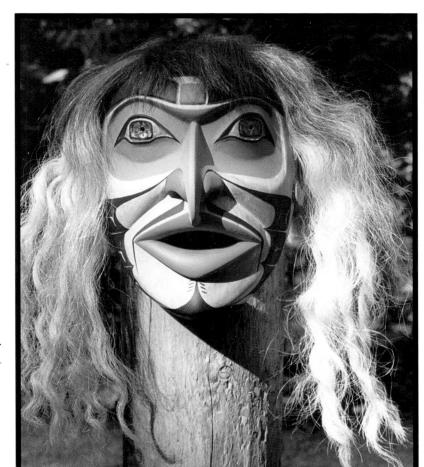

Ceremonial mask.

Photo: Shelton Jackson Museum, Sitka, Alaska.

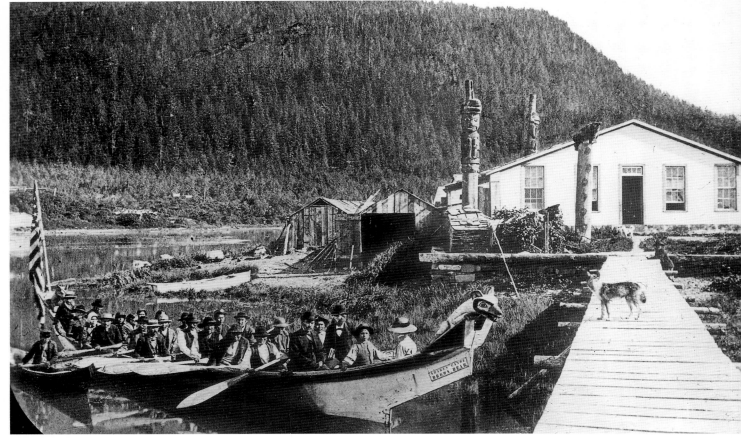

Guests arriving at Chief Shakes V house on Wrangell for a potlatch circa 1900-1912.

The authors' old photo of a family funeral. The deceased family member was a victim of the 1918 flu pandemic. The man with the hat and lots of hair is a shaman.

Photo: Marilyn Williams

Atlin, B.C. - Potlatch given by
William Williams, circa 1926.
Although breaking the law in
Canada, this was stealthily held.

Photo: Marilyn Williams

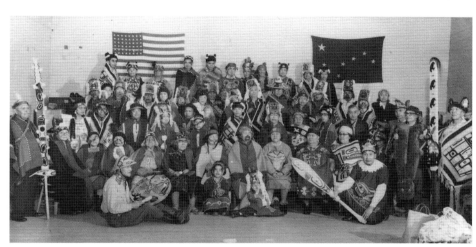

Juneau, Alaska. Alaska Native
Brotherhood Camp, 1950.

Photo: Marilyn Williams

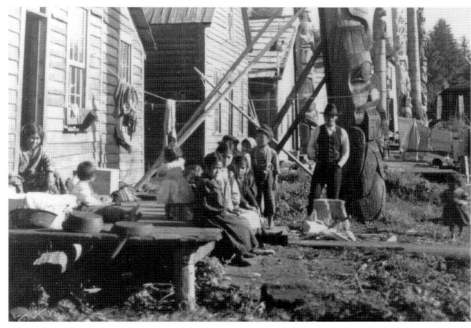

Kake, Alaska, 1890.

Photo: Marilyn Williams

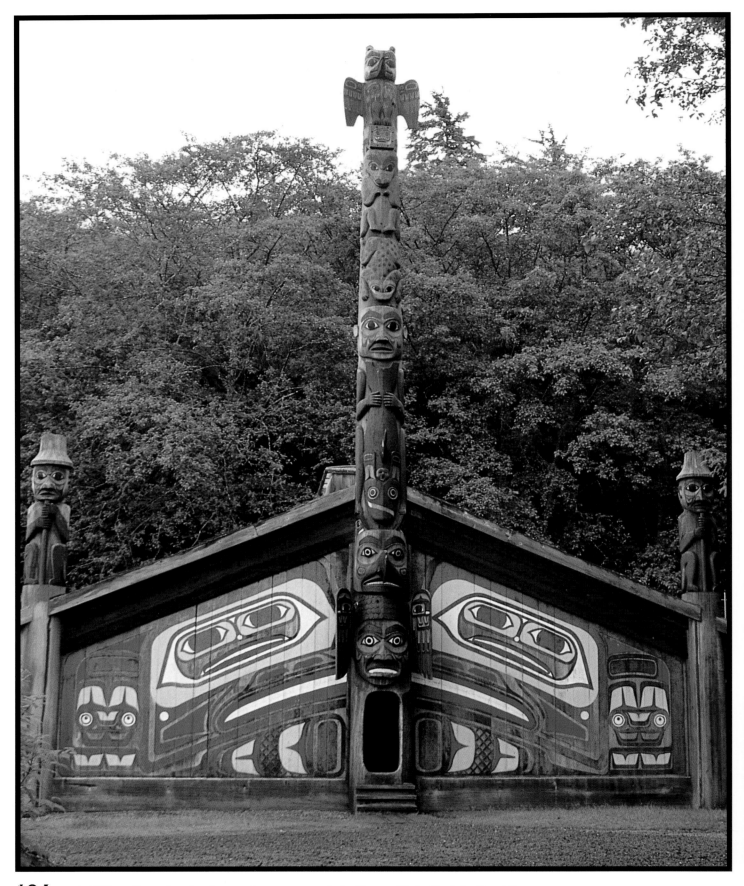

104 A 1933 replica of a clan house that now stands in Totem Bight Park in Ketchikan.

GRAVE MARKER WITH RETALIATION EVENT CARVED ON POLE

Man With Crest Hat

Another type of mortuary pole from Kat Island may be seen in Mud Bight Village near Ketchikan. The pole is a grave marker and is from early in the late classic period. Charlie Brown carved a replica of the original pole in 1936; and his nephew, Israel Shotridge, reproduced it in 1995. It depicts the figure of a man wearing a wooden crest hat carved with the figure of a bear. The brim of the hat is decorated with painted Killer Whales, also a crest of that clan. Originally the bear was carved with a closed mouth, but a chief of the Bear clan was murdered and the killers refused to make restitution for his death. The clansmen of the murdered chief had the wooden hat recarved with the bear's mouth open and teeth bared ready for attack. The accused refused to pay and were attacked in retaliation. Since this event, the bear has been carved with his teeth bared signifying the Bear People are a proud people who will defend their honor and attack!

A GRAVE MARKER DEPICTING A FEMALE MONSTER OR DEMON

Koos-da-shan

This particular grave marker (see page 86) is from the west coast of Prince of Wales Island and is questionably dated as 1865-75, thus representing the end of the early classic period or the beginning of the late classic era. In the 1930s it somehow was placed in Wrangell; but it is not known whether the Conservation Corps moved it or Mr. Waters of Wrangell bought it. For years it stood on the main street in front of Mr. Waters' store. Now it no longer exists except in photographs. The Koos-da-shan is a female monster and had the same significance as the terrifying male monster the Koosh-ta-Ka. In this pole the Koos-da-shan is shown as the figure of a woman with a land otter carved on her head, one carved on each shoulder, and another on her breast. The pole, also known as the Land Otter Woman, belongs to the Taku ane'dî Clan.

The story tells of five Indian boys who left their village, Warm Chuck, in a canoe. The canoe capsized and they almost drowned. The Koos-da-shan appeared and called the Koos-ta (the Land Otter) to save them. The boys were taken away. The Indian doctor in their village made medicine and called on his spirits, and he learned where the boys were. The Indians

105

A replica of the Shining Face of
Copper Pole (left and detail
below). The carver is unknown.
Seattle, Washington.

Photo: David Hancock.

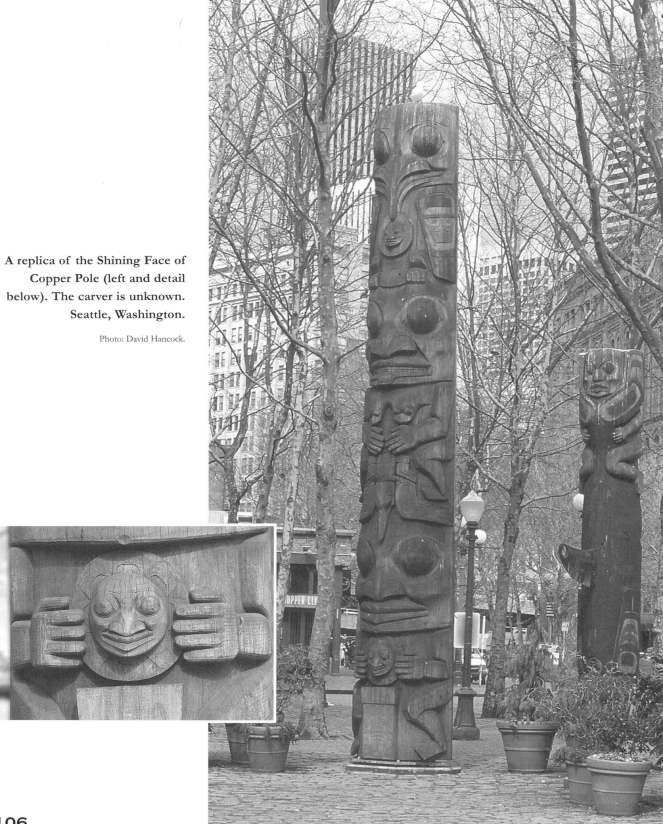

set fire to the land otter dens on the island and killed many of them, including the boys. The Koos-da-shan came and saved the rest of the land otters, and war was declared upon the Indians. At night the land otters approached the village singing and dancing. The Indians became sleepy and upon waking found they had lost their names and did not know one another. The Koos-da-shan appeared and many got sick and died.

GRAVE MARKER ILLEGALLY REMOVED FROM ALASKA

Shining Face of Copper

Stolen totem poles probably reside in many museums throughout the world, but one that has been legally acknowledged as such is the Tlingit pole, the Shining Face of Copper, that stands in a public square in the city of Seattle. It is a copy of a grave marker from Tongass Village and has an interesting history. The original totem pole was erected shortly after 1870 by the family of a woman who drowned in the Nass River. She was the daughter of a Tongass chief, a member of the Gānax adî lineage group, and related to the Kyinauk family. Her maiden name was Ebbett.

According to the story, a group of prominent citizens from Seattle were cruising the Inside Passage in 1894 and saw this totem at Tongass Village. They claimed the village was deserted at the time and, therefore, they felt the pole was for the taking. They took the pole back to Seattle and raised it in a public square. When the Tlingits returned to their permanent village of Tongass, there was an immediate outcry. The pole was traced to Seattle and the heirs made legal claims on it. Eventually they were duly compensated for the pole, some individuals receiving as much as $3,000. The original pole later began to disintegrate in Seattle and a copy was made of it.

On top of the pole is the Raven who stole the light. Below the Raven is a woman carrying a frog; she was the woman who spoke lightly of frogs and was carried away by them. Mink appears below the woman and was important as Raven's traveling companion on many of his journeys. On one of these journeys, Raven and mink wanted to cross Icy Straits, and they met a whale that elected to take them across. While crossing they started eating the whale's fat. They ate so much of the whale's heart that they killed it. The Raven appears again on the pole below the mink, then the whale, and at the bottom is the sea eagle.

This version of the story is one that Franz Boas obtained from George Hunt, his informant. Dr. Swanton recounts a slightly different

**Memorial Pole of Chief Johnson.
A replica of the original was
carved by Israel Shotridge and
his brother Norman in 1989.
Ketchikan, Alaska.**

Photo: Manfredini photograph,
Ketchikan Museum.

version that he obtained from David Kyinauk of Tongass, a clan relative of the princess. In his version, it is not Mink but Low Tide Woman who married Raven, the whale is a killer whale, and the bird at the bottom is The Keeper of the Light, or the Raven. Emma Williams, née Kyinauk, half-sister of David Kyinauk and the authors' informant, tells yet another version where it is not a mink but a bear holding a seal.

MEMORIAL POLES IN TRANSITION

MEMORIAL POLES STILL FOLLOWING TRADITION

Chief Johnson's Pole

Memorial poles went through a similar series of changes, from the very early poles that honored a dead chief and legally validated his new heir, to a more democratic version that could honor a kinsman or an event. Chief Johnson's pole was set up in 1901 and, in the historical sense, is still a classic memorial pole. It was replicated by Israel Shotridge and stands in the city of Ketchikan near its original location and is assumed to be a validation of Chief Johnson's right to be chief, or Hít s'àtí. Chief Johnson was of the Kadjuk House of the Ganāxa'dî clan of Tongas. A clan house was later built behind the pole, but it burned down, and now the only remaining legacy of the past is the Kadjuk pole. Surmounting the pole is the mystical bird Kadjuk. The fabled bird represents the golden eagle who lives high in the mountains and is rarely seen. Interestingly, there are those who claim it is dark brown in color with black-tipped wings, while others state that it is white. The bird is a special crest of this house, and the undecorated space on the pole symbolizes its lofty position. It is said that he amuses himself by throwing pebbles at groundhogs, and if one is fortunate enough to find a pebble, wealth is assured him for all time.

The two bird forms beneath Kadjuk are Gitsanuk and Gitsaqeq, servants of the Raven. Below them is the Raven with his wings spread out. On his breast is the headdress of his wife who sits beneath him. The woman is wearing a large wooden labret in her lower lip, a mark of rank among ancient Tlingit women. She holds two salmon in each hand. On the tails of the salmon are carved two faces representing the wealth in abundance of salmon in the Northwest Coast. The woman is called Fog Woman, and it is said that she produced all varieties of salmon and placed them in the creeks. To the Indians, she became associated with the summer salmon runs.

The story tells of Raven and his slaves who were fishing at the mouth of a creek and caught nothing but a miserable lot of codfish. Fog suddenly settled in while they were out in Raven's canoe, and they could not find the way back to camp. A beautiful woman appeared in the center of the canoe. She asked for Raven's spruce root hat and held it upside down, and all the fog went into it leaving the sky sunny and clear. Raven fell in love with the woman and married her. He then went on a short journey leaving behind his wife and slaves.

When Raven had gone, his wife commanded one of the slaves to bring her Raven's spruce root hat. She went to a nearby stream and fetched water in it. The slaves were surprised to see sockeye salmon swimming around in the hat. She ordered the slaves to cook them. They ate the fish and were very careful to hide the fact as Fog Woman warned them not to tell the Raven. Upon his return, the clever Raven saw the meat between their teeth and demanded to know what they had eaten. Gitsanuk told him, then Raven sent for his wife and asked her how she got the fish. She told him to bring her his hat, and just as she dipped it in the water four sockeye salmon appeared in it. Raven immediately ate them and asked her to create more fish, which she did.

He built a smoke house as she directed. Each morning they found the bay and the streams full of salmon. Raven and his wife worked very hard, cleaning, smoking, and drying salmon. Raven saw how rich he was becoming, and he felt very secure and behaved arrogantly towards his wife and struck her. She told him she would leave and return to her father, but Raven paid no attention and treated her badly. Nothing she could do would please him. One day she left the house and walked slowly to the sea. Raven rushed after her, but he could not hold her for she slipped through his fingers like fog. "But," he thought as he saw her fade away, "I still have my winter's supply of fish." Much to his chagrin, he found that she had taken all the fish with her and there was nothing left for him but codfish. Because Fog Woman created salmon in a spruce hat of fresh spring water, they return each year to the fresh water streams from the sea. At the head of all creeks lives Creek Woman who is the daughter of Fog Woman.

The Kadjuk crest hat of Chief Johnson passed after his death to his leading nephew, Frank Williams. His nephew never assumed title of Hít s'àtí nor sought to hold the position. It is interesting to note that upon Frank Williams' death in 1979, the hat, now a valuable heirloom, was bequeathed to his nephew as tribal custom required, overriding Alaskan law which would have favored his widow or daughters as more direct heirs. They were, of course, of the opposite moiety, and according to tribal law could not be beneficiaries of the Raven moiety; therefore, no difficulties arose and the family members considered the inheritance reasonable and equitable.

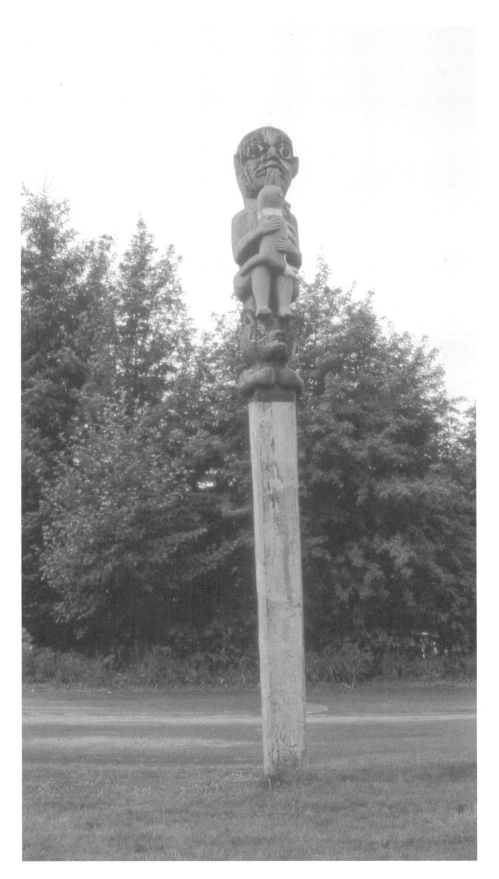

The Memorial Pole Dog-Eater Spirit. This replica of the original pole was carved circa 1938 by either Albert or Bob Smith for the C.C.C. restoration project. Klawock Totem Park, Klawock, Alaska.

MEMORIAL POLES USING REPRESENTATIONS OTHER THAN CLAN CRESTS

The-Dog-Eater-Spirit

There is a rather unique memorial pole in Klawock Totem Park, The-Dog-Eater-Spirit. On top of the pole is a man holding the limp body of a dog in his arms; beneath him is the head of a brown bear that is the crest of the Wolf Clansmen who owned the pole. Very few poles of the Tlingits used dogs as insignia since dogs were not taken as crests or identified with house groups. There were among the southernmost Tlingits certain very powerful spirits that strongly influenced men. These spirits were the basis of secret societies. One of these was the dog-eater spirit. One in possession of the dog-eater-spirit would lose all control over his actions. The only remedy to return the victim to his right mind and save loss of soul was by eating dog flesh. "Among the Tlingit the right to the dog-eater-spirit was zealously guarded by a few shamen whom it was said brought the privilege from the Tsimshian of the Nass River" (Garfield and Forrest, 1948: 145).

The secret society connection is, however, debatable. Garfield refers to it in the village of Tuxekan but later anthropologists doubt this. The middle Northwest Coastal groups in the area of Alert Bay had secret societies with open broad group membership. The more northern groups, such as the Haidas and Tsimshians, also had secret societies with more selective membership composed of high-ranking chiefs and operated within small elite groups. The Tlingit elite did not have such inherited powers. Thus it is now thought that the Dog-Eating practice was a shamanic practice in Tuxekan, incorporated from nearby Haidas, and adapted in the form of Yéik (shaman spirit) power. Shaman were always in search of new powers. Gunya is a Haida name that was acquired somehow by some members of this southern Tuxekan clan and they may have acquired the Dog-Eater Spirit along with the name.

The memorial pole was put up after the death of a now unknown man. Whoever he was, by being an ancestor of Gunya (the last known person to be possessed by the spirit), he earned the right to the crest on his memorial pole.

The story of Gunya is well known. It took place at Tuxekan on an occasion of a potlatch given by his father. He suddenly became very agitated during the feasting and dancing, then he simply disappeared. The next day they found his clothes in the forest, but no sign of Gunya. They

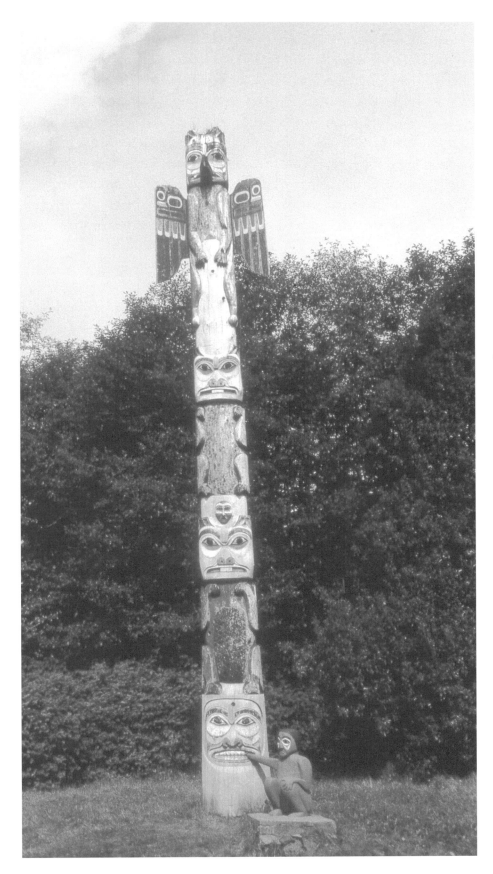

The Memorial Pole Giant Rock Oyster. This pole was restored during the 1930s. The carver is unknown. Saxman Totem Park, Saxman, Alaska.

searched for him, and a shaman experienced in the way of spirits was chosen by his father to get Gunya back. The shaman sang for eight days and still no Gunya, but later that same day Gunya was heard singing on the beach near the village. They saw him wading in the water naked, carrying a dog's head. His uncle pulled him ashore with a cedar bark rope and took him to his father's house. The shaman sang and danced to call back the mysteriously lost entity of his personality. Gunya could not recall what had happened to him nor where he had been. It took several weeks to restore him to the person he was before.

Universally, on the coast, dog flesh was considered unfit for human consumption. Even under dire hardship, such as those faced by traveling parties stranded on barren inlets or hungry groups after a military siege, they did not eat their dogs. The dog-eaters did so because they were temporarily non-human. They acted compulsively to satisfy the appetites of the savage Wolf Spirit who possessed them. "In the light of the 20th century, we might interpret this as the society's outlet for violence that, otherwise undirected, could be harmful to the group" (Drucker, 1958: 163).

MEMORIAL POLE HONORING THE GENEALOGY OF FOUR RELATED HOUSE GROUPS

Giant Rock Oyster Pole

This pole was erected at Cape Fox to honor the deceased members of four related clan house groups. It now stands in Saxman Park near Ketchikan. On this pole are carved the emblems of four related house groups of the Nēxa'dî clan, descendents of the Eagle Claw House whose crest appears at the top of the pole. The human body with eagle claws instead of feet appears at the top of the pole, which symbolizes the members of the Eagle Claw House as distinct from other Eagle clansmen (Garfield and Forrest, 1948: 41).

Below the eagle crest is a beaver with his tail up over his body which signifies it as the emblem of the Beaver Tail House. Below this emblem is another beaver representing the Beaver Dam House. The face at the bottom of the pole is that of the Giant Rock Oyster House. Carved separately from the pole is a young boy with his hand caught in the shell of the oyster. This youth was fishing for octopus when his spear became jammed under a rock. He dug under the rock to free his spear but as he reached under to retrieve it, a giant rock oyster caught him by the wrist. His friends could not free him. Villagers came to help but they could nei-

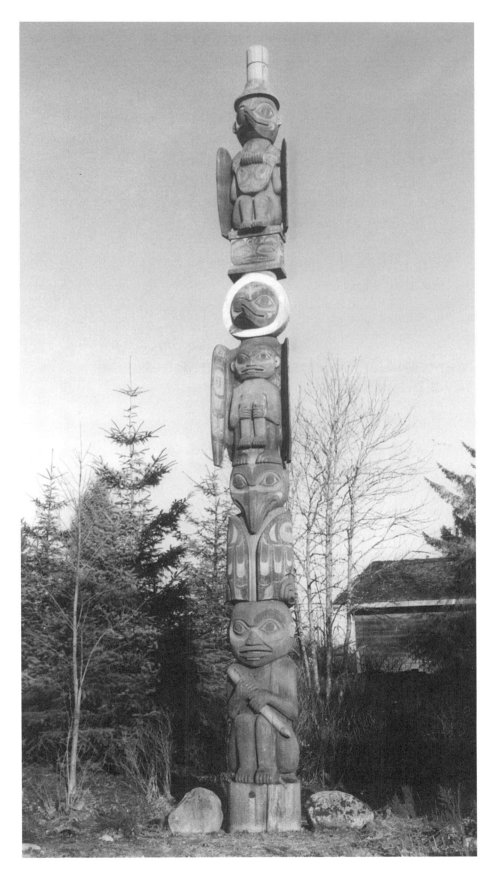

The Memorial/Commemorative
Pole, The Wrangell Raven Pole.
Steve Brown and Wayne Price
carved this replica of the original
in 1987. Kik.setti Totem Park,
Wrangell, Alaska.

ther pry him loose nor lift the huge rock. Desperately they worked to free the boy as the tide rose higher and higher. He began to sing and continued until he drowned.

> "Where is the tide, where is the tide?
> Watch for thy self, watch for thy self.
> Oh, spirits of the tide, they are coming up.
> Oh, spirits of the tide, they are coming up.
> Oh, sons of the tide spirit, they are coming up."
> (Garfield and Forrest, 1948: 41).

Later, at low tide, his family found his body lying on the shore near the tidal basin where the oyster had grasped him. They sang the song at his funeral and took the Giant Rock Oyster as their crest.

MEMORIAL/COMMEMORATIVE POLE FOR TWO INDIVIDUALS

The Wrangell Raven Pole

This is another variation of a memorial pole. The original pole stood in front of Chief Shakes' house in Wrangell. A replica now stands in Kik.setti Totem Park. Dr. Thawing, a missionary, wrote to *The Alaskan*, a Sitka newspaper, on 29 February 1886: "This winter there has been a very general feeling of suspense and expectancy, in view, of the great feast and inter-tribal dancing for which Chief Shakes has been preparing for a year or two. A totem pole has been carved to dignify a living son and commemorate one dead son, and the Tongass natives have been called to dance and feast here. These guests arrived February 1st, and were received with great honor and much noise" (Keithahn, 1963: 91).

The pole is surmounted by a Raven wearing his crest hat, which has several potlatch rings, and he stands on his box that contained daylight. Beneath the box is the young Raven who stole the box. Below him is his mother, daughter of the Raven chief, who surmounts the pole. The lowest figure is Haica'nak, the woman who guards the foreleg of a beaver on which rests the world. It is claimed she was the first mother of Raven before his reincarnation as the grandson of the keeper of the light. The top raven is actually Nas-ca'ki-yel, meaning Raven-at-the-head-of-Nass-River.

COMMEMORATIVE POLES

PRESIDENT LINCOLN POLE

Commemorative poles developed in the nineteenth century were a completely new adaptation to an old custom. An example is the President Lincoln pole, or Proud Raven Pole, a copy of which stands in Saxman Park near Ketchikan. It is a tall pole, with the figure of the Proud Raven at the bottom. At the very top of the pole, higher than the Tlingit Raven crest, is the figure of Lincoln—an exceptional honor. It was raised in Tongass village in the 1870s. The Gānaxa'dî Ravens and the Kā'gwantān Eagles were constantly fighting with one another, raiding villages, and taking slaves. This was not a feud, "but warfare aimed at driving out or exterminating another lineage or family in order to acquire its lands and goods" (Drucker, 1955: 148). The more powerful Kā'gwantān were determined to destroy the Gānaxa'dî Ravens so they increased their harassment. They burned the village and the people were forced to flee and take refuge on another island where there was little food or water and no shelter.

The Kā'gwantān waited for the surrender of the Gānaxa'dî Ravens. But it so happened that a small fort and custom house was built on Tongass Island by the U.S. government and a revenue cutter, Lincoln, was assigned to patrol the area. The revenue cutter, with soldiers aboard, was near the island where the people had taken refuge. They signaled the cutter and asked for assistance, and they were given food and water and taken to a small fort. The two tribes made peace, and to commemorate the event and three chiefs, one of which was Chief Ebbits, sealed the peace with the erecting of the pole and had a Tsimshian artist carve it.

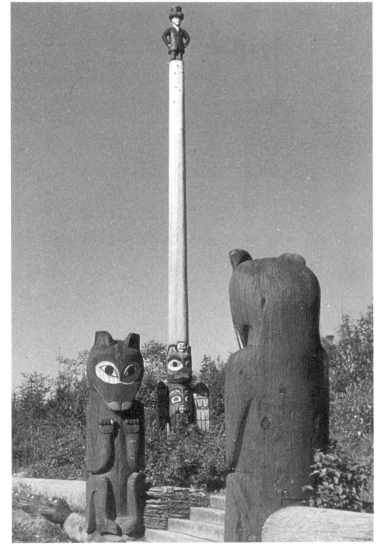

President Lincoln Pole. This is a copy of the original pole done during the C.C.C. restoration period. The carver who replicated the pole is an unknown Tsimshian artist. Saxman Totem Park, Saxman, Alaska.

117

RIDICULE POLES

Shame or ridicule poles were another nineteenth-century innovation. Saving face was of utmost importance, and damage to clan honor, suffering a public indignity, or failure to redeem an infringement of Tlingit law brought on serious consequences—but transferring it to a totem pole was an unique factor in the acculturation process of the Indians.

Tribal justice was explicit, exact, and precise. A person was held responsible not only for the act of wrongdoing, but also for the honor of the clan and lineage lines. If the guilty party was not available for punishment, then one of his kinsmen of equal rank would step forth and become the surrogate for atonement. He would come forward singing and bravely dancing a ritual dance as he met his accusers. There was no detachment of a remote court system with its levels of appeals. Tlingit justice was swift and revenge was keenly calibrated. Tribal law demonstrates redress in most expert fashion. Honor had to be maintained for both the opposing groups, and lineage honor was upheld at all costs.

REVENGE/GRAVE POST

Joséph Wherry describes a grave post at Kake that was also a ridicule pole in his book The Totem Pole Indians. The late classic period pole no longer stands and can be seen only in photographs. A carving of a white man, clothed in Western attire, sits at the top of the pole and is said to be a Russian. Beneath him is the figure of a Tlingit Indian whom he murdered. Beneath the Indian is the Raven, the crest of the murdered man, and beneath the Raven is presumably a halibut who, if properly identified, presents a dilemma in that the halibut is a Wolf crest. What it represents on a Raven moiety pole is unclear. The grave post was standing in Kake in a photograph taken in 1890. All that is really known for certain is that the post stood as a grim warning of the retribution expected by the man's clan—demanding the blood of a white man for wrongfully slaying their clansman.

Drawing of the Revenge Pole/Grave Post Raven. The carver is unknown. Kake, Alaska.

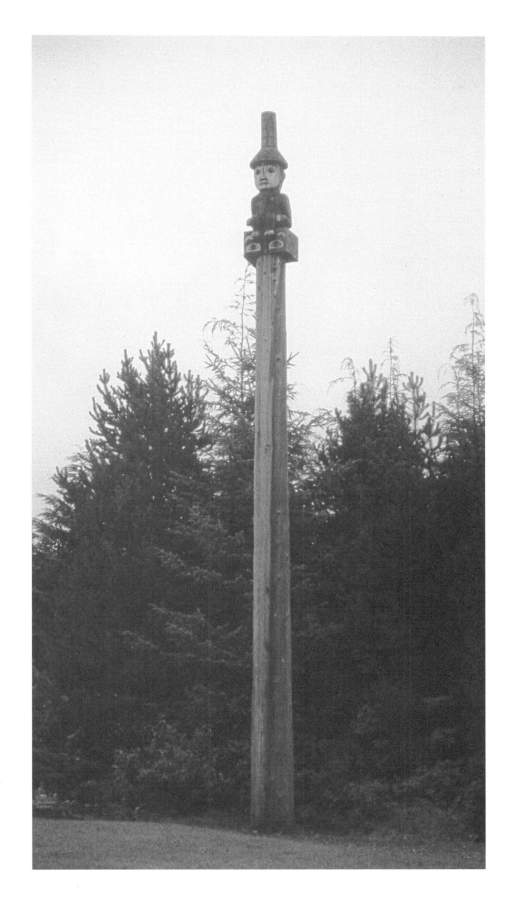

The Ridicule Pole of the Secretary of State. This is a restored pole during the 1930s by the C.C.C. restoration project. The carver is unknown. Saxman, Alaska.

SHAME/UNPAID DEBT

A carved pole at Shakan, owned by the Dog Salmon people, shows a salmon resting on the arms of a bear. Shakan is an abandoned village of the Henya Tlingits, and the pole has now completely disintegrated. Viola Garfield explains its significance:"It was set up as a public record of a debt owed the Dog Salmon people. A bear belonged to the Chilkat Kā gwantān house group whose member had borrowed twenty copper shields and a slave from the Dog Salmon people for a potlatch. They were slow in repaying their debt" (Garfield and Forrest, 1948: 147).

The Dog Salmon people take their lineage from the story of a young boy who was out playing on the beach with seagulls. He grew hungry and went to his mother for some food. She gave him a piece of dry salmon. He threw it down and said, "Why did you give me moldy salmon?"

He returned to the beach and found a seagull in his snare. As he tried to get his snare out of the water the lad was pulled under by a salmon and taken to their village. He was brought to their chief's house, which he recognized by the painted crest on the outside, and though the people were salmon they looked like Tlingits. They gave him the name of Moldy End. While there the boy began playing with the children. Again he became hungry and his new friends told him to club a salmon. The boy did, and cooked it and ate it. He disposed of the bones but overlooked one small bone. When he returned to the chief's house he noticed the chief's son had suddenly become ill. The companions of the boy said, "Go look for the bone you left behind and throw it in the water." He did as he was told and found the bone by the fire and threw it into the water. Immediately the chief's son became well.

During the spring spawn of the salmon Moldy End returned with them to the creek. It was the same creek where his parents lived. His mother saw a large dog salmon jumping and told her husband to catch it. The man speared it, and as she began to cut it up, she found her son's copper necklace. She and her husband sadly laid the salmon on a cedar bark mat, and placed it on top of their house. As they did, the dog salmon was transformed into their son. He told them all of his experiences; and thus their descendants took the dog salmon as their crest in memory of the event.

Drawing of the Shame Pole of the Dog Salmon People. The carver is unknown. Shaken Bay, Alaska.

DISDAIN FOR A DIPLOMAT OF A SOVEREIGN NATION

Another interesting ridicule pole is one that is called Secretary of State pole. The original was carved sometime after 1869 and a copy now stands in Saxman Totem Park. It is a tall slender pole with the figure of a white man dressed in Western attire sitting on a carved chest. He is wearing a ceremonial hat to indicate that he is an important person of some nation. On this pole he represents the former Secretary of State, William H. Seward. He visited Alaska in the summer of 1869 and great homage was extended to him. He was given many fine carvings, a painted wooden chest, furs, and an important crest hat of Chief Ebbits of Tongass. It is said that furs were spread out for him to walk on. On his return to Washington he did not extend appropriate acknowledgement of his gifts nor did he attempt to respond in a similar way with invitations or gifts to Chief Ebbits. He showed a great breach of etiquette, and so this very stark pole was created with no embellishment. Quite simply the figure of the Secretary of State is sitting selfishly on the carved box he was given. The pole was erected to shame him and to remind Tongass people of his barbaric manners.

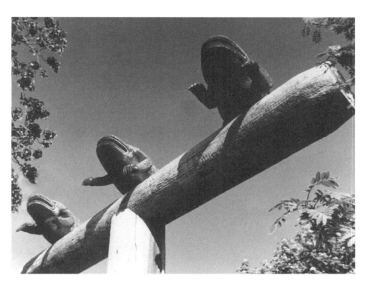

The Ridicule Pole The Three Frogs. The original was carved during the late classic period and was restored by Joe Thomas in the 1930s. It has now fallen to the ground and will be repaired or replicated. Shakes Island Totem Park, Wrangell, Alaska.

Photo: Alaskan Images; photographer Ivan Simonek of Wrangell, Alaska.

RIDICULE/SOCIAL RESPONSIBILITY

A copy of a ridicule pole called the Three Frogs was carved in the mid- or late-nineteenth century. The late Joe Thomas made a copy of it around 1938-40 during the Civilian Conservation Corp restoration period. Until recently the pole stood at Shakes Island in Wrangell near where the original stood, but it blew over during a severe storm and now lies on the ground. A replica of the pole was erected in June 2000. It is a Raven pole and so the Raven moiety was involved in its dedication. The guests of honor were the descendants of Chief Kadishan, still living in Wrangell, who represented the opposite moiety, the Eagle. It is a small, T-shaped totem pole, plain except for three frogs sitting on the T bar. It is the story of three women of the Kîksa' dî tribe who cohabited with three of Chief Shakes' slaves. After a time Chief Shakes of the Nanyaā'yî clan grew tired of feeding the women and putting up with the difficulties their presence caused. He requested payment for their care from the Kîksa' dî people. The chief refused, saying that the three women were no longer the responsibility of his people and that they, the Kîksa' dî people, would not accept them back. "So Chief Shakes ordered the three frogs to be carved and erected to ridicule the Kîksa' dî chief whose major crest was the frog. As he put it, three frogs for three no good women" (Wherry, 1964: 20).

MODERN POLES IN TRANSITION IN THE LATE TWENTIETH CENTURY

POLES WITH MODERN TRIBAL AFFILIATIONS

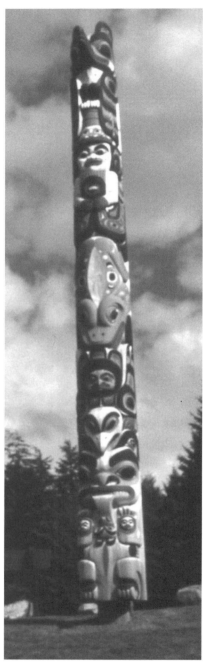

Standing in the Sitka National Historical Park, near the main entrance to the park, is the 36-foot Haa leelkk'u has Kaa sta heeni deiyi Pole. The name translates to "Our grandparents who were the very first people to use the Indian River and the other people who were here too." The Southeast Indian Cultural Center commissioned the pole to honor the first Tlingit people to settle in the area and to proudly depict the unity of all the Sitka Tlingits. In doing so it combines crests from both Raven and Eagle moieties. A true rarity! Master carver Will Burkhart and apprentice Tommy Joséph, both of Sitka, and Master carver Wayne Price, of Haines, carved the pole in 1996. The erecting of the pole was, as always, followed by potlatch and celebration.

> The top figure is the Raven, below the Raven is a human figure representing the first people to settle Sitka. The figure wears a Kîksa' dî crest hat and holds two Coho salmon, representing two of the clans honored by the pole. The third segment of the pole is the frog, which is the crest of the Kîksa' dî clan. The next figure represents all the Eagle Clans. The bottom figure is the Brown Bear, representing the Kā'gwantān, Tcukane'dî and Wucketa'n clans. The mother bear's tongue touches the head of the little bear, passing knowledge from one generation to the next. (Knapp and Meyer, 1979: 29).

The Sitka National Historical Park is a stunning park situated along Sitka Sound. Strolling through the forest one encounters some eighteen poles, three of which are Tlingit and the others exquisite Haida poles. Some are restored while others have been replicated. Inside the Park Service building are two groups of original house posts from two different Sitka Kā'gwantān Clan houses. Three are on loan from the Gooch Hít House and date from 1904. They were carved by Anaxoots for what was to be the last great potlatch in Sitka (or at least, that was Governor Brady's assumption). The four others are on loan from the Eagle Nest House (both houses are the Wolf Moiety) and are said to be over 200 years old.

Haa leelk'u has Kaa sta heeni deiyi Pole. Carved in 1996 by Will Burkhart, Wayne Price, and Tommy Joséph. Sitka National Historic Park in Sitka, Alaska.

Photo: The National Park Service, Sitka National Historic Park in Sitka, Alaska.

122

In the early part of the twentieth century, shortly after the end of World War II, the practice of erecting mortuary poles or grave posts for individual gravesites began to wane. This occurred because of the considerable expense involved, the ever-present threat of breaking the law and the Indians' growing acceptance of Christianity.

` In spite of these circumstances, the archetype of the shuka was far too deeply rooted within the Tlingit psyche to destroy it, and the spiritual experience of the transformation of the At.óow to an event in the distant past was too ingrained in the culture to cast aside and shatter the lineage lines that traced in a balanced ratio who they were and from whence they came. They desperately clung to this inheritance. It was all that remained, and the people could not tear away these last remaining vestiges and face the world naked of all transcendental experience, rupture from their lineages and sever their covenants with nature and the animals and the land. They had to sustain their heritage and affirm their historical past. The Tlingit would say, "I cannot destroy the Shuká nor deny the Shagóon of my lineage for they define me and without them I am a shadow."

The culmination of all this was the adoption of small grave houses with totemic designs and filled with grave goods for the long journey. Often the graves were fenced, and the fences decorated with clan crests. Chief Shakes V grave in Wrangell reflects this well, and throughout this book there are photos and drawings of many grave houses. Although not totem poles as such, they represent another manifestation of them, perhaps in their final cultural phase.

By the middle of the century the Tlingits began using gravestones as markers on graves. These small monuments continued to use the carving of the clan crest and the deceased Indian's name and lineage. The Indian cemetery in Atlin, British Columbia, sits high on a knoll overlooking Atlin Lake, quietly displaying grave houses, grave stones, white picket-fenced graves and unadorned shamans' graves. The Indian cemetery in Carcross, Yukon Territory, has the honor of being one of the National Historical Sites of Canada, and is another lovely burial ground. Situated on the edge of the village in a forested area on the shores of Lake Nares, the headwaters of the Yukon River, it silently guards the fenced graves and grave houses and headstones. The Tlingit people continue to use both cemeteries and bury their dead in the traditional way.

Grave houses from the early 1900s

TOTEM POLES COMMISSIONED FOR PUBLIC BUILDINGS

The two poles standing in front of the Nesbett Court house in Anchorage were commissioned. One pole is of the Raven who stole the stars, moon and daylight, and the other is the Eagle and the Giant Clam post. The latter pole depicts the legend about a young man who had an affair with one of his uncle's wives. This is a very serious offense in Northwest Coast cultures. The uncle discovers them, but does not kill the young man. Instead, he puts him in a bent wood box and set him out to sea.

A young woman finds the box washed ashore and discovers the young man inside it. She takes him to her clan house and when he awakens he sees scores of eagles flying into the house with fresh fish. The eagles take off their eagle cloaks and become human. He then realizes he must be in an Eagle House. When he regains his health, he wants to go hunting with the other eagles. The matriarch allows him, but cautions about a giant clam saying, " You will encounter him someday. The clam is stronger than you, so for your own good stay away from it!"

The young man becomes a very successful hunter, and one day when he is soaring about he sees the giant clam. He forgets the warning and dives down trying to catch it in his talons. The second time he dives down, the clam opens up and seizes him and pulls him down. The other eagles try to save him, but they too get pulled down by the clam. The matriarch hears their screams and, shaking her head she cries out, " The young man has found his clam." She puts on her tattered eagle skin and flies out to save them. Singing her special song, she manages to raise the column of eagles, and free all of them except the young man. She succeeds only in pulling his eagle cloak away. The young man is absorbed within the clam and dies.

Lee Wallace, the carver, said he sees the clam as representing social abuses and thought it was appropriate for the whole spectrum of people who pass through the court building. When asked, "Were these eagles or human beings?" he replied, "Who knows? Reality is very fluid in myths reflecting on the many transformations in the human psyche."

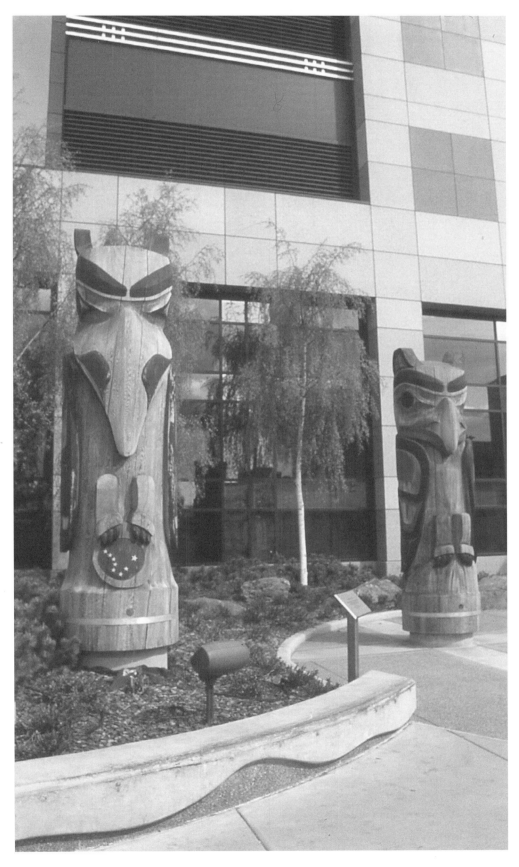

The Raven Pole depicting the raven who stole the sun, moon and the stars, and the Eagle and Giant Clam Pole. The plaque reads "Attain Within." Carved by Lee Wallace in 1996 for the new Nesbett Court House in Anchorage, Alaska.

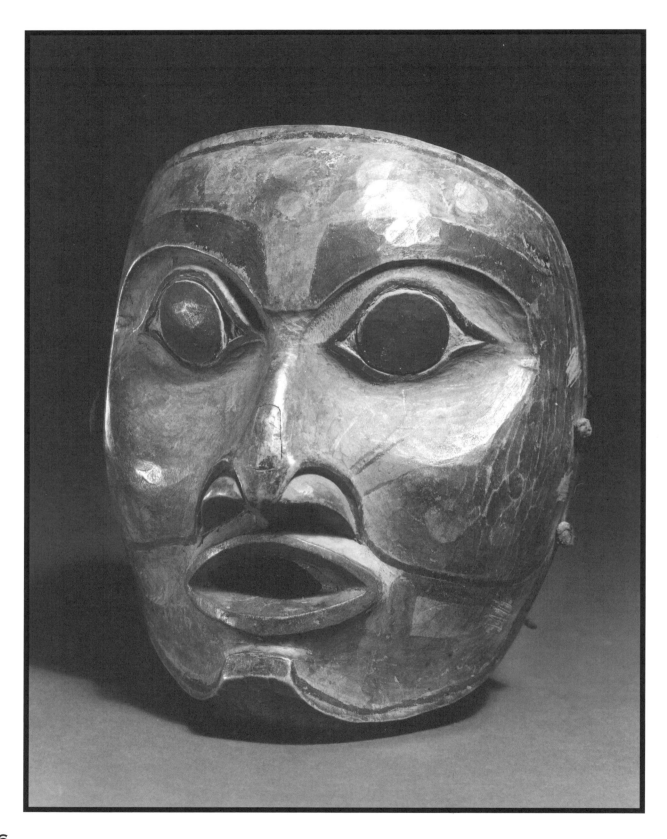

THE TECHNIQUE AND MEANING OF THE ART

WHILE THE OPPORTUNITIES FOR CARVING A TOTEM POLE increased because of the fluidity of status within the lineage lines and the introduction of new technology, the lineage crests and legends remained remarkably traditional and were faithfully portrayed according to the principles of formline design system. Indeed many of these conventional practices are still adhered to in modern times. The carvers continue to select the most suitable red cedar tree from the rain forest for carving the pole, but the modern techniques of cutting down a large tree, transporting it to a village, and the tools used to carve the pole differ greatly from pre-contact technology.

In pre-contact times the tree was felled by means of a heavy chopping stone adz and controlled burning at the base of the tree. The bark was stripped of its branches at the felling site. The immense log was then transported to a secluded place near the village for carving. Today many of the carvers work at totem parks and museums where they demonstrate their artistry to an appreciative public.

In the past, ropes of cedar bark and rawhide were used to convey the tree from the forest to the water's edge where it would be ferried to the concealed area. Tall red cedars do not grow north of 57° latitude. In the area of Klukwan, therefore, only a few yellow and red cedars are available

Opposite: **Shaman's mask, painted wood.**

Photo: Field Museum of Natural History, Chicago

127

and so the logs continue to be transported from southern Alaska or British Columbia for the poles of the Northern Tlingits. When the log reaches the carving site the bark is traditionally removed. Prior to modern tools, scrapers of rock or horn were used to remove the bark, and sanding was done by shark skin or sea lion skin. After this process it is necessary to split the log to give it a more linear surface on the posterior, or uncarved, surface of the pole. The old carvers forced a wooden or bone wedge into the grain with hafted stone mauls and wrapped ropes of spruce root about the ends to prevent splitting. After the bark was removed, the log, then as now, was divided in as many sections as there were figures to be represented.

A number of apprentices and skilled assistants cooperated in the process, but there was and continues to be the specialist, the artist, the master carver, whose creative genius and esthetic brilliance create the design. In the past this group was an integral part of the Tlingit cultural tradition. "The artist and the artisans working together within the traditional framework of their culture spent much of their lives creating material for ceremonial living. Working generation after generation they established a rich tradition in woodworking techniques combined with a distinctive art form to create many works of art, among them the totem pole" (Hawthorne, 1956: 29).

Despite great difficulties and many barriers, in the late nineteenth century the masters were able to pass their traditions on to their grandsons and great-grandsons. Today, from the capable hands of these modern carvers, totem poles emerge into artistic representations that continue to define the highly stylistic designs and abstract schematic accents of certain features of the creatures depicted. Within their micro-universe creatures split, disjoin, and appear on other creatures; profiles double; figures are represented upside down, become a part of another being, and are often simply reduced to a silhouette form that outlines the essence of the design. Illusory and realistic figures share equally in a domain where reality and myth coexist in negative and positive space, and portray, both philosophically and artistically, the significance of timeless legends.

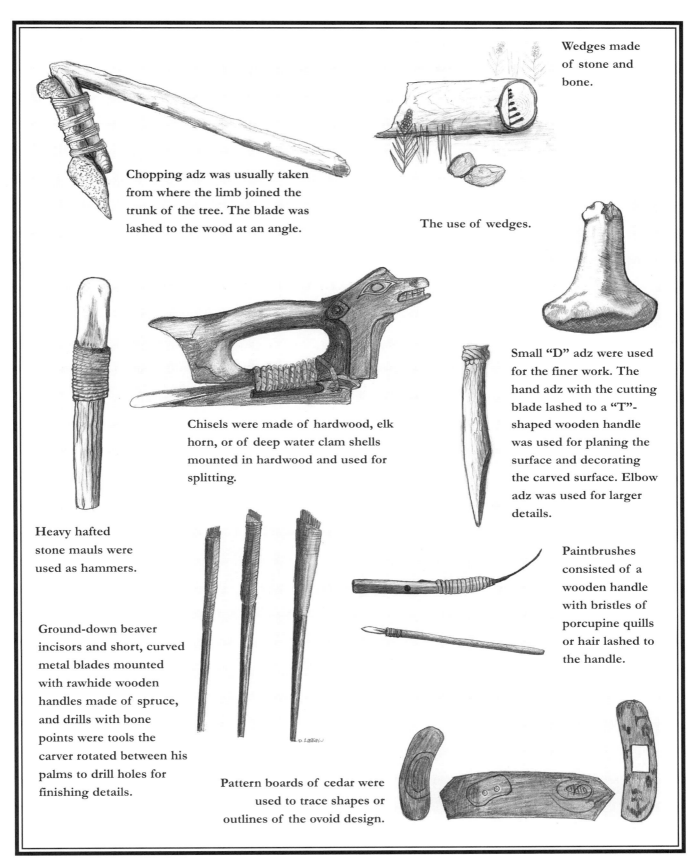

Wedges made of stone and bone.

Chopping adz was usually taken from where the limb joined the trunk of the tree. The blade was lashed to the wood at an angle.

The use of wedges.

Chisels were made of hardwood, elk horn, or of deep water clam shells mounted in hardwood and used for splitting.

Small "D" adz were used for the finer work. The hand adz with the cutting blade lashed to a "T"-shaped wooden handle was used for planing the surface and decorating the carved surface. Elbow adz was used for larger details.

Heavy hafted stone mauls were used as hammers.

Paintbrushes consisted of a wooden handle with bristles of porcupine quills or hair lashed to the handle.

Ground-down beaver incisors and short, curved metal blades mounted with rawhide wooden handles made of spruce, and drills with bone points were tools the carver rotated between his palms to drill holes for finishing details.

Pattern boards of cedar were used to trace shapes or outlines of the ovoid design.

Pre-contact tools and techniques used in carving a totem pole (Drucker, 1955: 58-64).

THE SIGNIFICANCE OF
THE TOTEMIC SYSTEM

Totemism is a method of organizing and reasoning for a society and, by its symbolic content, offers the basic structure through which sophisticated and abstract thought may evolve. The totemic system is a system of concepts and categories that provides the basic building blocks and elasticity to impose meaning on, and adaptation to, the world.

Throughout history every culture has had its own system of concepts and patterns to order and give meaning to the surrounding world. Totemic classification is but one method to define reality and man's place in it. It is a very old system and still in use today in many parts of the world, and is a very effective organizing system that offers avenues for complex thought and abstract thinking to evolve. A similar analytical system led to the great Neolithic age that began about 9000 B.C. in the Tigris and Euphrates valleys of old Mesopotamia (now Iraq) and led to the domestication of plants and animals, pottery-making, textile-weaving, and food preparation and storage. All modern civilizations are built on the developments of the Neolithic age.

The narrative logic of an animal, bird, or other figure does not represent all such creatures but involves a more specific representative. In other words the creature of the myth is a conceptual tool that can be both abstract and real. "What is significant is not so much the present of this or that level of classification as the existence of *a classification* with as it were an adjustable thread which give the group adapting the means of focusing on all planes from the most abstract to the most concrete, the most cultural to the most natural, without changing its intellectual instrument" (Lévi-Strauss, 1966: 136).

Anthropologists have developed sophisticated totemic models as well as a specialized terminology to describe kinship groups and systems. Even the smallest band society classifies. The complexity of the social world seems to require a simplification so that social groups can function and be understood.

A particular aspect of the Tlingit and all Northwest Coast cultures is the matrilineal clan organization that built kinship groups with cross clans within the divisions of the moieties, creating what is known as the exogamic marriage rule. Imposed within the clan system was a thread of flexibility that allows clan status to be raised, thus giving pliancy to the

culture. The totemic system was further expanded to accommodate mythical geographic sites in actual areas and designate spirit and crest names for existing topography. The native people regard this "as a historical landscape, and the whole countryside thus becomes the Indian's living, age-old family tree"(Streblow, 1968:31).

The paradigm assumes the multi-dimensional form of a prism in order to demonstrate the interlocking of social groups within the network of their environment, thus creating a solid unity and reinforcing social cohesion. The resulting totemic structure is composed of systems within systems, which provides the means for achieving a balanced and meaningful view of the world. "It is a conceptual tool with multiple possibilities for detotalizing or retotalizing any domain, synchronic or diachronic, concrete or abstract, natural, or cultural" (Lévi-Strauss, 1966: 149).

When the basis of the Tlingit philosophical thought is unknown, as with a casual Western observer, the totemic system seems not only incongruous, but appears as a rubbish heap of superstition and taboos. Totally unaware of the profound cognitive thought processes underlying it, they fail to see it as the Tlingit paradigm for living in the world. Westerners' deeply encoded linear system, "which focuses on salient objects or people, uses attributes to assign them to categories and then applies formal logic to understand their behavior, is a very deterministic and simplistic view of the world." (Nisbett, 2003:xiii) Thus it is not surprising that they always find it a bit jarring when they come upon other forms of reasoning, such as the American Indian, whose thinking is in a more circular than linear pattern. Tlingit thought is drawn to the perceptual field as a whole and to relations among objects and events within that field, and by dialectic reasoning seeks the middle way between opposing thoughts and events. It is fundamentally holistic, less divided into categories, and the form of formal logic developed from Greek thought does not exist as such.

The totemic animals used on their crests as designations for lineage lines are not prohibited or forbidden to be made use of in daily life. The Tlingit trap beaver and otter, fish for salmon and halibut, and hunt bear and wolves; and in the past they wore fur garments, spun wool of mountain sheep and goats, used the hooves of deer for drinking cups, and the beaks of puffins for decorations on their clothing

In the Tlingits' seasonal rounds, however, animals, birds, and fish are treated with great respect and regarded as worthy and equal adversaries. The Indians express a kind of chivalrous bond or a form of obligation toward wildlife and the land. This great admiration for the animals' skills

and qualities is bound in a totemic sense with a profound awe of the land from which they all share subsistence. The overwhelming attachment of the Indians for their ancestral lands does not lie in its great beauty, its potential for profit, or its representation for social status. Rather, as Strehlow so profoundly expresses it:

> The mountains and rivers and inlets are, to him (the native), not merely interesting or beautiful; they are the handiwork of his ancestors from whom he himself has descended. He sees recorded in the surrounding landscape the ancient story of the lives and deeds of the immortal beings whom he reveres; beings who, for a brief space, may take on a human shape once more; beings, many of whom he has known in his own experience as his fathers and grandfathers and brothers, and as his mothers and sisters. The story of his own totemic ancestor is, to the native, the account of his own doings at the beginning of time, at the dim dawn of life, when the world as he knows it now was being shaped and molded by all-powerful hands. He himself has played a part in that original rank of the ancestor of whom he is the present reincarnated form. (Strehlow, 1968: 30)

This integration of mystical elements with the land is seen in the three rocks in the Stikine River representing Lq!aya'k and his brother and sister, in Sitka Sound where Raven rocked his canoe, in the person of the glacier on Chief Kahl-teen's memorial pole, and the promontory of land on Kicks Bay where the Kîksa dî camped on their migration from the Nass River, and is the site from where they derived their name. These are not only a part of the oral history they also a part of the totemic structure, and, as such, are represented by clan crests.

The beauty of their logic lies in the abstract power of the lineage crest figures and how they are transposed to give pattern and structure to the society and answer the universal question of man's place in the universe. The drama of their art, meanwhile, alludes to the ever challenging dilemma of what is reality by deftly opening other dimensions and transforming the world in which they live. The power of the lineage crest…*Khà shuká* is indeed profound.

Paint pestle.

PRE-CONTACT PIGMENTS

"Color was the great unifying characteristic of the art" (Holm, 1965: 26). The principal colors were red, black, greenish blue, yellow, and white. The pigments were made from fungus, moss, berries, charcoal, cinnabar, lignite, and white, red, and brown ocher.

Black pigment was prepared from a mixture of charcoal or graphite, hemlock bark, and sulfur, and boiling the mixture in salt water. The trailing rootstocks of horse tail were also used for black. White was obtained from baked clamshells. The greenish blue color was made by soaking pieces of copper rock in urine, and yellow was developed from a mixture of wolf moss and ocher. The red dye was obtained from ochre and by steeping alder bark in urine. The pigments were mixed with salmon eggs, forming a tempera paint and then were wrapped in cedar bark. According to Francis Paul, each color had a name, "red was known as 'the-sky-at-sunset,' yellow was called 'the color of the yellow warbler,' and greenish blue was named 'the color of the crested jay bird'" (Paul, 1944: 18).

THE CARVING AND THE USE OF FORM AND SPACE

The uniqueness of Tlingit art is the artistic adaptation of form, space, and narrative into a highly stylized formline design system, the placement within the restraints and controls posed by the object to be carved, and the tools and pigments available. This requires great ingenuity on the part of the artist. A finely carved totem pole displays the mastery of this technique and skill by containing the focus within the internal design by a seemingly effortless distribution of weight and balance while allowing the external projection of the sculpture to create the drama of the legend. In doing so, it unites the dichotomy of reality and mysticism within the totem pole as realism dissolves into mythical symbolism by: "Stylistic representation as opposed to a realistic one, schematic characterization by accenting certain features, splitting, dislocating split details, representing one creature by two profiles, symmetry, reducing and the illogical transformation of details into new representations" (Holm, 1965: 8).

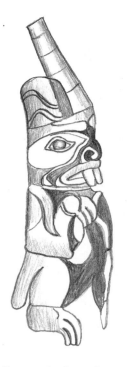

Beaver design taken from a carved spoon.

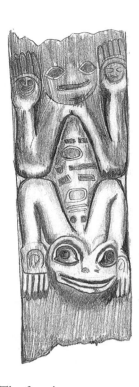

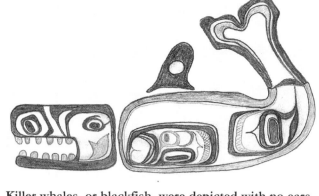

Killer whales, or blackfish, were depicted with no ears, a blowhole, and a very important dorsal fin often decorated with ovoids. The dorsal fin is placed to conform the design to the space. The mouth is square, showing many teeth, and the nostrils turn upward toward the forehead and are large and elongated. The eyes are round, and the general shape of the head is high and elongated. Drawing taken from house-front painting.

The frog is characterized by a wide toothless mouth and a very flat nose and no tail. Design from a wooden comb.

Both the eagle and the golden eagle are portrayed with a large curved beak that ends in a sharp point. Drawing of the golden eagle on the crest hat of the late Chief Johnson of Tongass.

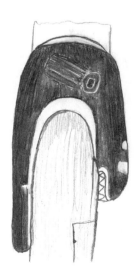

The dogfish or mudshark is portrayed with a square head, a large drooping mouth with many sharp teeth, round eyes, and a miter-like design rising from the forehead. Lines on the cheeks represent gills, and lines on the miter are wrinkles; the curved lines on the forehead to the mouth represent nostrils, and the tail may appear above the head forming the body of the pole.

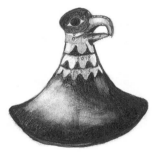

The hawk is similar to the eagle but has a more pronounced beak that literally touches the chin, and in many cases, the hawk has a human face. The drawing is taken from a ceremonial mask.

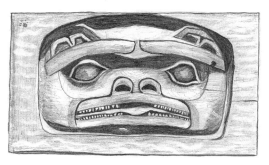

The raven has a long straight beak and is often portrayed with outstretched wings. Drawing taken from a dancing rattle.

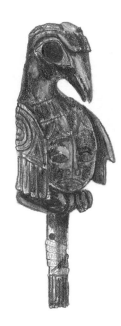

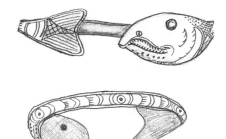

The bear is usually shown with teeth bared, ears pointed. He has a wide face with a protruding tongue and a large, round nose that turns abruptly upward. Drawing taken from a carved box.

The salmon has a large head with lines for gills at the base of the head, round eyes and a curved mouth with the nose turning down. Drawing taken from a carved silver bracelet.

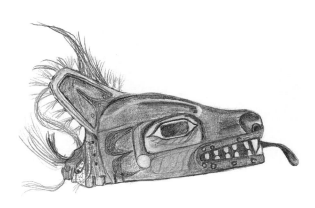

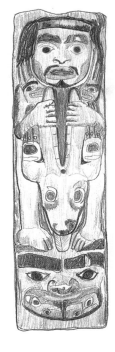

The sea lion has large teeth, a round nose, eyes near the nose, and small ears. Drawing taken from Dukt!ū.L! Hít yìgâs'i (house post) of the Whale House in Klukwan.

The wolf is shown with an elongated nose, long slanting eyes, pointed ears that lie back, and a mouth with many teeth. Design taken from a ceremonial mask.

The land otter has a wide mouth, flat head, slender legs, paws, and a tail. Drawing taken from a shaman's grave house.

The vision of the artist is transformed into a meaningful cultural reality by using distinct and characteristic Northwest Coast designs, such as ovoids, U-forms, secondary U-shapes, positive and negative relief area juncture lines, split Us, tapered eyelids, double U-shapes, hatching lines, trigons, angularity, and color to create a formline design system that follows very formal rules. It is often simply referred to as the formline system.

> In essence the system provided that the creatures be portrayed by representing their body part and details with varying broad formlines which always joined to present an uninterrupted grid over the designed area. The body parts were stylized in forms consistent with the semi-angular, symmetrical, non-concentric qualities of formlines. Certain uniform shapes resulted, the most obvious and recognizable being ovoids and U forms of different sizes and proportions. Formline joined one another in a limited number of juncture types, which were designed to permit smooth transitions form one formline to another to avoid the increase of design weight at the junctures. (Holm, 1990: 607)

The technique often represents a creature in sections by spreading a section of the body along the curved front of the pole, and then splitting the rest of the animal and carving it on the sides of the pole (hence the term split representation). Alternately, a realistic form of the animal might be used, but added to it is another figure of an animal in silhouette form appearing, for example, on the wings of a Raven, the dorsal fin of the killer whale, the paws of the bear, or the breast of the beaver.

Within the formline system points of tension are created at the corners of the ovoids when other formlines merge into them. The balancing of these tensions in the design is the key to holding the force together in a rhythmic movement, and involves superior technique and artistic skill. Achieving this balance makes the totem pole a work of art. "In two dimensional art, a flowing line usually begins as a fine narrow line and swells out, then returns to the narrow line. This line may trace the outline of the form and then become part of the form itself. This technique provided a rhythmical movement in decorated areas and emphasizes planes and contours of the wood sculpture" (Inverarity, 1950: 42).

The tertiary area that results from the carved out spaces created by the Us, split-Us, tapered eyelid, double Us, and inner and outer ovoid, defines the very complicated grid of varying tapered, fine lines, and thick form-

136

lines that create the feeling of movement in the positive and negatives areas. "Not only does the form grow into form, but lines flow into lines. The simplification obtained by making one form line flow into another is a simple movement very evident in the sculpture particularly of a sine feature in which the shoulder flows with pleasing simplicity into the upper arm" (Inverarity, 1950: 44).

The artists are very accomplished in controlling positive and negative forms and thus controlling or manipulating the negative spaces with complete mastery by joining lines together and overlapping, using ovoids and U-forms with absolute control to accentuate the positive space. A release from the two-dimensional to a three-dimensional design is expressed by a change in the composition of the design and with the addition of beaks, wings, or snouts. All this conveys an effect of balance within the total design so that the viewer's interest is constantly held within the universe of the design.

Textured materials, such as copper, ivory, bone, hair, fur, rope, and inlays of abalone shell were used, *but most important was color.* In sculpture, the color in the tertiary, or the recessed area within the U-forms and ovoids, is greenish blue. The positive broad formlines representing the animals' body parts were painted black while the secondary or negative space of the larger carved-out areas around the positive formline were painted red (in contemporary times this can vary). Hatching and dashing produced differentiating techniques in tertiary, secondary and primary areas that gives relief from the concentric and non-concentric lines. They create an effect of shadows, and when the pigments are used, they act either to change the shades of the coloring, or to give the effect of transparency thus creating the impression of richness and intensity.

Hands and feet, although often placed in an abstract position, tend to represent those of the actual creature being portrayed. The hands are depicted with the palms in a dorsal position and the fingers extended; the treatment of the thumb and its position to the hand can vary in at least half a dozen positions. Claw appendages are usually depicted with two large claws and one adjacent claw in a non-parallel position to the others. All three claws are shown in varying degrees of flexion and usually treated with secondary color.

The art thus manages to convey for all its great intrinsic detail a feeling of simplicity because of the artist's mastery of unifying the primary formlines with secondary and tertiary space to form a continuous pattern in the design. The formline technique is combined with the use of pigments and texturing by both materials and cross-hatching in the wood to

Above: **A drawing of ovoid templates (Holm, 1965: 31).**

Below: **A drawing of eyelid and U templates (Holm, 1965: 39).**

A drawing of the typical U complex with semi-angular curves. The B and U complexes with soft curves are not characteristic of archaic Northwest Coast design but are seen in later periods. C is a split U with an outline (Holm, 1965: 42).

produce effects of light and shadow in the color. Shifting to another dimensional design allows the artist to create subtle transitions of space and depth. The flow of movement continues further in the sculpture itself from one creature to another, often transforming into a part of another figure or becoming human, turning upside down, and finally blending into the background of the pole and transforming into the function for which the pole was made. "The Indian artist was so skilled that no square inch of the most elaborate distributive design was left to chance; but every form, positive and negative fitted without strain into the whole pattern and every element conformed in all its parts and relationships to the system" (Inverarity, 1950: 72).

THE TRANSCENDENTAL EXPERIENCE OF THE AT.ÓOW: THE ENDLESS KNOT

The totemic art not only encompasses a fluid dimensional universe but contains varying levels of significance among the individual art pieces. This is quite apart from the artistic elegance that the non-Indians admire but are prevented from experiencing because they are not encoded in the cultural patterns and therefore cannot transcend the boundaries that would permit them to enter into the transformations of thought, the paths of spiritual power, and the world of mystical beliefs that the carved objects imbue. Limited by ethnocentrism, non-Indians judge the art only on their own terms, and in doing so they miss the compelling significance of the art as a ritual object and its ability to transpose reality, elicit visions and release time. In an esoteric sense that is where their beauty lies, and that is what they cannot see. "A work of art over time in Tlingit culture achieves a status, and become an At.óow which literally translated means *an owned or purchased object,* but its significance extends far beyond this phrase to embody *our way of life ... our culture ... life itself*" (Dauenhauer, 1995: 2).

The At.óow is so interwoven into time that it really means all that was and is and will be. It is the knot of eternity. The transcendental experience of the intangible is evoked in the reality of the At.óow, in that it links the living to the dead, the mystical past to the present and reaffirms the covenants with the animals, the spirits, and the land. By synthesizing these abstractions, the At.óow expresses unity and wholeness that signifies the philosophical basis of the Tlingit way of life, balance and reciprocity, and

is the core of their religion. Scholars of Eastern religions have noted the similarity of North American Indian religions and the Bon religion, the animistic pre-Buddhist religion of Central Asia and Tibet. Bon is probably the oldest living religion in the world. It is still actively practiced in Asia and in the last decade has been introduced to the Western world.

The At.óow is an image that alludes to a critical moment in time, often involving a great personal sacrifice, and functions as a symbol with multi-faceted links to myth, spirits, and the land. Within the ritual context where the At.óow is most often used, it evokes a transcendental awareness of the Tlingit metaphysical world and reflects it as a living reality.

There is a conceptual fluidity in the At.óow that is so typical of the Indian non-linear pattern of thought in that the crests can represent other realms, portray figures of the spirit world, Raven's adventures, mythical creatures, and human encounters with animals, while other crests may portray existing mountains, promontories of land, actual events, and living animals and sea creatures as they really appear. Both views can exist together because when you live on the land for millennia, the land itself becomes filled with meaning. Stories, mythical and legendary, as well as personal memories, fill the landscape with a meaning that an outsider cannot possibly comprehend. Time and space could be defined as circular and thus *so-called* reality can exist wherever you focus on the circle.

The At.óow has a dual persona in that, in and of itself, it also has validity. It exists. It is an art object and a crest and is owned. It has value and collateral and can be relinquished to the victor in war or forfeited to the family of a slain victim. It is honored across moiety lines and is respected by other sovereign Indian groups. It is a teacher for the children and identifies them with their lineage and genealogy. It is a legacy to pass on, and as such must always have a caretaker upon whose death it passes to another worthy steward. An At.óow is an immensely complex symbol that solidifies Tlingit beliefs much like a complex equation explains a phenomenon in the distant universe, through the use of symbolic numbers that make it a reality. Tlingits, meanwhile, substitute the medium of art to perform these complex transformations to define their universe. Perhaps this is why strangers, sensing a more complex meaning in the art, find the art form so intriguing and mystifying.

Closely related to the At.óow are Shagóon and Shuká, names for the concept pertaining to ancestors. Each word has a different shade of meaning in relation to its contextual significance within the concept and *time*

within the lineage acts as the catalyst in effecting these interchangeable relationships. Shagóon refers to ancestors or living kin. The conception of Shuká is more encompassing and extends its dimension to the future generation in its transformation to the At.óow and the intangible world symbolized by the crest (Khà shuká). The Dauenhauers, who have written eloquently and extensively on this subject, explain it more succinctly:

> The Raven design is a Shuká of all Ravens. If a wooden Raven hat is made by a specific person or a clan, and brought out at a ceremonial and paid for, it is an At.óow. "Kaat's paid for the bear design with his life, and it is an emblem of the T'eikweidí. Kaat's is also Shuká, and he is Shagóon (biologically) to the children of T'eikweidí clan who use the bear crest on their At.óow.
>
> In Glacier Bay history (hāa Shuká) the woman who remains behind and is killed by the advancing glacier is a Shagóon of the Chookaniedí clan. She is also Shuká and At.óow on specific art objects. Moreover, the glacier and the icebergs are also At.óow because the woman paid for them with her life. In fact, icebergs are called Chookan sháa (Chookaneidí women) for this reason. The songs and the stories are the property or At.óow of the Chookaneidí clan. (Dauenhauer, 1995: 27)

The name "We Shakes," the splash of the whale's tail as it enters the water, was the At.óow of the Niska people that a Nanāa' yî chief of Wrangell won as a trophy in a victorious battle with the Niska. The Woodworm crest is a possession of the Gānaxa'dî, and there was a special mask representing the woman who suckled the woodworm. Ganùk, from whom Raven obtained fresh water is an At.óow of the Ravens of Chilkat. Kadjuk, the fabled Golden Eagle is the crest of the Kadjuk house of Tongass. The Tr!it (murrelet), a small bird that makes a whistling sound belongs to both the Daql!awe'dî and the Kā'gwantān. The Daql!awe'dî also claim the Killer Whale.

Steve Brown summarizes all of this so simply and poignantly. "All these qualities are in an important way separate from the mere outward appearance of any particular piece of what outsiders call art" (Brown, 1998: 140).

ORIGINS AND CHANGES IN NORTHWEST COAST ART

The origins of Northwest Coast art began long ago and have developed richly through time. The Western world was introduced to the art form in the late eighteenth century, and somehow the art has become encased within this perimeter of time. However, its complexity, composition, and drama, and the sheer abundance of the art objects existing in the eighteenth and nineteenth centuries imply that the art has evolved over a long period of time. "The depth of development indicated in Bill Holm's study *The Northwest Coast Art: an Analysis of Form,* indicates the elaborate system of forms and conventions were certainly not invented overnight, nor even in a single century" (Brown, 1998: 4).

Since the 1980s, research from various disciplines has been able to shed more light on the development of the art form. Archeological discoveries by MacDonald and Carlson have uncovered fragments of a basket dated 5,500 B.P. in a cave in British Columbia. Its structure and design is not unlike baskets made by Tlingits some 5,000 years later. A Tsimshian handle fragment, beautifully carved, was found at the Lachane site and is dated 2,000 B.P. Later, at the same site, which is near Prince Rupert, archeologists found a collection of bent wood boxes, bowls, canoes, and paddles dated between 2,520 B.P. and circa 1,700 B.P. Two excised bone artifacts with dates of 700-1800 B.P. were found at a Kwatna, and at another site in British Columbia a carved bone comb dated 800 B.P.-1000 B.P.. was found.

There continue to be tantalizing discoveries of pieces to the puzzle with the findings of more archeological relics that further define the early forms of the Northwest Coast art. A tool handle carved in the Northwest Coast tradition, and dated 2,770 B.P. was found at Makah, near Neah Bay on the Olympic Peninsula, an area that is part of the core of the Northwest Coast culture. "We glimpse from these artifacts the embryonic beginnings of the historic northern two-dimensional style, the stages of an evolutionary concept that could be termed *Proto-Northwest Coast art*" (Brown, 1998: 4).

Bill Holm followed the art's path to the museums that have collected some of earliest objects beginning with the Pérez and Malaspina voyages, and the collection at the Museo de America in Madrid. He continued on in his search to the Museum of Anthropology and Ethnology in St.

Petersburg. He then made comparative studies on artifacts with known dates in other museums, and by making meticulously detailed comparisons of all the art objects he had studied, he was able to note two millennia's worth of changes in the art.

Artists, art historians, tribal art authorities aided by the great Haida artist, the late Bill Reid—the first living Native artist to have his works displayed in the *Musée de l'Homme* in Paris—and Bill Holm developed an analytical paradigm to explain the developmental periods of the art. It is a highly complex analysis of the variance in the patterns varying from thick heavy formlines to fine, thin formlines, the percentage of positive and negative design elements in the art, the rudimentary or lack of two dimensional design, complexity of the formlines, and line junctures. "By sorting out the oldest objects from those that have been made in the 19th century and later we can identify stylistic progression that can assist in attributing undocumented artifacts to comparable time frames" (Brown, 1998:5).

The progression of the different periods in the evolution of the art are documented and analyzed by Steven Brown, carver, artist, and assistant curator of Indian Art at the Seattle Museum of Art, in his book *Native Visions*. The brief outline that appears on these few pages is only a synopsis of the periods of development of Northwest Coast art with emphasis on the northern style as appears in his book.

I Proto-Northwest Coast Art Period 2000 B.C.-1200 A.D. It is defined "as the northern style in its conceptual infancy. It is the beginning of the evolution of the path of the art" (Brown, 1998: 9). Artifacts display incised circles, crescents, trigons, and minimally incised negative areas. Representative of this period are the bone comb, possibly Tsimshian, dated 800 A.D. and the tool handle found in the Makah area and dated 750 A.D.

II Late Prehistoric Period 1200-1750 A.D. "This is a broad period of exploration and development when new ideas were added to the core elements of the Proto Northwest Coast Art" (Brown, 1998: 25). Analysis of artifacts notes the lack of many tertiary lines, and the depth of the lines, when they are present, appear simple and shallow, while the formlines are wide and very positive. Representative of this area is a Tlingit bent wood box, dated from the 15th century. It was collected by George Emmons and is now housed in the American Museum of Natural History. It reveals small carved-out areas, no inner ovoids and is archaic and simple in style. Another chest or container, assumed to be three hundred years old, displays minimal carved-out areas and, again, the old archaic simplicity. A

Haida grease bowl, dated 1700 and collected by Captain George Dixon in 1778, represents the older styles with its minimal carved-out areas. There are carved wooden ladles and sheep horn spoons from this period that also show the small and minimally carved-out negative areas.

III Early Historic Period 1750-1820. The historical voyages of Juan Pérez and Alejandro Malaspina occurred during this time. The art is elaborate and complex, abalone inlays are used and the evolution of more highlighting is evident. There are more positive spaces and the treatment of the design by the use of pigment appears and acts as a catalyst to differentiate the formline. "The conception of the opposite color tradition represents one of the most significant departures from the more elemental concepts of Proto-Northwest Coast and those of historic central coast Salish art styles" (Brown, 1998: 15).

The original house posts of Chief Shakes' house were carved during this era circa 1775 by Kadjisdu.āxch' II. The ivory charm representative of a small sea bird was dated 1750 and was collected by Commander Juan Pérez in 1774. The bird has the minimally thin incised lines as is typical in the older artifacts, and the positive formlines are more pronounced. The addition of U-shaped designs representing wing feathers and the outline of the checks begin to show the development of the northern-style formline embellishments. A Tlingit war helmet, dated 1750 and collected by Malaspina in 1792, continues to display tertiary areas and negative relief crescents as thin and shallow, and much of the surface of the helmet is unpainted. Both of these pieces are now in the Northwest Coast collection at the Museo de America in Madrid.

IV Early Classic Period 1820-1865. The changes noted in this period are many and varied. "They are based entirely on the concepts of color, space and formline structure so evident in the two-dimensional art created in and before the eighteenth century. The new directions taken by the Native artists in the decades of the ensuing period (especially between 1820 and 1870) transformed the pre-contact Northwest Coast tradition into a complex and elaborate system during this period" (Brown, 1998: 48).

The development of the art accelerated rapidly because of the contact with Europeans, new materials, tools, ideas, and the challenges that confronted the carvers, as well as the weakening of the old hierarchy controlling the tradition. Formlines lighten so that positive and negative design areas are largely equal. The secondary design becomes more elaborate and the primary structure more complex. The artists created inno-

vations by exaggerating the non-parallelism of the horizontal formlines and the concentric placement of inner ovoids "The bi-level positive-negative structure of the Proto-Northwest Coast styles gave way to new multilevel conceptions of design space" (Brown, 1998: 68). The artists began to produce larger poles and in greater numbers. "The most significant difference between Proto-Northwest Coast objects and the fully developed northern tradition is the conventionalization of the inner and outer dimensions of the positive forms" (Brown, 1998: 25).

The house posts in the Whale House of Klukwan, carved by Kadjisdu.āxch II, represent the very beginning of this era. Swanton's drawing of the mortuary pole at Hoonah that he copied from an earlier sketch by Krause is probably from this period.

V The Late Classic Period 1865 to 1920. "During these decades the most significant conceptual innovations that have been incorporated into the northern formline tradition made their appearance" (Brown, 1998: 99). These artists were inventive and imaginative and stretched the tradition to its limits, reflecting the uncertainty of their time. It was a time of intense social pressure resulting from the negative position of the colonial government against the potlatch and their ban against clan houses. While the international connoisseurs were collecting art pieces, the carvers had to clandestinely make objects for their own tribal potlatches, and discreetly carve special objects for the clans. It was a period of great movement and at times brilliance. The formlines were much thinner; there was a simplification of design and an animation of the images. The red secondary formlines and somewhat broader black formlines often gracefully combined with the red on top of the black; and the negative areas began to dominate the design.

Charles Edenshaw, a Haida artist, was one of the outstanding figures of this era. He adapted the formline style to other media, such as argillite, ivory, glass, and silver; and he split the formlines, carved animal figures in a more natural way than the formal representations of previous times, and in his woodcarvings he created deeper dimensions by more undercutting. Other artists turned to free form and asymmetrical design, stretching the traditional cord to its limits. The Davidson brothers, who were also Haida, carved during this time, as did Toya.aat, the Tlingit artist from Wrangell, who carved until he was killed in battle in 1880. The artists were innovative and masters of the technique, but it was Edenshaw who carried the art to a lightness of being and balance. Many of the totem poles that appear in this text are from this time or are copies of original poles erected during this period.

VI Bridging Generations: The Art in the Mid-Twentieth Century, 1920 to 1965. "The levels of skillful craftsmanship, artistic vision and imaginative development of the art form that were common in the previous periods were not truly equaled again until the last two decades of the contemporary period" (Brown, 1998: 139). It was a very difficult time for the native people of Alaska. There were many fine carvers who strove to keep the tradition alive, and they were often very much alone and unrecognized in their endeavors to save the art from dying. They made heroic efforts to carve while struggling to earn a living by fishing commercially, working in canneries, in mines and in logging camps. Important carvers spanning the nineteenth and twentieth centuries were Mungo Martin, Willie Seaweed, and Henry Hunt, all of whom went underground for long periods, and bravely carved for potlatches despite risking jail sentences by breaking the law in this way. George Benson of Sitka and Dan Katzeek of Klukwan were prominent Tlingit carvers. John Wallace, a Haida, was the lead carver for the Civilian Conservation Corps during the totem restoration project in the 1930s. "The traditional styles that distinguished the classic period survived more completely in terms of sculpture than in the two dimensional traditions" (Brown, 1998: 144).

VII The Contemporary Period 1965. Bill Reid, the great Haida carver well deserves to represent this era. In 1948, at age 28, he decided to follow in his grandfather's footsteps and began carving. The era began with him, but not because of him. His entry into the field was simply as an artist in synchrony with his time, a time that marked the beginning of the rebirth and development of the art tradition. By 1960 an explosive revitalization had begun, and the Indians on the Northwest Coast were carving in the tradition of their forebears. Sadly, both Mungo Martin and Willie Seaweed died at the beginning of the advent of this era. Robert Davidson, the great grandson of Charles Edenshaw began carving. The late Jim Shoppert, a Tlingit from Juneau followed in the path of his grandfather. Israel Shotridge, a Tlingit, chose to follow in the footsteps of his uncle Charlie Brown, a carver in the 1930s, and Israel's brother, Norman, soon joined him. Reggie Davidson, brother of Robert Davidson, began carving. Marvin Child, the great grandson of George Hunt who was the ethnographer for Boas, became a carver. Tony Hunt, a Kwakiutl followed in the footsteps of his grandfather Henry Hunt, and became a carver.

"The tradition continues to expand and develop as it did in the last two previous centuries" (Brown, 1998: 162). John Hoover, an Aleut artist born in Cordova in 1920 and now living in the state of Washington is one

of the most creative and avant garde of all current Alaskan native artists. Familiar with all forms of Alaskan native art, John Hoover brilliantly adapts innovative changes to the traditional art forms. Other artists have introduced new media and borrowed from all periods and regional traditions in order to create new visions of ancient ideas. Susan Point, of Central Coastal Salish, casts glass from an iron mold then etches it and combines it with wooden accents; others cast in bronze, copper, and concrete and experiment with many different materials. They are radically changing the negative design fields, reversing the whole color system, blending flat designs with three-dimensional features and making revolutionary changes in curved lines, massive lines, and fine line junctures.

The talented and imaginative carvers in both Alaska and Canada have their art in museums in Europe and the United States, in private collections, and in public buildings. Among the Northern group of carvers are Nathan Jackson, Dempsey Bob, Israel Shotridge, Lee Wallace, Will Burkhart, Tommy Joséph, Wayne Price, David Boxley, and Jack Hudson. Boxley and Hudson are both Tsimshians. All are master carvers with their own distinct styles and have apprentices working with them. Non-native artists, because of their great interest in the art and the culture, often work with native carvers on projects and participate in workshops.

THE RAISING OF A TOTEM POLE

Each procedure in the preparation of the totem pole was and is carried out with painstaking care. Every task is thoroughly completed before the next step is begun. Felling a large cedar tree and transporting it overland or by sea, sometimes for considerable distances, carving it and finally erecting it often took several years; even in contemporary times it is not an easy task. Delays were, and continue to be, unavoidable. Prior to the present century owners needed time to gather their resources and the expenditures were made in installments. The raising of a totem and the accompanying potlatch could be several years in the making and, because a great deal of capital was required, might involve barter and trade with Haidas, Tsimshians, and Kwakiutls for articles.

In previous times the pole was carried or rolled over logs by workers and slave helpers in the presence of the dignitaries and their guests. Ropes of cedar bark and babiche were attached to the pole and placed over the leverage log. The honored guests grasped a few selective ropes

and, at the proper moment, they strained with the workers to raise the monument. The trench was then filled in, the ropes cut away, and the totem pole stood in place. Directed by the song leader the people burst forth in a song composed especially for the pole. The event still follows a similar protocol but modern equipment is used to move the poles and there are no longer slaves.

Commissioning and raising totem poles began again in the late twentieth century, but is no longer as an individual or family effort, for it is far too costly and there is no longer a Hít s'à tí or clan house. It has, instead, become the primary responsibility of a clan, or more often than not a group of clans in a village, to carry out the event. This has happened in Sitka, Angoon, Klawock, and Ketchikan.

It continues to be a united effort and Tlingits come from other villages and towns to participate in the event. People wear whatever regalia they may still possess, and there is dancing, drumming, feasting, oratory, and gift giving. The raising of the totem pole is still a very important event and one marked with great dignity and decorum.

More recently, public buildings in the state have commissioned and erected totem poles to convey an Alaska motif. The Alaska State Government building in Juneau has an original Haida totem, in Anchorage the Nesbett Court House has a grouping of three poles carved by Lee Wallace and the Home for Homeless Veterans has two poles carved by Nathan Jackson and his son. There is a totem pole carved by Dempsey Bob in front of the Library in Ketchikan. An original Tlingit totem pole—over 100 years old—from Tuxekan, on Prince of Wales Island, stands in the foyer of the the Anchorage Museum of History. The atrium of the Southeast Alaska Visitor Information Center in Ketchikan holds several poles, one of which is the very modern double moiety crest pole by Israel Shotridge. In contemporary times the poles have been erected for many occasions, ranging from the restorations at Chief Shakes Community House in Wrangell, the Native Brotherhood's pole to honor their ancestors at The National Monument Park in Sitka and the State of Alaska's recognition of Tlingit art by placing pieces in state or public buildings. Whatever the occasion, it is always cause for celebration and follows a highly structured protocol that includes oratory by dignitaries and tribal leaders, and the bestowing of Tlingit honors such as a great name or adoptions into the clan for those deemed worthy of receiving of them. The last song is sung as the pole is raised, and is followed by the speaker rapping his carved staff for silence, and then the chief begins his formal oratory.

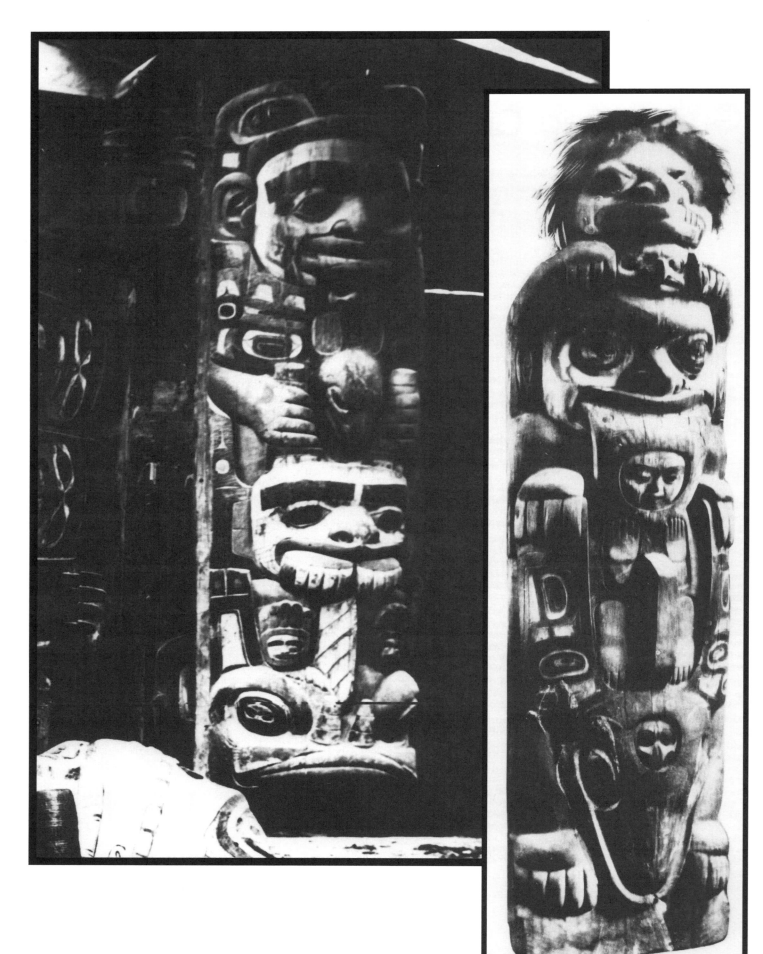

THE FATE OF
THE ARTIFACTS

THE EARLY PERIOD OF THE
COLONIAL GOVERNMENTS AND
THE ART COLLECTORS

O N 14 DECEMBER 1898, SIX TLINGIT CHIEFS AND TWO OTHER
Tlingit leaders traveled to Juneau, Alaska, to meet with the
Governor John Brady and Frank Grygla, a special agent for the
General Lands Office, to discuss the problems of the Indian people of
Alaska. The record of the meeting is presented in an edited format. The
source document is located at the Anchorage, Alaska, sub-depository
office of the National Archives, Interior Department, Territorial Papers,
Alaska. The interpreter was George Kostrometinoff.

Chief Kah-du-shan from Wrangell spoke first and said:
"We have lived in Alaska long before the white men came.
When the Russians came we traded with them, but they
did not build stores. Then Captain Smith came and told
us the United States had purchased our land. Soldiers
came and businessmen followed, then fur trappers and
gold seekers, canneries got built, and then we began to
lose our lands. When we complain about it, the white men
hire a lawyer and go to court and win the case. We are not
fish; we wish to live like other people. We are very poor
now, and the time will come when we will not have any-
thing left."

Opposite page: **Artifacts from
the Whale House have whetted
the appetites of art collectors
for years. The Raven post (left)
stood beside the Woodworm
post (page 64). The Gunakadeit
post stood at the right of the
doorway beside the Duck-toolth
post (page 66).**

Photo: American Museum of Natural History
(left) and Royal British Columbia Museum (right).

Chief Yash-noosh—grandfather of Awêi' x and great grandfather of Gaanash Shoo (Gloria Williams)—also known as Chief Johnson of The Taku Tlingits followed the chief from Wrangell and began by saying that he agreed with all that Chief Kad-du-Sham had said. He then continued:

"We have not been able to talk to you for a long time. We have not said anything to you since the Russians lived in this country. All of my people would like to say something to the governor. We are perfectly willing to share this country Alaska to you. We know this is our country. How long we have been here we do not know, but for a very long time.

I do not know whether the lawmaking people at Washington get any pay. We do not know anything about the United States law, the law that the governor knows. Things that I am saying now did not used to happen in the olden days. The government now sells the land. Our people had simple patches of ground raising vegetables and places where they could go fishing and creeks where they would fish. We want you to give them back to us ... We did not know that the Russians sold this country; of course, we know it now. When the American soldiers came to this country that was the first time we heard that this country was sold by Russians. The Indians in the United States made a great deal of trouble for you about land. We never made any trouble. We love you as friends.

The Thlingits are getting poor because their ground is taken away from them. We ask you to return to the Thlingits the places that brought us food. If you refuse to do that, then our people will starve. My friends and I have come here for the purpose to tell you what we want for our people, so you can tell Washington. We have not talked to you for a long, long time, and now we feel compelled to talk to you because white people are taking all those places away from us. Places where we used to make food. I would like to say more, but my friend Chief Koogh-see wishes to speak also."

Chief Koogh-see, representing Hoonah, continued much in the same manner pleading for understanding.

"My people get arrested and go to court for breaking the law. What is your law? Why are the missionaries teaching our people against our own ways? We have always lived here and thought Alaska belonged to us.

Our ancestors lived here and had the possessions of different creeks, lands, and bays. Not very far from this place where I live is Lituya Bay where our ancestors used to go hunting for sea otter and hair seals. Now that place is taken away from us because many white people go there in schooners and scare the sea otter away. Now there are no sea otters.

I have seen nice homes and gardens in Seattle and Tacoma. Supposing I tell my people here to go with me and burn certain grounds and destroy all their goods and shoot their animals?"

Chief Kah-ea-tshiss from Hoonah followed and continued commenting on the same subject:

"My friend who just spoke speaks the truth. We used to go to a place called Lituya Bay and get a lot of sea otters for making clothes. Now we kill very few. The white people drive the sea otter away. I feel very bad the way white people treat us. I would like to tell them to pay us for the ground. When a man goes into a store and buys different things, he does not take those things for nothing and leave the store. But then when we tell the white people to pay for the ground, they refuse to make payment and say all this belongs to Washington and we have nothing to do with it."

Chief Shoo-we-Kah from Juneau spoke next. He was accompanied by two men, one named Charlie and the other named Jack Williams. Both were Tlingit leaders from Douglas Island near Juneau.

"We are at a loss to know what to do. I know that down below (the States) that if a man possessed a certain property and another man comes along and wants that property, he pays for it. We paid for everything in this house and take good care of this house. And in the different villages here, our people take good care of it and see that no one

151

interferes with it. I never stopped the white men from coming to this place, and I never stopped them from cutting timber. Everything I possess I gave to the white people. Now I am an old man and have nothing left. The canoe rocks and we do not know what will become of us."

Chief Ah-na-tlash from Taku was the last Chief to speak:

"I have lived a good many years. I am an old man now. The Russians used to live here in Sitka and never treated the Tlingit like they are being treated by the white people now. They take the ground from us. When Vice President Adlai Stevenson [Grandfather of Adlai Stevenson III] was here, I went to him and complained how the Tlingits were treated. When we have trouble with white people about the ground, they get angry and want to fight us.

Now the salmon come up the Taku River, and these spring salmon our people get for food. Now the white people come early in the spring before the ice breaks to catch fish there. There is no store, and Taku people make their living catching salmon.

The white people here sell our ground to other white people, and we have a great deal of trouble about it. I ask you to put a stop to it."

Governor Brady's address to the Tlingit People at the Pow-Wow in Juneau, Alaska, 14 December 1898, which Fred Moore interpreted for the Tlingits, included the following statements

"I am glad that you are thinking, but what I have heard here tonight, it is in my mind to say that there is trouble ahead for them if they entertain such notions as they have expressed here.

When the United States bought this country from Russia, they paid $7,200,000, they made a treaty, or a law, between the United States and Russia. The Russian people regarded the Tlingits as savages, as sort of wild men, who could not be trusted. Now the United States has treated them kindly and proposes to treat them well."

Governor Brady was probably referring here to The Treaty of Cession, and the phrase "The uncivilized tribes will be subject to such laws and regulations as the United States may from time to time adopt in regard to aboriginal tribes of that country." The Russians had established schools for the Tlingit children and translated books into Tlingit. Furthermore, the Russians, like the French and Spanish, were far more successful in genuine racial assimilation

> "It is nearly twenty years since I saw the Thlingit for the first time. The Indians had few cabins and clothes. It was seldom that they had one pair of shoes. They sold furs for molasses. There was a murder every week. Now they are better off. I know that Yash-noose has handled more money and has been more of a man than his uncles."

Governor Brady was most certainly exaggerating about the incidence of murders—although drunken brawls and fights were indeed a weekly occurrence.

> "I often think a wrong was done to the Thlingit; it was not until 1884 that the United States made civil law for Alaska. I am afraid the Thlingit are entertaining notions of how much land they own. Right here they need a little instruction. Koogh-see has been down below and seen fruits and vegetable gardens. But he is not thinking rightly. Those places he saw were the results of a great deal of work. The men had to do all the labor. Now, if any Thlingit goes and does likewise, it is the duty of every official to see he is undisturbed.
>
> The United States has so far sold little ground here. We have mining laws, but other laws aren't in force yet. The Indian can't claim the whole district. Shall we take the different tribes and place them on the large island and let them live by themselves and not have some agents to keep them straight? Or do you wish to obey the white man's laws and have all the privileges that he has? Which do you want?
>
> This is plain talk. I understand wrongs have been

done. Now, so far as what Koogh-see says, one of his ancestors sold all that Lituya Bay area country to the King of France, and by the bargain of his own ancestors, he really has no right to it. The Thlingit never hunt in such a way as to spare the young."

According to Ted Hinkley's account in *The Western Quarterly Review*, this reference to the legality of the French purchase of Lituya Bay was questionable, to say the least. Clearly the governor was engaging in the kind of disputation learned from years as a district judge.

"I was very glad to see the Hoonahs. They are nice, clean people. One of the things that has helped them is the missionaries have gone among them and taught them. But as a people, they have not had any pride, for they allowed their girls to be bought by every white man that has gone up there. It is difficult for nice, young, healthy men to get a good, healthy wife, and they have to take women for wives who have been living with white men and are diseased. Such men as Yash-noosh and other chiefs are to blame. I know that from Sitka fifty girls have come over here and died here. Many of their parents come with them and took them around to the miners and tried to sell them. Now, if they continue such things, they are a doomed race.

Mr. Waldsley says if the Indian workers persist in getting drunk, he will have to ship in Chinamen to do the work, or the fish will spoil. Now, I do not want the Tlingit to tell me they are poor and cannot earn a living in this country. Every Thlingit can earn a living like I can.

I propose to help them all I can. If they want to become United States citizens, then I will advocate that. If they do not want that, and want to be put on an island by themselves, I will do that. They can see I am in earnest. I am not fooling with them; I am telling them the truth."

Governor Brady's derogatory reference to the uncles of Chief Yash-noosh is an insult to Tlingits. He also did not address the Chiefs by their titles as Chief. This is disrespectful in Northwest Coast etiquette. The Federal Land Officer Frank Grygla's address that followed was brief.

He also shared the same interpreter, Fred Moore, a Tlingit.

> "It was eight years ago when I first met the Thlingit. I returned to Washington and impressed the lawmakers that the Thlingits should not be confused with the Indians of the Western states. Governor Brady has always considered the Indian the equal of white men if they could be educated and cared for.
>
> After eight years I am astonished to return and see what the Thlingit have accomplished. Now if you want to take advantage and advance yourselves, all of the officials and missionaries will help you.
>
> You must decide yourselves whether you are to be classed as aborigines like the wild men of the West. You must think for yourselves and decide whether you want to be American citizens or want to live with your old customs. I am the official agent sent by the government to look after several matters, and the governor kindly assists me to see to it as the head of the government for Alaska that we have the evidence to report to Washington on this question."

A year later Chief Yash-noosh pleaded with the Chairman of the Senate Committee on Indian Affairs for the rights of his people. "I have come a long way from my home to see you and tell you of the condition of my people. I was sent here by the chiefs of the principal tribes to represent them, and I have brought with me a petition signed by them" (Miller and Miller, 1967, 207).

Needless to say, his address fell on an apathetic Congress, careless about the assimilation of Indian lands and communities by settlers and business enterprises and who further condoned the very actions by an arm of the federal government, the Department of Interior, whose whole aim was the liquidation and dissolution of Indian tribes. While Congress overlooked the plights of the Indians of Alaska, and other nations of the world took little or no interest in their welfare, it certainly did not overlook their art.

THE ART COLLECTORS

Beginning with the Russian occupation and increasing during Baranov's sojourn in Sitka, a great amount of items were collected—masks carved with spirit figures, coppers, armor consisting of vine maple slats and painted with crest designs and lashed with babiche, wooden crest hats, war clubs, carved chiefs' staffs, carved and painted wooden storage chests (the famous bent wood boxes), mantles of buckskin painted with crests and trimmed with fur and porcupine quills, and robes of martin skins. These are now on display in the St. Petersburg Museum of Anthropology. At Yakutat Malaspina collected wooden trays, ceremonial dishes that represented the Raven, ceremonial masks representing seals and birds, masks depicting human faces with tattoos and movable eyes and decorated with hair and teeth, garments of moose skin with painted crests, trimmed with rows of bear claws and fur and puffin beaks, painted wooden boxes, ceremonial garments of mountain goat hair dyed black and yellow and trimmed with mink. This collection is housed in Madrid in the Museo de America.

Captains Cook and Vancouver took, bartered, bought, or were given as gifts, many artifacts such as carved war helmets (often represented with animal crests), helmets with protective neck collars, complex masks of birds or animals with movable tongues and wings which were used in dramas, daggers with babiche lashings with carved handles representing bear or wolf heads, carved canoe paddles, food boxes and feast dishes. All these items found their way to Europe and were sold.

The Russians, during their occupation, were more interested in exploiting Alaska's natural resources than in exploration voyages, and from their settlements based in the Aleutian Island and Kodiak Island they built up a lucrative trade with China in Alaskan sea otter pelts. In the eighteenth century sea otter pelts became a commodity as precious as gold, and the enterprising Yankee traders saw them as way to enrich both themselves and their nation's struggling economy (England had embargoed American ports and Europe had little or no interest in American crude goods). "In 1778 the first Ship laden with trade goods calculated to appeal to the taste of the untutored Indians sailed from Boston" (Miller and Miller, 1967: 96). It arrived on the Northwest Coast a year later and marked the beginning of the American sea otter trade that lasted until the close of the war with Great Britain in 1815. "Their ships were able to sail as far as St. Elias which tacitly marked the northern extremes of Yankee

trading, and beyond this were the Russians" (Miller and Miller, 1967: 109). The Yankees were ingenious traders who went so far as to barter with unnecessary ship items as they filled the hatches with sea otter pelts. They were not oblivious of Tlingit artifacts and added to their booty of sea otter pelts painted drums, chilkat blankets, war rattles, carved dishes, spoons of sheep horn, shaman sticks, and gambling sticks. The pelts were sold in Canton, China; and tea from China and artifacts from Alaska were taken back to Boston.

The Hudson's Bay Company, a British company with offices in London, received its charter in 1670, supposedly to explore for the Northwest Passage. With the British acquisition of Canada it became a major player in the fur trade in Canada and the Northwest Coast (and it continues to operate stores in Canada today). It was in an excellent position to barter with the Indians on the Northwest Coast for furs, and at the same time collect interesting tribal items. At every village where they bought furs, representatives of the company collected button blankets, dancing aprons of mountain goat wool, dancing hats with carved crest designs, war clubs, carved halibut hooks and lures, baskets of spruceroot and red cedar bark, wooden floats carved in the forms of animals. The traders gave or sold these items to interested parties; and all in all, rich hauls of treasures were taken back to museums in England.

Ships' captains continued to add to the hemorrhage of artifacts both for themselves and friends until the late 1830s when there occurred a unique development of museums devoted solely to ethnographic collections. This type of museum began in St. Petersburg in 1837, and continued to expand rapidly in the Western world for the next four decades. The Smithsonian Institute, created by an Act of Congress in 1846, as a result of a bequest by an Englishman, was an integral part of this movement. Spencer Baird was appointed Assistant Secretary of Collections in 1850, and worked diligently for more than thirty years to gather, build up, and enrich collections for the Smithsonian Institute.

In 1863 Baird issued a circular to members of the army and navy, U.S. Medical and Technical Corps, Indian agents, and other individuals stationed in Indian Country stating, "It is especially important to make immediate collections as almost everything has value in giving completeness to collections" (Miller and Miller, 1967: 239). With the purchase of Alaska in 1867 the circular was forwarded to the U.S. army officers attached to the command of General Davis in Alaska. It was augmented by a letter to Vincent Colyer, Secretary of the Board of Indian Commissioners, just before his departure to Alaska stating, "The duty of

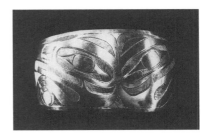

Silver bracelet, modern.
Photo: Canadian Museum of Civilization

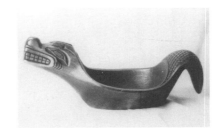

Beaver dish.
Photo: Canadian Museum of Civilization

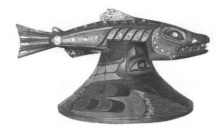

Salmon headdress.
Photo: Canadian Museum of Civilization

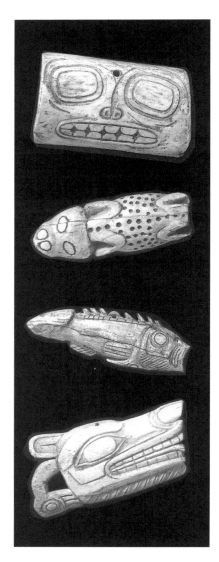

Ivory carvings used by Shaman in healing ceremonies.

Photo: Field Museum of Natural History, Chicago

Opposite: **Salmon fishing charm, painted wood.**

Photo: Field Museum of Natural History, Chicago

this country to collect and preserve all the relics possible of the races-of-men who have inhabited the American Continent" (Cole, 1985: 13). Naturally, as a good citizen, General Davis responded to the plea, and he returned from his tour of duty in Alaska with crates of excellent material from Alaska's Northwest Coast. A group of army, navy, and revenue service personnel agreed to collect for Baird. However, much to his chagrin, one officer sold his collection to the Peabody Museum at Harvard. Within a few years this group had acquired entire collections of chests, screens, daggers, pipes, hunting implements, wooden crest hats (painted and inlaid with copper and abalone shell, decorated with hair and adorned with a capes of ermine skins trailing down to the floor), war shirts of moose and walrus hide and war clubs of whale bone. These eventually found their way to the National Museum in Washington, D.C., or to the Peabody Museum at Harvard.

James Swan, a teacher at Neah Bay Indian School, also saw the circular and made contact with Baird. He was well acquainted with the Northwest Coast and had good relations with the Indians and knew how to trade and barter. He formed a close alliance with Baird and became one of the major collectors for the Smithsonian Institute. His acquisition on behalf of the Smithsonian for the Columbian Exposition in Philadelphia in 1875 was undoubtedly impressive. Swan proudly boasted, "I can safely say that I have the most extensive and valuable collection of Indian curiosities that were ever collected in the Northwest Coast" (Cole, 1985: 27).

Dozens of crates were shipped to the Smithsonian Institute and the contents were purchased for next to nothing. They included dancing skirts trimmed with puffin beaks, ornate potlatch dishes, shaman's rattles and dancing rattles, wooden crest hats, spruce root hats painted and trimmed with sea lion whiskers, shell dentalium and beads, hair, armor of double layered buckskin painted with crests, stone tools consisting of hand hammers, stone pile drivers, "D" adz, elbow adz, carved shamans' rattles, house posts and totem poles.

In 1873 the Pinart de Assac expedition from France appeared on the Northwest Coast to study the natives and collect for Musée de Boulogne-sur-Mer. The director of the Imperial Natural History Museum in Vienna, and a representative from Amsterdam, also visited Swan, and, like Pinart, implored Swan to collect for them. He refused since he had been commissioned and was being paid to collect for the Smithsonian.

The Reverend Sheldon Jackson was appointed Presbyterian Superintendent of Missions for the Western States in 1875, and was instrumental in sending missionaries to Tlingit villages. He was an avid

collector of artifacts and instructed his missioners to collect for his alma mater Princeton. While working tirelessly to make Indians and Eskimos discard their pagan ways, he acquired a magnificent collection of their masks. An exhibition of Alaskan masks compiled in 1996 by Dr. Anne Fienup-Riordan entitled "Our Way of Making Prayer" contains many of the masks he collected. He became the U.S. education agent in Alaska, a position that created further opportunities to acquire artifacts, and he was often in serious competition with Swan. Ironically, although he never lived in Alaska, he created lasting effects there in both education and religion.

Two brothers from Germany, Auriel and Arther Krause, arrived in 1881 and spent the winter in Klukwan. They represented the Breman Geographic Society and were instructed to carry out ethnographic studies of the Tlingits and collect interesting objects. In that same year Johan Jacobsen was sent by Bastian, chief of ethnology at the Berlin Museum für Völkerkunde to collect ethnographic material, "and in his extensive travels his assembled Northwest Coast collection totaled 2,036 catalogue entries which probably included, at least 2,400 pieces" (Cole, 1985: 66). In 1886 he took a group of Bella Coola Indians to Leipzig to give demonstrations and dances. They traveled to Berlin where Bastian and his staff did extensive interviews. This whetted the appetites of European collectors, and they came from Amsterdam, Paris, Dresden, Stockholm, and Cambridge to collect. The Canadian government became greatly alarmed about all the foreign collectors and set barriers and restrictions against exportation of such material. Baird and Swan were offended over these actions, but they really could not complain about Canada protecting its own territory. Instead they promptly wrote a letter, hinting for more money, to the speaker of the House of Representatives and informed him, "Amply provided foreigners were carrying away American materials—almost in shiploads—to foreign museums" (Cole, 1985: 37).

The Canadians became more and more concerned about the plundering of their indigenous art and entered the market aggressively in the early l880s. Mercer Dawson, a geologist with Canadian Geological Survey, became acquainted with the Haidas while working on the Queen Charlotte Islands and began to collect for both Ottawa and Montreal. He met Israel Powell, the Federal Indian superintendent for the West Coast of British Columbia, and suggested to Powell that in his capacity as Indian Superintendent he might be able to collect interesting items on his visits to Indian villages. Powell was initially sanguine about the idea, but he soon became aware of the profitable aspects of his position. He

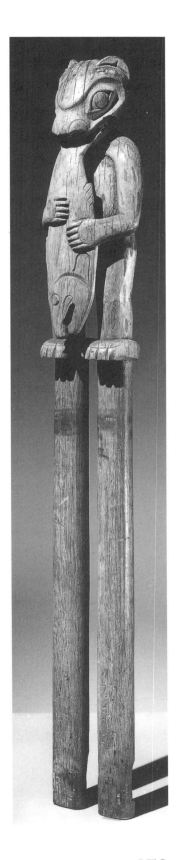

enhanced both Ottawa and the recently (1869) opened American Museum of Natural History in New York with major collections of valuable artifacts. These included many things from Chief Shakes in Wrangell, a sixty-five-foot canoe, totem poles, war clubs, ceremonial curtains, elk hide armor painted with clan crests, shaman's rattles and spirit masks, a chief's ceremonial seats, wall screens, and crest hats and coppers.

The American Museum of Natural History's coup not only incensed the Smithsonian it also established Alaska as a rich treasure house of bounty, and native areas were parceled out to individual specialist with orders to collect. Representatives from foreign museums came and vied with each other to obtain artifacts for their museum collections, while the American groups struggled clandestinely not only to outmaneuver one another but their foreign counterparts as well. Thousands of items were thus removed. Beginning in 1867 and continuing until 1900, there was a wholesale exodus of Northwest Coast artifacts. "The smell of collecting was in the air and it turned into something more than a casual accumulation of Indian curios when world art authorities were called upon to evaluate the art work" (Miller and Miller, 1967).

Lieutenant George T. Emmons was posted to Alaska aboard the U.S.S. Adams, placing him in close contact with the Tlingits. Since childhood he had been exposed to ethnological collection and in his naval career sought out collecting wherever he was posted. Fortuitously for him, his ship escorted the *New York Times* Mount St. Elias Expedition on the Northwest Coast.

> Someone made a great find of some boxes in the grave of a medicine man. That evening two sacks full of material were spread out on the floor of the Captain Nicholl's cabin: among other things, a quantity of painted wooden masks, a leather shawl ornamented with puffin bills, and a crown of wild goats' horns. Someone else had bought a small charm or soul catcher. Professor Libby preserved a large share of the booty for Princeton, and it can only be assumed that Emmons, an old friend of Libby and perhaps the sagacious discoverer of the find was able to keep a share of the material. (Cole, 1985: 87)

This whetted Emmons' appetite, and from 1882 to 1887 he scoured the Northwest Coast for tribal items. In 1888 the American Museum of Natural History received his significant collection of some 1,284 artifacts; among them were totem poles that were often cut in half to facilitate shipping.

Lt. Emmons was selected by President Theodore Roosevelt to inquire into the needs of the Indians because of his (Emmons') great interest and appreciation of Tlingit Indian culture as shown by his excellent accounts of the Whale House in Klukwan and of Indian tribal customs in Alaska. During his journeys to Alaska, Emmons collected so much of their art that most of the museums in the United States were indebted to him for parts, or most of, their Northwest Coast collections. Artifacts were shipped to the American Museum of Natural History, the Chicago Field Museum of Natural History, and the United States National Museum. Items such as dancing staffs, song leaders' staffs, parts of house fronts, shaman grave houses and carved burial boxes, chilkat blankets, and button blankets decorated with red and dark blue flannel and pearl buttons forming crest designs, silver bracelets hammered out from silver dollars and gold bracelets out of gold dollar pieces and etched with clan emblems, hair ornaments, carved combs, ivory hairpins, and carved hats worn by the emissaries for peace who acted as peace hostages for the victors (called Deer, or in Tlingit, Khuwakàn) were collected. Nothing was too great or too small for Emmons to collect.

The formidable Franz Boas, a young German geographer, was working with Bastian at the museum in Berlin when the southern coastal Salish group, known as the Bella Coola, were invited there. In fact, Boas was one of the men who conducted ethnological investigations of the Bella Coola group in Berlin. From then on he was entranced with the Northwest Coast; and went on to become an ethnologist, museum curator, and, finally, Professor of Anthropology at Columbia University. His whole professional career was built on ethnographic studies and analysis of Northwest Coast cultures especially the Kwakiutl Indian group, and his research and theories were to effect ethnology and anthropology until the 1960s.

After studying Eskimos at Baffin Island with a German expedition, Dr. Boas settled in the United States because he felt it offered more opportunity in his field of geography. Lured by his interest in the Northwest Coast he financed his first trip to there. His plan was to study the cultures, improve documented material already in place in museums, and collect artifacts. "Boas brought the sensitivities of a seasoned field worker and the discriminating taste of an experienced ethnographer and museum man" (Cole, 1985: 106). The largest part of his collected items were sold in Berlin and earned him enough to pay for his trip.

In 1888 the British Association and the Canadian government funded Boas' second trip to do a survey of the tribes on the west coast of British Columbia and to map their area. He did a great deal of physical anthro-

pology on this trip, and he personally collected twelve skeletons and twelve skulls. He would later augment his collection by buying more bones from local collectors. He ran afoul of the law and a complaint was registered with the provincial police. He did manage to get them through customs complaining, "The bones were a possible embarrassment and I would like to get them off my hands as soon as possible" (Cole, 1985: 120) He sold some of them to Berlin and some to the Field Museum in Chicago.

Chicago World's Fair was held in 1893, and work began on its exhibits two years prior to its opening. Boas was chosen to assist in the anthropology section, and, naturally, he would supervise the Northwest Coast's exhibition. It was an immense undertaking and involved collecting a massive amount of material from the area of the Northwest Coast from collectors in the field, private collectors (for Tlingit material), teachers, missionaries, and Indians themselves were contacted. It is said that three boxcars alone of Haida material were sent to Chicago. Boas was acquainted with George Hunt, a Kwakiutl, and now he leaned heavily on him for assistance. It was the beginning of a long relationship. After the Fair the material collected by Hunt remained in Chicago.

The success of his efforts at the Chicago Fair finally propelled Boas to a position he had long coveted: Curator at the American Museum of Natural History in New York and a teaching position at Columbia University. It also offered a unique opportunity for him to take part in the ambitious Jesup North Pacific Expedition funded by Jesup himself, the President of the American Museum. The Expedition, begun in 1897 and lasting for six years, was essentially to study the relations of the groups in Alaska and in Asia. Within three years "Boas reported to Jessup that the expedition had collected 6,626 artifacts and 1,896 physical anthropology specimens for a mere $14,127 compared to the $37,500 paid to Emmons for only 3,824 specimens" (Cole, 1985: 153).

> It was the Jesup Expedition that sealed Boas and Hunt's collaboration, and in the history books he became known as Boas' major informant. He proved himself to be a very valuable collector, as noted in records of the Jesup Expedition stating that he had procured some 25,000 specimens. His collaboration with Boas and the collection of all these artifacts were not without a great sacrifice for Hunt. His own people and family turned against him, and there were some very difficult times for both Hunt and Boas especially when they searched caves for artifacts and skulls. (Cole, 1985: 154)

In 1896 Dr. George Dorsey became director of the newly formed Field Museum in Chicago, which was founded on the collections from the earlier 1893 World's Fair. He wanted to expand the Tlingit aspect of the Northwest exhibit that Boas had left there, and proceeded to travel to the Northwest Coast. He was particularly interested in totem poles, grave posts and the contents of the graves because, as he noted, "It is not an easy matter to secure osteological material from the Tlingits for they burned their dead" (Cole, 1985: 171).

Resentful of Dr. Boas, because he thought of the Northwest Coast as his domain, Dorsey could not help but admire the man for the enormous amount of material he had collected there, as well as for his methods of collecting. At one point he actually joined forces with Boas to do some collecting, and they were almost arrested for molesting graves. Dorsey was somewhat rash and superficial in his fieldwork and there were instances, which would later plague him, of his disturbing graves in a wholesale manner. He needed a colleague who knew the ins and outs of trading on the Northwest Coast and was finally able to hire Dr. Charles Newcumbe, an English physician living in Victoria, to collect for the Field Museum. Newcumbe had freelanced as a collector for various museums in different countries but he now agreed to work solely for Dorsey. In Klukwan he collected some items from a shaman's grave and also some large ceremonial feast dishes – he complained bitterly about the cost of removing artifacts from the Whale House.

> To clear out merely the big things in the Whale House at Klukwan would take something like fifteen hundred dollars, one thousand being required for the chief's inside posts and carved house back alone. The necessary formalities in the custom of house-building, erecting a monument to the uncle and the distribution of property had never been completed and the prospective vender was too poor to do it. Some near relative with sufficient means may at any time do so, but until the custom alluded to has been carried out, the title to the poles and many other interesting and valuable things, is in abeyance" (Cole, 1985: 194).

Dorsey's reply was, "Let the Chilkat rest until I have heard from Emmons" (Cole, 1985: 195).

Since Newcumbe was much more knowledgeable and experienced with Haida, Tsimshian, and Kwakiutl cultures than he was with the Tlingit, it was natural that Dorsey would turn to Emmons, who had recently sold him 1,438 items of Tlingit material and was considered the seasoned expert on the Tlingits. The sale did not place Emmons under any special obligation to Dorsey and he continued to freelance among his many lucrative clients by astutely keeping his options open, while shrewdly keeping his methods covert. Just after the sale to Dorsey he wrote to the Secretary of the American Museum of Natural History in 1899.

> Having cleaned Alaska out I was surprised to come across a set of Indian Doctor's instruments. It has quite a local reputation and while I have heard of these things for years, I have never been able to see one. There are 20 pieces in all but the value of the things rests wholly in the eight wooden, copper-ornamented masks which stand for the eight spirits personated by the Doctor. No white man has ever seen them. I think I can arrange to keep them out of sight until I hear from you. (Miller and Miller, 1967: 247)

He did not add, but almost certainly would have thought, "I can always sell them to Dorsey who desperately needs more Tlingit material."

Newcumbe, Swan, Emmons, Hunt, Powell, other minor collectors and the academic scholars knew one another, kept in contact, and maintained an uneasy awareness of what their colleagues were doing. It was like a "Cold War" among spies of allied nations. There were those rare moments when they actually assisted one another, and certainly all were united against the tourist trade in Alaska, which was raising prices and increasing the outlets available to the Indians for selling their curios and artifacts.

In 1903 Newcumbe visited the Field Museum to ascertain what their collections lacked and how he could augment them. On his way back to Victoria he stopped in Albuquerque to visit Fred Harvey (of the Acheson, Topeka, and Santa Fe Railroad food service fame who also collected in the southwest for the Field Museum) to look over his museum and curio shop. Stimulated by his knowledge of what the Field Museum needed and his visit with Harvey, Newcumbe returned to Victoria and began to collect from all along the coast such things as a chief's headress, old rare baskets, mortuary posts, a number of skulls and skeletons, ceremonial leather armor, an old copper, several totem poles or sticks, as he

called them, copper neck rings, and a whaling outfit. He lamented how he just missed a sale at two Haida villages where dance outfits had been sold because "they were abandoning *heathenish* ways and selling off their ceremonial property" (Miller and Miller, 1967).

The St. Louis Fair was held in 1904 and Newcumbe, at Dorsey's suggestion, took an exhibit there, including a performing group of Kwakiutls. Governor Brady of Alaska "brought two clan houses and 15 Haida poles that stood by the clan houses. Newcumbe who earlier had tried to buy them was livid when he heard that Governor Brady had gotten them as a gift from the Haida!" (Miller and Miller, 1967). Some of these poles were sold in St. Louis, while other items from Brady's personal collection were purchased by Mrs. E. H. Harriman, widow of the railroad magnate, and donated to the Smithsonian Institute. The remaining Haida poles were placed in a park in Sitka, now The National Monument Park.

The year 1912 marked the arrival on the scene of George Heye, heir to a Standard Oil fortune. He became one of the greatest private collectors of Indian lore and artifacts, and he collected by the boxcar. Powell, Newcumbe, Emmons, and Marius Barbeau, a Canadian anthropologist, sold to Heye, who also purchased the coveted but tainted collection of Tozier—an officer of the U.S. Revenue Service who had the reputation of stealing, collecting by threat, and selling Indians illegal whiskey to obtain artifacts—in Seattle. Huge quantities of his New World art collection were stored throughout the country in various museums, but the major part of his Northwest Coast collection was loaned to the University Museum in Philadelphia. In 1916 the complete Heye collection was finally housed in its own building, the Heye Museum of the American Indian Art Museum in New York, now known as the American Museum of the America Indian, Heye Foundation. The University of Pennsylvania felt keenly the loss of his collection and began to assemble its own. The museum sent Dr. B. Gordon, who had been appointed Curator of the University of Pennsylvania Museum, as its representative to Klukwan to collect. There he met Louis Shotridge, a young Tlingit from noble lineage, who spoke English and was most knowledgeable of his culture and its history.

And so begins the strange and twisted story of Louis Shotridge, the Tlingit who turned quisling. He was the son of Yeilgooxu (George Chartrich in English), who, as the House Master, had attempted to rebuild the Whale House in 1889; and he was the grandson of Chief Chartrich, who led his warriors in a raid on the Hudson's Bay fort in 1852 when the company intruded on his territory (Chartrich burned the fort and it was never rebuilt). In addition, his mother was the daughter of Chief

Kahlteen of Sitka, and he was heir apparent on his mother's side to many titles of the Ká'gwantán clan under the Wolf moiety. He was a valuable resource for the University Museum and Dr. Gordon because of his knowledge of Tlingit art, its meaning, its history and its ownership through the lineage lines. He was also an outstanding interpreter. By 1913, he was on the staff of the museum in Philadelphia, identifying and deciphering the meanings of artifacts, judging their value according to Tlingit standards and actively collecting for the museum. A handsome man, he would dress up in Tlingit ceremonial garments and give talks to the public as they toured the museum. He had one other valuable asset: he knew what was in Sitka and Klukwan and, more importantly, he knew how to get it. As he wrote of a Sitka acquisition:

> When I carried the object (a rare shark's helmet) out of its place, no one intervened; but if only one of the true warriors of that clan had been alive, the removal of it would never have been possible. I took it in the presence of an aged woman, the only survivor in the house where the old object was kept, and who did nothing more than weep when the highly esteemed object was taken away to its last resting place. (Enge, 6 April 1993)

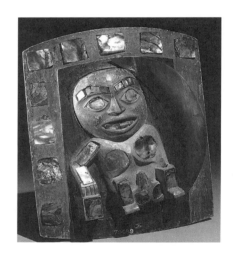

Headdress ornament, wood carved and painted with shell and brass additions.

Photo: Field Museum of Natural History, Chicago

Shotridge wanted the rain screen and the four sought-after house posts of the Whale House in Klukwan; but under Tlingit law he was not his father's tribal heir but his mother's. He attempted to steal them and was shot at as a warning—a warning he should have heeded. In 1917 he collected three important helmets from the Drum House of Klukwan, a house belonging to his own lineage, the Kā´gwantān.

> "Taking these out of the Drum House was something like juggling a hornet's nest," he wrote to Gordon. "Everybody there became the nearest kin to old Daq-tank for whom the bear helmet had been made and in almost no time they searched my shack to claim ownership of the wooden hats." (Enge, 9 April 1993)

He returned to Philadelphia in 1920 having collected 232 objects on the Northwest Coast. Steve Brown, curator of the Native American art at the Seattle Art Museum stated:

"The things that ended up in Philadelphia as a result of his efforts are unlike any collected anywhere ... He documented every object with name, clan, caretaker, previous caretakers, the artist and the occasion. No one had ever bothered to ask these questions. Ninety percent of the stuff in museums don't have that" (Enge, 9 April 1983).

Shotridge returned to Alaska in 1922 with the primary goal of acquiring the Whale House treasures. He felt he was the legal heir to the Whale House under Western law. The controversy came to involve most of the Chilkat people, and he was forced to leave to allow things to quiet down. He returned in 1923, ready to take possession, but the House Master had changed hands, and the new Hít s'átí would not permit the articles to leave. Shotridge would return two more times and each time he failed in his mission. So much animosity was created in Klukwan that the village held a peace-making ceremony, and the elders warned him to halt. Shotridge's second wife died in the fall of 1928 and he remained in Sitka to take care of his children. In a letter to the museum he expressed feelings of ambivalence: "The modernized part of me rejoiced over my success in obtaining this ethnological specimen for the museum; but, in my heart I can not help but have the feeling of a traitor who has betrayed confidence" (Enge, 05 April 1993). He was speaking of his earlier acquisition of the Shark Helmet, one of the oldest possessions from his own clan in Sitka.

In 1929 he returned to Philadelphia to work on his notes and documents of oral history of the Tlingit. By this time the Great Depression had struck and the museum could no longer afford to employ him. He had five children and a new wife to support and could not find work, so he returned to Klukwan—which he must have known would place him in jeopardy. No one would help him or hire him.

He retreated from Klukwan to Sitka, his mother's village, to make a living from fishing and doing odd jobs. In 1935 he was a stream guard to prevent fishing in closed waters, an unpopular duty among Indian fishermen. His last days were spent in a tattered tent pitched near a cabin he had built in Redoubt Bay, about sixteen miles south of Sitka. He was found unconscious there by his cabin in 1937 and died ten days later at a hospital in Sitka.

"The report stated death resulted from a fall from scaffolding, although there was no scaffolding where his body was found" (Lael, 1977: 40). He suffered a broken neck and had apparently been lying there several days without help. His death was mysterious enough to be investigat-

ed by a coroner's jury, who ruled it accidental death due to a fall from a roof, but Robert De Armond, who served on the coroner's jury, was not convinced. "The story among the natives has always been that he was killed by his own people, and they were very clever at making it look like an accident. It is one of those mysteries that never will be solved" (Enge, 7 April 1993).

Elder Tlingits would not speak of his death, nor even of him, when questioned by their own sons. When asked, "Who killed Louis Shotridge?" they would stoically say nothing. Up until the late 1980s, some who knew him were still alive in Klukwan, and the two elderly women (Anna Smith of the Frog House and Mildred Sparks of the Whale House), when asked about the events of his death, smiled sphinx-like smiles and remained silent and motionless.

TLINGIT ARTIFACTS ARE RECOGNIZED AS ART

The tribal art of the Tlingit Indians had been collected by museums, missionaries, traders, explorers, anthropologists, tourists, and a Tlingit pawn (that is, Shotridge) until 1920. The Western art world at that time had became involved in a great fermentative period that had commenced at the beginning of the twentieth century when artists began turning away from French Impressionists and the still older and more classical forms of art, and began searching for new inspirations, seeking new art forms and struggling to find different modes of aesthetic expressions.

The modern artist turned to the Orient for subtle design effects and a style that touched a sense of feeling and emotion not only for the design created but for the emptiness of space left by the creation. Others turned to the tribal art of Africa for passion, earthy boldness, and vitality. Artists were experimenting in all elements of visual expression and the art world was alive with change. Art salons were excited by the new ideas of the modern artists and were intellectually debating the unlimited dimensions of art. During this period, an interest developed in Pre-Columbian art. Its sheer richness of gold and silver molded into elegant masks and jewelry and bold and grotesque carvings on temples, hitherto unknown, greatly influenced modern artists.

In the early 1930s, expositions of North American Indian art held in New York City, and later the 1939 Indian Art and Craft Exhibit, held in San Francisco, alerted the art world to the artistry of the tribal art of the North American Indians. The art connoisseurs of this time were also being influenced by Sigmund Freud and his theories of the unconscious aspect of the human mind. Carl G. Jung, a great contemporary of Freud who developed the theory of the archetypes of the unconscious, was also proving to be influential. The art world now saw another compelling aspect in so-called *Primitive art* ... the force of the unconscious. They were particularly drawn to Jung's theory that the myths of primitive man refer to something psychic:

> Primitive man impresses us so strongly with his subjectivity that we should have guessed long ago that myths refer to something psychic. His knowledge of nature is essentially the language and outer dress of an unconscious psychic process. But the very fact that this process is an unconscious one gives us the reason why man has thought of everything except the psyche in his attempts to explain myths. He simply didn't know that the psyche contains all the images that have ever given rise to myths, and that the unconscious is an acting and suffering subject with an inner drama which primitive man rediscovers, by means of analogy, in the process of nature both great and small. (Jung, 1959: 6)

Art shows displaying Indian Art began opening across the nation and museums slowly recognized the need for representative collections in response to the appreciation the art received and the high regard for its aesthetic value. This prompted the creation in 1919 of the first museums devoted to Primitive art. "The Golden Gate Exposition in 1939 and the Museum of Modern Art shows gave native art a legitimacy and influenced the public in a major way. In less than a generation, the definition of Northwest Coast pieces changed from ethnographic specimens to *fine art*" (Cole, 1985: 285).

The art collecting now involved the local Alaskan merchants who ridiculed the art but increasingly realized its saleable value. By 1940 Walter Waters, the owner of the Bear Totem Store in Wrangell, ended up with more of Chief Shakes VII's artifacts than the chief had himself. This rare collection was sold to the Denver Art Museum in 1953.

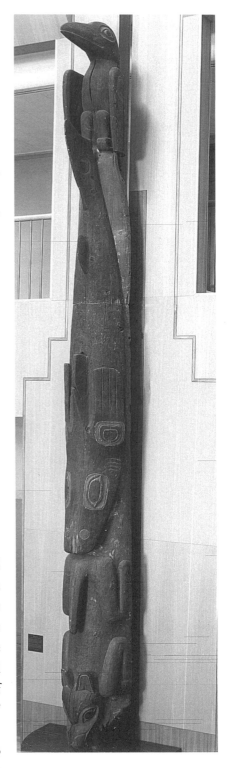

In 1898 a fur trader, Charlie Goldstein, had come north during the gold rush. He soon discovered that he was also in a good position to pick up interesting artifacts as he traveled by dog team into the Taku River country as far east as Atlin, British Columbia. He learned Tlingit and was knowledgeable of the culture. Eventually he opened the Nugget Shop in Juneau, by far the finest in Alaska at that time. It had some real treasures and was run by his daughter, Belle Simpson.

The editors of the old *Alaska Sportsman Magazine* (now *The Alaska Magazine*), Emory and Clara Tobin, originally published the magazine in a home-like setting from the 1940s until the 1970s in conjunction with a curio shop where rare and unusual ceremonial items could be found.

Axel Rasmussen, who came to Yakutat as a missionary in the early 1990s and served as Superintendent of Schools at Wrangell and Skagway over a period of twenty-five years, collected hundreds of artifacts. He was spoken of as a quiet, reserved, religious man, keenly interested in Indian art. He died in 1945 and hundreds of masks and baskets and carvings were sold to the Portland Museum of Art. The sale of his collection brought art dealers into the arena of Northwest Coast Indian art. "The purchase of the Rasmussen collection transformed the collecting into commerce, lifting it once and for all out of the hands of the nonprofessional and turned the art into a commodity" (Miller and Miller, 1967: 254). Items from the Northwest Coast now found their way into the great private art collections of the world.

This seemingly endless flow of fine art pieces and artifacts from the eight Indian groups who inhabited the area of the Northwest Coast was astounding. One must pause to marvel that such a small group of people living on the fringes of a northern coastline could produce such vast amounts of extraordinary art work. The sheer abundance alone is staggering, but its excellence, ranging from a simple hair ornament to a tall cedar monument, is almost beyond comprehension. More remarkable still is the fact that not all the art is gone from Tlingit hands. Individual families and clans still have chilkat blankets, crest hats, daggers, silver and gold bracelets, and baskets, and the collectors and art dealers continue to be mesmerized by the collections.

If Louis Shotridge had been consumed by the Whale House artifacts, Michael Johnson, an art dealer, was obsessed with them. In the 1980s, the

Frog House and the Whale House still held on to their clan treasures. The contents of Frog House were sold to a Canadian art dealer, and slipped out of Klukwan, across the Canadian border in 1985. The Whale House alone remained the center of a raging controversy between the clan's ownership of the art and that of hereditary individual heirs. Although there is some confusion over who the legal heirs are, the main problem was whose laws applied: tribal or U. S. laws? The fate of Klukwan's art is one of the final chapters in the drama of Tlingit art. The great Whale House, as described by Lt. Emmons, and coveted by Louis Shotridge, still holds its treasures—the four house posts, the rain wall screen, crest hats, a broken wood worm potlatch bowl, and other ceremonial items. These items, sought after by the art world, became a fetish for Michael Johnson and his wife in their bid to acquire them.

> Since 1970 court records show that he kept pressure on various Gaanaxteidi elders to sell the Whale House artifacts for large sums of money. Johnson said he was misled by people who falsely claimed ownership. But some villagers called him a hyena who identified the weakest clan members for his sales pitch. His letters paint a portrait of a man obsessed, who could make almost any claim or offer to secure the carvings. (Enge, 8 April 1993)

He made many attempts to gain the artifacts, going so far as to plan a raid on the Whale House, this time with hired Wackenhut guards, but Wackenhut warily pulled out of the deal. Finally, he succeeded in stealthily secreting the artifacts out of Klukwan in April 1984. They reached Seattle by ferry and were locked in a warehouse while Johnson contacted a buyer.

The people in Klukwan did not hesitate. They called the State Troopers and the artifacts were located in Seattle where, under court order, they remained until 1993 when a judge ordered the art objects be returned to their home. The judge ruled that a village ordinance that was activated in 1976 was violated. The ordinance prohibited the removal and sale of artifacts from Klukwan. The artifacts were returned to Klukwan. There they remain at the time of this writing.

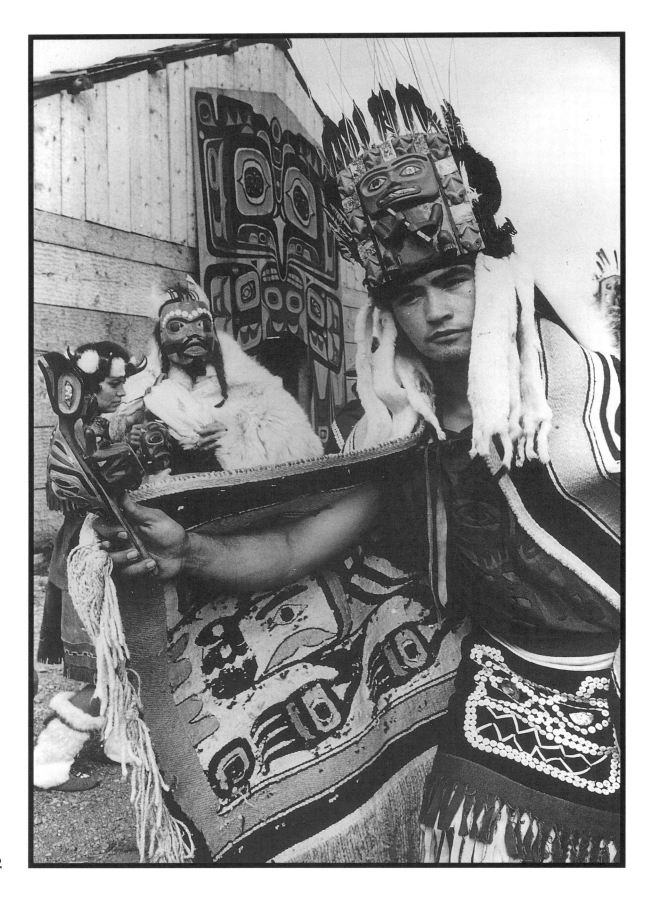

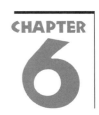

THE STRUGGLE TO REGAIN WHAT THEY HAD LOST

SOME FIFTEEN YEARS AFTER THE THREE CHIEFS SPOKE TO Governor Brady, the Tlingits knew that they must either develop coping strategies or perish. Unlike the ghost dancers of the plains, they were fully aware that they could not return to the past. They realized they had to create their place in the new society of Alaska, and they chose to do so through the medium of their own culture.

THE ALASKA NATIVE BROTHERHOOD

The Tlingits and Haidas adopted a political stance and formed the Alaska Native Brotherhood (ANB) in 1912. It was the first Alaska Native political organization and until 1960, the only one in the state. Anthropologist Philip Drucker states in his book on the ANB that:

> These are a people who have stood on their own feet and fought their own battles with no handouts, until recently, from paternalistic administrations; a people who passed in one jump, or almost a hop-skip-and-jump, from the blanket to life in an industrialized economy and by their own

Opposite: **Chilkat Native dancers.**

Photo: Victory Daily Times

173

efforts managed to compete with reasonable success with the heirs of generations of such industrialized systems; and a people who, by and large, have retained those characteristics that Emmons described for the Chilkat Tlingit as he knew them in 1880, proud, vain and sensitive but with all, a healthy, honest and independent race, and friendly when fairly met. (Drucker, 1958: 6)

The ANB worked diligently to elect Indian people to the territorial government, fought segregation, secured voting rights for Natives in 1922 (two years before the U. S. Congress established voting rights and U.S. citizenship for American Indians), sued the United States government for land claims in the 1940s, and won the lawsuit, known as the Tlingit/Haida Land Settlement Act some twenty-five years later. (See excerpt of letter from William Paul, Tlingit elder, to William M. Williams regarding the land settlement and corresponding map at the beginning of this book, page 15.) The ANB continues to be an impressive and efficient organization that adroitly applies parliamentary rules and practices to its advantage and works closely with the federally recognized Tlingit/Haida Tribe and Sealaska Corporation.

ANB halls were built in each village and, in these halls, the group carried on their meeting conventions and tribal ceremonies. In a sense, the halls replaced the great clan houses' function but shifted them to a more multi clan significance. The great tribal emblems were displayed, the crests of totem poles exhibited, the potlatches held, and the forty-day commemoration for a deceased celebrated. The events were accompanied by ritual dances, clan songs, and oratory, complemented with the crest hats, chilkat, and button blankets. Noteworthy carvers such as John Wallace, a Haida, George Benson and Dan Katzeek, both Tlingits, toiled away quietly carving for their people while working as loggers or fishing commercially.

It was not so much that the people went underground but rather that they were much less lavish and gave minimal public display and acknowledgement to the events where dance, music, and oratory was displayed. Realizing they no longer controlled the economic power even through demographically at that time the non-Indian and Indian populations were in balance, they wisely chose to conceal and congeal Tlingit tribal sovereignty within the confines of the Alaska Native Brotherhood and the ANB Halls. By this clever maneuver, the ceremonial expressions appeared more muted and social rather than still culturally dynamic.

Anna Katzeek, leader of the Thunderbird dance group from Klukwan, states: "We never lost our culture; the thunderbird, the myths, the dances, and the masks have always existed. There has been no revitalization, it has always been with us. How well I remember all these things as I grew up in it as a child. Not only the celebration events that we do now; but the way of life was always with us. The elders would show us and say it's your turn now. Of course, we had the potlatch and the people wore their clan garments with their crests, they danced and sang, and the other invited groups responded with songs and dances for whatever occasion it was" (Williams, 1996: 245).

Bea Halkett, a Tlingit elder and Director of the Tlingit Haida Dancers of Anchorage, makes similar comments: "How I remember the ceremonies when I was a child, there was the forty-day celebration and the potlatch or the payback part."

Tlingit families still possessed crest hats, masks, shaman rattles, baskets, and robes, the items were treated with great respect and reverence. The clan system was strong; and until the early 1950s, people fifty years or older spoke their language, retold the legends, and in rare moments would even share them with non-Indian friends. A few older women continued to weave baskets and a small group of the aforementioned artists continued to carve for the clans, albeit guardedly until the law against the potlatch was repealed in Canada in 1951. Alaska decreased its resistance to the custom in tandem. Ironically, two decades earlier, during the Depression, the carvers had begun carving openly again on a federal project to restore or replicate old totem poles for new parks in Alaska.

THE RESTORATION PERIOD

The apathy of the Territory of Alaska toward retaining its Native art, and the lack of interest in maintaining any of the art in Alaska, continued until Franklin Roosevelt's administration. Roosevelt appointed a sympathetic commissioner to direct the Bureau of Indian Affairs and this marked a change in federal policy toward Indians. Attention was finally directed to their needs, their art, and their Aboriginal land claims. In 1937 Ernest Gruening, also a Roosevelt appointee, was engaged as Director of Territories and Insular Possessions. He would later become Governor of Alaska from 1939 to 1953. As governor, he raised the question of doing something about the totem poles remaining in Alaska. The Forest Service

collected data on the location and condition of the existing poles, community houses and rightful owners, and, if possible, secured title to some of the poles so that they could be moved to various centers for rehabilitation. The actual restoration was carried out by the Civilian Conservation Corps as a public works program under the direction of the Forest Service. Several workshops employing Tlingit and Haida craftsmen were established in the Native communities where the parks were to be established. Agreements were made by which all the salvaged poles in the old abandoned villages could be brought to these workshops. More often than not, new copies were made and the originals discarded. In addition, three old-style community houses were built and numerous copies of original poles were carved. The parks, therefore, contain a few restored poles of advanced age and many replicas of old poles and original poles made after 1960.

The Indian carvers who worked in the program were the best of their time. The artistic results, however, were uneven, probably because the project did not involve a meaningful tribal event. A few of the poles made at that time were quite poor, although most were very well done. However, none could quite equal the aesthetic value of the old original poles. It is a tragedy that, with a few small exceptions, the old original poles, once copied, were not preserved, and that many old poles were left to decay in the forest. The totem parks project, which ended in 1942, was an impressive effort and valuable contribution to Northwest Coast art and would later prove to be a valuable asset for Alaska.

The care of the parks in the past has been uneven. As late as the 1960s the poles in the towns and parks suffered from neglect and decay from standing in the elements. Parts, such as arms, legs and beaks, were missing. Many were painted with thick coats of garish colors, leaving none of the natural beauty of the wood sculpture showing. Old weathered poles at abandoned village sites were left to disintegrate in the dark, damp forest of their origin. The community houses showed evidence of decay in the beams, the roofs leaked and the entry steps were falling away. Amateur archaeologists were frequently permitted to dig in abandoned village sites—they were actually trespassing and destroying sites for future scientific investigations.

Following the late 1960s Totem Pole Survey of Southeastern Alaska, federal, state, civic, and private groups began to take an interest in the preservation of totem poles within the state of Alaska; and there were individuals, such as Carl Heinmiller who developed an art project in Port Chilkoot and helped awaken Alaskans to Tlingit art. The Sitka National

Monument had an outdoor exhibit of Tlingit and Haida poles since 1901; and finally an indoor exhibit in the Southeast Alaska Cultural Center was opened in 1970. It is operated by the Sitka Alaska Native Brotherhood in cooperation with the National Park Service.

In 1976 the Heritage Center opened in Ketchikan, Alaska. The building was built by the Federal Economic Development Administration and the land was donated by the city of Ketchikan. State agencies, corporations, and private individuals provided funding for the retrieval of the poles from abandoned village sites and the early preservation work on them. The expenses of the Center are currently funded by the city of Ketchikan with matching funding coming from state and federal sources as well as the private sector. In the early 1970s the poles identified at old village sites by the 1960s survey were taken to an abandoned cannery and dried out little by little for seven years. Preservation work was begun in the cannery and the poles were then removed to the Heritage Center for exhibition. By 1977 all the poles were at the Center. There are now no poles known to exist unclaimed at abandoned village sites.

The State of Alaska appropriated monies to the city of Saxman for a totem preservation project. This involved the restoration of the poles in the park at Saxman, maintaining the aspect of the area in a park like setting with the addition of a few poles following a restoration project by the Ketchikan Heritage Center.

In March 1980, the 100-year-old Haida pole, "The Old Witch," underwent extensive restoration and was given a place of honor within the spacious halls of the new State Office building in Juneau. It took a volunteer crew a day to set up, followed by three hours of hard work, to hoist the 2,500-pound, 38-foot pole from its horizontal position on the floor to a vertical place of honor against the elevator shaft. This project was funded by the State of Alaska.

By the end of 1980, the preservation project for the fine old houseposts from inside Chief Shakes' Community House in Wrangell had begun. State and federal monies funded this project. Under the supervision of the Royal British Columbia Provincial Museum in Victoria, the house posts were removed from the community house into a special "micro-environment" room at the Wrangell Native Community Center for drying out, a process which took a year. They now reside in the Wrangell City Museum. The preservation project expanded to include creating replicas of the original house posts and placing them in Chief Shakes' Tribal House, as well as replicating the deteriorating poles that stood outside the house. Sealaska donated more land, a charming area called Kik.seetti Park, for the project and placed a select few of the restored poles there.

Since the 1960s there has been an intense movement in the restoration and revitalization of the art in the area of the Northwest Coast, and the art is now highly regarded by both the Canadians and the Alaskans. This awakening interest in the art can be attributed to political efforts, the growth of tourism, and the belated realization of its aesthetic value; but most of all it is due to the efforts of the Tlingits themselves and their social evolution of the late 20th century.

The Indians of Southeast Alaska, as well as the Eskimos, Aleuts, and Athabascans were fighting against a twofold enemy: the obliteration of cultures and of their physical health. Sheer survival was their consuming problem; and it was this very struggle for survival that eventually united all the Native groups in Alaska and precipitated a rebirth of their culture and art.

One major crisis was a tuberculosis epidemic of unparalleled dimensions and serious consequences that ravaged the Native population. Many died, but many others were sent away to sanitariums (there were long waiting lists for the two sanitariums in the state of Alaska); and consequently patients had to be cared for in sanitariums in the continental United States. If both parents were ill, the children were put in foster homes; and many of the children with bone and joint tuberculosis were hospitalized away from home for years, only to return as strangers. There was not a Native family left unaffected by this disease until the discovery of anti T.B. drugs in the 1950s when a massive chemotherapy program was introduced in Alaska to control the epidemic. By the early 1970s the new treatments had almost obliterated the disease. Thus, to survive their illness, the Indians had to leave behind their family and culture.

Another critical but more smoldering situation affecting the culture and the family was the Nelson Act of 1905, which created a segregated educational system by forming two systems of schools: territorial schools operated for white students and federally operated schools for Native students. Thus, for many years until statehood, there were two separate schools systems: an ineffective one for the Native children supported by Christian missions and the federal government and the territorial schools for non-Natives. The Indian schools were transferred in 1931 to the Bureau of Indian Affairs, but it still did not provide high schools in "bush" areas for native students who, if they desired to further their education, had to attend boarding schools hundreds or thousands of miles from their village homes. Being disconnected from their families, their language, and their cultural practices was devastating for the young people in their formative years. They often lost their language, their culture, and the opportunity to be trained as artist and carvers.

The both tragic and disastrous era of the boarding schools ended when a number of Alaska Native students filed a lawsuit in 1972 against the State of Alaska, referred to as the "Molly Hootch" case. The Native plaintiffs sued the state to force the end of boarding schools; they wanted schools built in villages. It took eleven years before all the major villages had schools; and, by the mid-1980s, virtually all Alaska Native villages had their own schools. Although the schools represent the Western approach to education and teach children Western ways, there is more tolerance of language and other traditional practices including art, music, and dance. This improvement in education, combined with the Native Rights Movement, led to a stronger cultural identity for Native people, coupled with more local control of education of the children. As a result, young Natives are born into a world with an acute sense of who they are and what they can achieve. Many people are learning their traditional language and participate in cultural activities. There is a tremendous pride in being Native and for the first time since the beginning of the 18th century, the Native people can again exercise their rights and assert themselves both culturally and politically.

THE RAMIFICATIONS OF STATEHOOD AND FEDERAL LAWS

Politically, the Statehood Act of 1959 was a major catalyst to unite Native people in a struggle for their rights. The state and federal governments began selecting hundreds of million acres of land—land the Natives felt was theirs or vital to their existence. Another important factor in the development of solidarity was the unity of the Eskimo village of Pt. Hope in their protest over a proposed nuclear testing site near their village. Howard Rock, an Eskimo activist of Pt. Hope, reinforced the movement by founding a Native newspaper, The Tundra Times, in 1962, giving a voice to the Native people of Alaska. In 1967, the Alaska Federation of Natives was organized and the Native people began to flex their political muscles. These efforts were also encouraged by the Civil Rights Movement of the 1960s, reinforced by President Kennedy's anti-poverty campaign, and further enhanced by President Johnson's social programs. All of these factors sparked a cultural renaissance and people began reclaiming their heritage with pride.

Secretary of the Interior, Stewart Udall, imposed a land freeze in 1966. As a result, the Alaska Native Claims Settlement Act (ANCSA) was enacted in 1971. This Act was a large-scale policy developed by the U.S. Congress and was designed to compensate Alaska Natives for the loss of their tribal lands. In effect it was designed to obtain clear title to the lands so that the oil pipeline could be built; and also to assimilate the Native people into mainstream Western culture. The Act involved the creating of 12 regional Native Corporations within the state and one within the state of Washington. These corporations formed non-profit groups to further enhance the Native communities. Music, dance, art, and other Native cultural rituals that had been repressed or gone underground began to reappear. The non-profit groups developed cultural programs and created avenues that led to the development of cultural heritage programs. Old artifacts were brought to villages for display and workshops were held for mask making, carving, and drum construction. Elder conferences, sponsored by the corporations, provided guidance to the young people. Also through the corporations, scholarships were offered to shareholders for higher education or technical training.

Sealaska, the corporation for the Tlingit and Haida of southeastern Alaska, developed a non-profit organization in 1980, the Sealaska Heritage Foundation, to offer cultural and education programs. The board of Sealaska hosted their first Elders' Conference in Sitka in 1980 and made a commitment to the traditional elders of their region to preserve the culture of the Tlingit and the Haida Indians. The theme was to preserve traditional knowledge, language, art, music, and dance. Sealaska continues to develop many programs. One of their more selective projects was the joint undertaking of Sealaska with the University of Washington Press to publish the research of Nora and Richard Dauenhauer. Nora Marks Dauenhauer, a Tlingit from Kake, has translated songs, stories, Tlingit oral histories, and the meanings of ceremonial events and compiled the material into several volumes. The material is of interest not only to the Tlingits but also to an international academic audience. The corporation has a highly prized collection of art from their region, and will buy artifacts and artwork to keep them in Alaska. The Sealaska building is filled with magnificent works of art that were made by the shareholders or their ancestors.

THE RENAISSANCE OF THE ART: THE MODERN CARVERS

In order to fully appreciate the work and circumstances of the modern carvers, the authors conducted a series of taped interviews, often speaking to the carvers as they worked.

Beginning with Bill Reid, a Haida carver, a growing group of talented Tlingit carvers began generating a renaissance of the art. Not only are they continuing to perpetuate the artform, they are seeking new pathways for an aesthetic journey that began many millennia ago. They are brilliantly changing the treatment of positive and negative space, blending formlines, and branching out in other mediums. Their carvings appear in museums in Europe, Australia, Japan, Canada, and the United States, and in public buildings in Canada and Alaska. The artists give international carving exhibitions, create their own works, often on commission, and somehow find time to teach master carving classes. Among the many modern carvers are some very well-known Tlingits. All of them display an inherent individual modesty and express a profound camaraderie and admiration for one another. It is the Tlingit way: ill-mannered to draw attention to one's self, but acceptable to express honor toward the group.

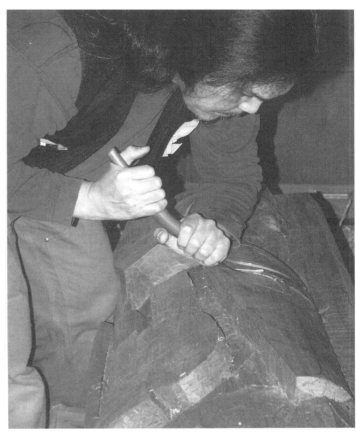

Israel Shotridge carving in his studio in Seattle, Washington.

Israel Shotridge is one of the Tlingit carvers who replicated many of the totem poles shown in this book. He is an intense, soul-searching artist, and pays great homage to Nathan Jackson, a traditional carver. Shotridge notes that Nathan is his mentor. He speaks of his desire to transcend the limits of the Northwest Coast style saying,

> I am developing ... maturing ... no, rather ... evolving. I am still not content with my style. But I do feel very fortunate to be living in this time with Nathan and Wayne Price and Will Burkhart and such non-native artists as Bill Holm and Steve Brown. They have been good teachers. Carving has

been a part of my family's traditions. My uncle Charlie Brown was the last carver in my family before my brother and I, and I have had the honor of replicating two totems he carved—The Man Wearing the Bear Crest Hat, which he carved in 1936, and now I am working on the replica of the Sun and Raven Pole, which he replicated in 1938.

As an artist, I am always looking for new ways to express myself and still maintain my links to the traditional style. I often choose to work with more contemporary mediums such as bronze casting. Two such panels hang in the foyer at Ketchikan High School. [He was speaking of the bronze doors with the turquoise inlays and adorned with Raven and Eagle crests.] I graduated from there in 1970, the first one in my family to graduate from public school, and I take great pride in my contribution to the school.

He paused and then added passionately, "I want to be able to take the art out of the ethnic setting to more diverse forms, but I never want to forget who I am and where I came from!"

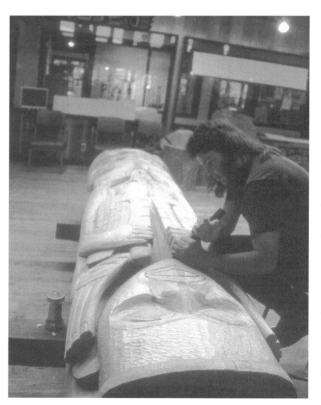

Tommy Joséph carving at the National Monument Sitka Park.

Tommy Joséph, who lives in Sitka, is young and adventurous; but in his work he is very traditional. He values the experience of carving with Will Burkhart, and the modern pole at the National Monument Park in Sitka is the result of their efforts. His studio is filled with beautiful carved pieces. One of them, a shaman's rattle, was particularly attractive. It lay near a carved alder potlatch bowl inlaid with abalone shell. At the time of the interview he was carving a replica of the Woodworm House Post from the Whale House and glanced up and said, "It would be interesting to study and to compare the early house posts carved by Kadjisdu.āxch' II for the Shakes' House in Wrangell to the house posts he carved 50 years later for the Whale House in Klukwan. But," he paused and said, "I don't think Klukwan is quite ready for it."

Will Burkhart, on the other hand, is a maverick, brilliant and courageous, who plunges daringly into the art. Although a fine carver, he will not dedicate himself solely to carving. He plans to carve a large canoe with Tommy Joséph and then do a commissioned totem pole. Afterward he will leave art and troll for salmon.

Dempsy Bob, half-Tahltan and half-Tlingit, carves because for him that is all there is. Although deeply embedded in his culture he is still a man of modern times. He knows who he is and what he wants to express. In his interview he explained his view that "the Western art critics do not truly define Tlingit art, but then," he pauses and laughs, "they want to tell us what is good. They are right from their point of view. But their views are not complete, not from within." He reflected again and then continued, "Mungo Martin and Willie Seaweed are our real heroes for they kept the art alive during some very tenuous times. We should never forget these men and what they accomplished." Dempsy has carved totem poles in Alaska and worked with Nathan on some of the house posts at Saxman Park Tribal House. His carvings are exhibited in European and Canadian museums. There are several Canadian video productions of his work. Modestly he says, "I could never equal those old carvers. They were good! I've seen some of finest Tlingit art in the Russian Museums. The Russians recognized the art, and of course were there at the beginning of contact."

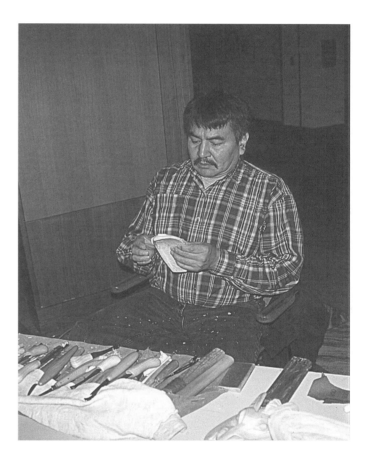

Nathan Jackson, the traditionalist, the noble teacher, mentor of so many young carvers, began carving in the 1960s. He laughs as he recalls, "Israel and I were so poor, and we carved in a small badly lit shed. We needed more light, and had to take windows from an old car. A junk car! We were cold most of the time, and probably hungry too." He has replicated poles in many of the parks, and his art is found in the Museum of Man in London, Britain, in the Ubersee Museum in Bremen, Germany, in Kanayama, Japan, and in Brisbane, Australia (where he did a pole for the World Expo '88). He has carved with most every major carver and fondly mentions helping Steve Brown and Wayne Price with the Wrangell House post replications. "It was really a learning experience being able to copy and try and to figure out what the artist had in mind. That same carver Kadjisdu.áxch' II carved the Whale House posts In Klukwan. Shaking his head he continued, "He was an artist. A great artist!"

Dempsy Bob carving at the Anchorage Museum of History and Art.

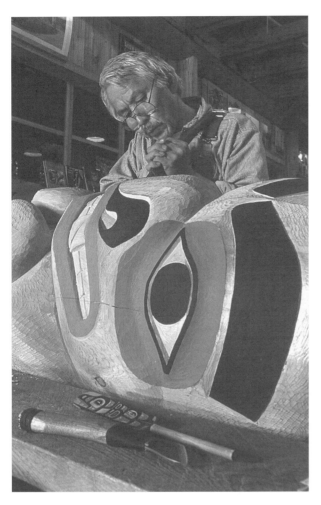

Nathan Jackson carving at
Saxman Park, Alaska.

Wayne Price, who lives in Haines, is another Tlingit carver, independent, spirited, and gifted. He is a left-handed carver, adding a unique touch to his technique, and he has created some magical pieces. He and Steve Brown, a non-Indian carver from Seattle, replicated the house posts in the Chief Shakes' House in Wrangell. The combination of the four house posts they replicated and the seven original house posts in the museum make Wrangell worthy of a visit.

Wayne was interviewed at Heritage Park in Anchorage where he was carving a 20-foot canoe. He began by reflecting on the past.

> I was born in Juneau and moved to Haines, and that is where I got my opportunity to study carving at the Alaska Indian Arts Center run by Carl Heinmiller. Carl was a real inspiration for me. I started when I was 12 just cleaning up the place and doing chores. I saw then that is what I wanted to do. When I was 14, Leo Jacobs handed me a brush and asked me to paint one of the carvings. From then on, I never faltered in my career. I am 42 now, and I look back with pride at my early work in Wrangell with Steve Brown. That was my real training ground, copying Charlie Ukas' works. He is my inspiration. No one in modern times can adz like him. In Wrangell I learned patience.

When asked if he was making innovative changes in the art, he replied:

> "After copying poles made by the great Kajisdu.āxch' II, I try to pursue what my ancestors did. I try to recapture their essence. But no one can match Kajisdu.āxch' II. He can't be equaled. I saw the Klukwan posts he did in 1810 after contact. He had gone through a lot of changes since the early Wrangell days. The whole Tlingit world was

changing. I noticed there was less detail in the Whale House posts compared to the Nanyaá'yî Q!A'tgu.hit House in Wrangell.

"My father was a carver, you know. My grandfather, Austin Hammond, carved too. I made a canoe for Austin for his Chilkoot Cultural Camp near Klukwan. Nathan Jackson was a big help to me when I started. Before Wrangell, I did the two large Bear poles at Saxman, and Nathan really guided me on this project. He is a great carver and a great man.

"There is now such a high demand for the art, and the art is certainly evolving, but I stay with the past least we forget it. I want to remain a traditional carver and preserve what was done in the past," he paused then continued, "and capture a part of the past and hopefully try and pass it on"—he smiled thoughtfully—"after all those lean years when the art was almost lost."

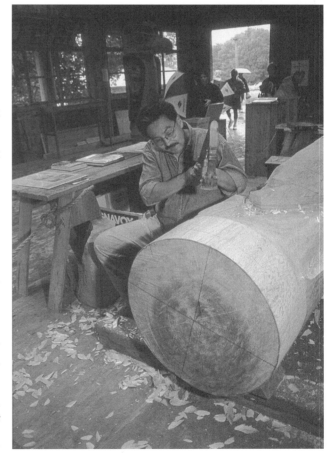

Lee Wallace carving at Saxman Park, Alaska.

Lee Wallace is half-Haida and half-Tlingit. He lives in Saxman. Lee comes from a family of five generations of carvers, but he did not begin to carve until he met the late Jim Shoppert at his art studio in Anchorage. "Jim had created some wonderful contemporary pieces that really intrigued me and started me thinking about carving. I returned to Ketchikan and worked on a team that prepared poles for carving. One day Nathan approached me and asked if he would like to assist him with a carving. I just jumped at the chance to work with Nathan, and left that adzing job in a heart beat!" During his time as an apprentice with Nathan, he also helped Wayne Price replicate a Beaver pole from Chief Kahshakes old house in Saxman. He finally reached the point where he could branch out on his own. "I carve more in the Haida style, and do a lot of undercutting. When I am creating something my thought patterns are concerned not only of with the creation of the piece, but the message of it and its universality. As you are aware, the Tlingit legends have many universal truths; but, of course, for the Tlingits there are layers of significance within the legends." He sighed. "And to think when the

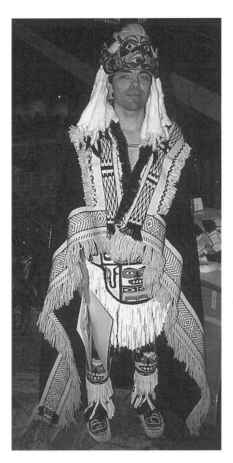

David Boxley, Tsimshian carver and dancer, in full tribal regalia at the Anchorage Museum of History and Art.

missionaries came they regarded them as idols! What kind of a calling did they have to say that is black and this is white? They demanded my grandfather cut some of them down. Poles he had carved! When I think about it and knowing the passion it required for him to originally create those poles, I realize that it must have been the most difficult thing he had ever done in his life!"

Many other prominent Northwest Coast carvers live and carve in British Columbia, Alaska, and Seattle. Stan Marsden, John Denny, and David Boxley are well-known Tsimshian artists. Richard Hunt and Tony Hunt, descendants of Boas' informant George Hunt, are well-respected Kwakiutl artists. Frieda Deising is a Haida woman who is famous for both her carvings and her carving classes. Robert Davidson and his brother Reggie are also Haida carvers. Ernie Smeltzer, Norman Jackson (Nathan's younger brother), Edwin Dewitt, the grandson of the late Chief Shakes VII, are all Tlingit carvers; Duane Pasco, Bill Holm, and Steve Brown are very talented non-Indian carvers. Steve Brown is very respected by the Tlingits, and at a Wrangell potlatch he was given the honorary name of the artistic genius Kadjisdu.āxch' II. It should be further noted that, at one time or other, The Gitenmax Carving School in Hazelton, British Columbia, run by the Gitksan tribe of Tsimshian Indians, has trained many of these carvers.

THE PAST RECAPTURED

In 1990 The Native American Graves Protection and Repatriation Act (NAGPRA) came into effect. It is a federal act that applies to any organization that receives federal funding and controls or possesses Native American human remains and associated funerary objects. The law requires that, when proved beyond doubt that any such objects belong to the clans or families of the original owners, they must be returned to the rightful heirs. The repatriation of artifacts and bones has begun—and is a long, tedious process that involves the potential owners making a claim, identifying the artifact, and establishing clan ownership and the use of the artifact in clan rituals. It is not a simple undertaking, but so far it has proceeded without rancor or animosity, although only a small number of relics have been returned. The wheels of repatriation turn slowly, but at least they are in motion and are reinforced not only by the federal act but a sincere effort on the part of the museums to redress past errors.

A 250-year-old Murrelet clan crest hat was returned to the Kā´gwantān clan in Haines, Alaska, from Eiteljorg Museum in Indianapolis,

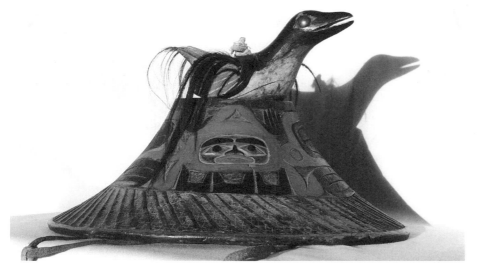

Murrelet Crest Hat. When the crest hat is worn the murrelet on the top moves about with the motion of the person's body (see page 101).

Photo: Williams Albecker
Hít s'atí Chilkoot Grizzly Bear House of the Kā´gwantān Clan of the Eagle Moiety in Haines, Alaska

Indiana in the summer of 1998. The crest hat that had belonged to the Chilkoot Brown Bear House of the Eagle Moiety was removed some years ago under what were said to be less than friendly circumstances. It was purchased about ten years ago by the Indiana museum from a dealer in Northwest Coast Native Art. The return of the artifact was achieved through the cooperative efforts of Tlingit-Haida Central Council, Chilkoot Indian Association, National Park Service, Eiteljorg Museum and Kā´ gwantān Clan. The people of Haines and the Chilkat Valley held a celebration of joy to honor the event in Haines. The Raven Clan of the opposite moiety in respect offered their Raven House for a private traditional ceremony. The Eagles performed the Crying Song and the Murrelet Crest Hat was presented to the Chief of the Bear Clan, Larry Albecker, who gave thanks to all those who helped in the return of the At.óow. The crest hat was later placed on display at the Alaska Native Brotherhood hall for public viewing, and Lillian Hammond, an 87-year-old Tlingit elder from Sitka slowly rose to her feet and addressed the gathering. "I just want to thank God that I could be here. I am old, but I have lived to see our past has returned." During the ceremony, eagles were soaring high above the cliffs, several ravens few directly above the ceremony, and seabirds glided by the thousands above the Chilkat River. The people commented that it seemed as if Nature herself was pleased with the return of the Murrelet Hat.

On October 20, 1999, on the 117th anniversary of the U.S. Navy's bombardment of Angoon, the village celebrated the return of the carved beaver prow of the only canoe to survive the attack. More than 250 people, including 85 dancers, showed for the celebration in a Tlingit village some 55 miles south of Juneau. The prow had disappeared from an

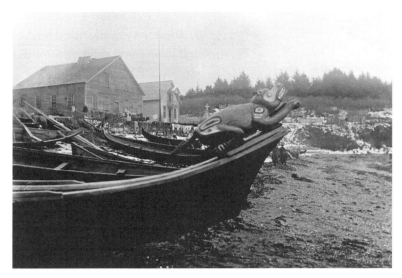

The Beaver Prow Canoe at Angoon some 30 years after the naval bombing. By this time the village of Angoon had revived their economic base — fishing.

Photo: Alaska State Library, Vincent Soboleff photo, PCA-83. Winter and Pond Collection

Angoon home 88 years ago. The artifact is a symbol of the village's survival of the bombardment that killed six children, wrecked most homes, and destroyed the caches of food. Without that one canoe, used to gather wood and hunt, the people of Angoon would have died the following winter. In 1911 the American Museum of Natural History paid George Emmons, a collector, $45 for the sacred Beaver prow, and probably never even displayed it. "Home at last!" cried out Howard Jacobs, a Tlingit elder, as he stood before the crowd on the dock and greeted the Beaver as it arrived by boat from Juneau. The Beaver is 32 inches long and made of wood with inlaid ivory teeth.

Private collectors are eager to learn more about their Northwest Coast art collections—when they were carved, who carved them, and the group for whom they were carved. They do not simply want a relic but rather an artifact that has a history, a place in time, and a cultural significance; and they often share their collections with museums and the public.

John Hauberg of Seattle began his collection of pieces of Northwest Coast art as a youth, driven by interest, respect, and admiration. In his later years he stated, "I began to realize that I was only the custodian of their very best and dearest former possessions, and in knowing that, I gave them all to an appropriate museum. The Seattle Art Museum received them with great pride" (Abbot, 1995: 12). Steven Brown (the carver mentioned previously), the assistant curator in Indian art at the museum, assembled a group of Indians who were represented in the collection. Nora Marks Dauenhauer, the late Mark Jacobs, and Judson Brown came to Seattle to identify and share information pertaining to the history and ceremonial importance of the Tlingit artifacts. They then related to their communities what was in the collection and the function of the exhibit. The meetings took place in several phases and involved other council members in determining the proper arrangement and placement for the artifacts.

The University of British Columbia, The Royal British Columbia Museum, and the State of Alaska have cooperated with carvers and shared with them access to their collections. Meanwhile, national museums and art scholars have produced many fine publications on Northwest Coast art that have further developed an awareness of the art. Private cor-

porations are often patrons of the arts, and Native communities and tribal organizations in Alaska and Canada have become involved in the advancement of the art tradition. The Ketchikan Cultural Center and the Wrangell City Museum hold classes and conduct workshops directed by Native master carvers. Non-Native artists, through their great interest in the art, have taken up carving and often work with Native carvers

In May 1999, under the auspices of Cook Inlet Regional Corporation —one of the thirteen regions created by ANSCA—the Alaska Native Heritage Center was opened. It is beautifully situated in a park-like area within a 26-acre forest with a small lake and trails. In this primeval setting a ten-foot high bronze raven carved by Aleut artist John Hoover greets visitors as they enter the large Welcome House (symbolizing Our Home). There are daily celebrations of the lifestyles and cultures of contemporary Alaska Native People. It opens into a immense foyer that overlooks an even larger atrium with a north wall of glass that reveals Tiulana Lake, named in honor of Paul Tiulana, a leader of the King Island Eskimos. In

an adjacent part of the atrium is a raised circular stage called the gathering place where traditional native dances are performed, storytellers relate the oral histories and legends and dance/dramas are enacted. On leaving this area one passes a small theater that features state-of-art digital projection and surround sound for multipurpose presentations and special programs. One then enters the corridor of cultures, lined with maps and exhibits of Alaskan Native lifestyles. Branching off this corridor are alcoves that transform into galleries and studios for artists. Leaving the building at the end of the long corridor one enters the trails that lead to the outdoor village sites that offer glimpses of ancient native traditions in the replicas of five traditional village sites. Each site reflects the five

Alaska Native Heritage Center, Anchorage, Alaska. View of Lake Tiuliana, with whale rib bones in the foreground. Courtesy Chris Arend Photography, Anchorage, Alaska.

native cultural groups in Alaska: the Athabascan Indians, Inupiaq Eskimo, Yupik Eskimo, Aleut, and Northwest Coast Indians. There are wooden benches to sit on and reflect upon the scenery, or watch people beading, making moccasins and headdresses, carving wooden totemic figures, and making the legendary Eskimo masks. Roy Huhndorf, Chairman, warmly expresses the purpose of the Alaska Heritage Center. "We look forward to expanding the circle of knowledge and appreciation of Alaska's Native People. In doing so, we hope that other Alaskans, visitors from across the country and around the world will come away from the Center with a greater understanding of our rich and varied cultures. It is with a great of pride we make this offering to you."

"It is a recurrent irony of history that renaissance and ruin are so closely intertwined" (Cornell, 1990: 71), or as Eskimo activist Harold Napoleon puts it, using the analogy of the Phoenix rising from ashes, "It is like a religious experience in that from suffering comes redemption." It is also not without historical irony that the theme of the Alaska Federation of Natives' 33rd convention in October 1999 was "Alaska Native Culture and Communities into a New Millennium."

The beginning of the new century is both a time of introspection and projection. The Alaska Federation of Natives resisted the temptation to look only backward to the past and long for what had been lost and turned instead toward the new century stating, "It can be a time when a people come together and make tough choices, in order, to create a new sense of themselves and to open doors to new possibilities that lie ahead. We can create a vision of our own future, for ourselves and our children." The convention adapted three proposals:

Self reliance as citizens of the United States and as the aboriginal recipients of legal agreements with the United States; self determination in the policies and programs that affect us, including that such development must be implemented by Alaska Natives; and to maintain the integrity of Native cultures, chiefly policies regarding subsistence and traditional cultural values.

In the ensuing period the Native people of Alaska are not only concerned for themselves, but for all other indigenous people in the world and their place in the 20th century. The Alaska Federation of Natives participated in the preparatory meetings for the United Nations World Conference Against Racism and Related Intolerance (WCAR) and attended the conference in

Durban, South Africa in August of 2001. Meanwhile, they persevere in their crusade "Our Children, Our Spirit and Our Life" and continue to pay homage to their great past.

THE LINKS TO THE ANCIENT PAST

The history of the Native people in Alaska goes back many millennia. Their ancestry is woven within the rich tapestry of the movement of peoples on the great plain of Beringia, "The Land Bridge," that existed between Alaska and Siberia. During the late Pleistocene age some 30,000 to 10,000 years ago, this land mass was at different times exposed and innundated as glaciers grew and then retreated during warming periods. Man entered the new world threading slowly across this great plain in a series of migrations. Often these prehistoric people moved back and forth, as did the flora and fauna, while others lived many generations on the plains of Beringia, and still others followed an existing ice-free corridor into the North and South American continents. By the beginning of the warm Holocene period some 10,000 years ago, the great land mass of Beringia was engulfed by the rising sea.

The remaining eastern Aleutian Islands once formed the southern boundary of Beringia, thus it is not surprising that this thousand-mile-long chain of islands that extends outward from Alaska toward Japan exhibits a rich palette of archeological evidence. Examples of the long history of man's occupation in the area of the Aleutian Islands are found at sites on Ananiuliak Island on the north side of Nikolski Bay, which dates as far back as 8,500 years ago, and the Chaluka site on nearby Ummak Island in the village of Nikolski dating 4,000 B.P. The latter is an old Aleut site, and indicates 4,000 years of virtually continuous Aleut occupation!

On the Alaskan mainland, north of the Arctic Circle in the area of the Kubuk River that flows from the Brooks Range to Kozebue Sound there exists a prehistoric portage site, "The Onion Portage," so named by archeologists because of the wild onions that grow there. In the past it was a place where the caribou passed through on their annual migration, and according to the artifacts found there, has been an important area for hunters since 8,000 B.C. These artifacts—stone tools—define the presence of diverse groups of unknown people who hunted there until 4,000 years ago when early Eskimo sites appear exhibiting a small tool tradition that links them to the modern day Inuplat Eskimo.

191

Further northward on North Slope, the Eskimo village of Point Hope sits on the edge of the Chukchi Sea in an area where there are the remains of ancient settlements of their ancestors, an Inupiat people who exhibited the technology of the northern whaling tradition, and inhabited the area some 2,500 years ago. Older sites may have existed, but they have been lost as the eroding coast fell into the sea and joined the now sunken continent of Beringia.

Kodiak Island, which lies in the Gulf of Alaska south of Cook Inlet and the Kenai Peninsula, contains several archeological sites dated as early as 7,000 B.P. of a people who colonized the area and are regarded as proto-ancestors of the Koniag inhabitants of the area today. The mosaics of the sites change between 3,500-3,800 and settlements appear that belong to the direct descendants of the present day Alutiiq/Koniag People.

A cave on Prince of Wales Island in southeastern Alaska reveals human presence between 10,000-9,000 B.P., and nearby in northern British Columbia at a site dated 4,000 to 5,000 B.P. Dr. George MacDonald and Dr. Roy Carlson found fragments of baskets that are not unlike those of the modern Tlingit. On Baronof Island at Hidden Falls, a prehistoric stratified site dated 4,500 and 3,000 B.P. depicts a different technology at each level. The technology of the latter date falls within the early Tlingit tradition.

The Alaskan Native societies are old cultures and many great civilizations in both the New and Old World have fallen during their time of continuous occupation in Alaska. They have existed in Alaska before the pyramids of the old kingdom of Egypt were built, the Mayan calendar invented, the Chinese language written and the rise and fall of Rome.

The passage of the art of only one group, the Tlingits, has been portrayed within these pages. One of their most cataclysmic times began at contact some 250 years ago when they almost perished, and their art would then have been viewed simply as artifacts of a vanished race. The people, however, clung on stubbornly to their way of life and having survived many turbulent events enter a new millennium holding on to their culture and producing art which still carries the same *tour de force* as in the past.

TOTEM POLE PARKS IN ALASKA

Totem Park	Location	Exhibits	Ethnic Group
Alaska Native	Anchorage Heritage Park	General	All Native groups
Angoon Park	Angoon Community	6 poles	Tlingit House
Hydaburg Park	Hydaburg	21 poles and 1 stone figure	Haida
Klawock Park	Klawock	18 poles	Tlingit
Kik.setti Totem Park	Wrangell	4 poles	Tlingit
New Kassan Park	New Kassan Community House	12 poles	Haida
Saxman Park	Saxman	27 poles	Tlingit
Totem Bight	Ketchikan Community House	17 poles	Tlingit/Haida
Shakes Island	Wrangell	Community House*	Tlingit
National Monument Park	Sitka	15 poles	Haida
		3 totem poles**	Tlingit

* Community House on Shakes Island has copies of original poles moved from Old Wrangell from the house of Shakes IV; and also has two original house posts from the Sun House of the Kîksa' dî clan and a Screen.

** Sitka's indoor exhibit at its park has three Wolf House posts and four Eagle House posts and a painted screen on loan from the Kā´gwantān clan of Sitka. These are original posts said to be over two hundred years old.

TOTEM POLES IN URBAN LOCATIONS OTHER THAN PARKS

Totem	Exhibits	Ethnic Group
Anchorage	6 poles	Tlingit
Fairbanks	1 pole	Tlingit
Juneau	6 poles	Tlingit/Haida
Ketchiken	18 poles	Tlingit/Haida
Klukwan	4 House Posts	Tlingit
	Rain wall screen	Tlingit
Sitka	1 pole	Tlingit
Wrangell	4 original house posts*	Tlingit
	2 Killer whale fence posts**	Tlingit

* Original house posts from the Old Wrangell House now in Wrangell Museum.

** Chief Shakes V's grave includes Killer Whale figures on the fence posts.

LEGEND OF PHOTOGRAPHS AND DRAWINGS OF TOTEM POLES

Name of Work	Art	Location	Artist
Dogfish (Mudshark)	House Post	Wrangell	Kadjisdu.āxch II
Ixt (right)	House Post	Wrangell	Kadjisdu.āxch II
Ixt (left)	House Post	Wrangell	Kadjisdu.āxch II
Salmon	House Post	Wrangell	Kadjisdu.āxch II
Sukheen	Interior Partion	Klukwan	Kadjisdu.āxch II
Raven	House Post	Klukwan	Kadjisdu.āxch II
Gunakadeit	House Post	Klukwan	Kadjisdu.āxch II
Woodworm	House Post	Klukwan	Kadjisdu.āxch II
Dark-Skin or Dukt!ū.L!	House Post	Klukwan	Kadjisdu.āxch.II
Cannibal Giant	Inside House Post**	Klukwan	Unknown
Kats!	House Portal Pole	Saxman	N. Jackson
Bear Mortuary Pole*	Mortuary Pole**	Yakutat	Unknown
Grave Post*	Mortuary Pole**	Hoonah	Unknown
Sockeye Salmon Pole	Mortuary Pole	Klawock	W. Ketah
Gonaquade't	Mortuary Pole	Wrangell	Ukas
Raven/Shark/Wolf Pole	Mortuary Pole	Tuxekan	Unknown
Raven Finned Black Fish	Mortuary Pole	Klawock	Shotridge
Sun Raven Pole	Grave Marker	Saxman	Shotridge
Man with Crest Hat	Grave Marker	Totem Bight	Shotridge
Koos Da Shan	Grave Marker**	Wrangell	Unknown
Shining Face of Copper	Grave Marker	Seattle	Unknown
Chief Johnson Pole	Memorial	Kechikan	Shotridge/ Jackson
Dog-Eater Spirit Pole	Memorial	Klawock	Bob or Albert Smith

Name of Work	Art	Location	Artist
Giant Rock Oyster Pole	Memorial	Saxman	Unknown
Chief Kahl-teen	Memorial	Wrangell	Brown/ Price
Chief Ebbit Pole	Memorial	Saxman	Unknown
Eagle and Clam Pole	Commissioned Pole	Anchorage	Lee Wallace
Raven Pole	Commissioned Pole	Anchorage	Lee Wallace
Haa leelkk'u has Kaa sta heeni deiyi Pole	Modern creation	Sitka	Burkhart/Price/ Joseph
Wrangell Raven Pole	Commemorative Pole	Wrangell	Brown/ Price
Lincoln Pole	Commemorative Pole	Saxman	Unknown
Lq! aua'k! Pole	Unknown	Wrangell	Unknown
Eagle Pole	Unknown	Wrangell	Unknown
Raven *	Revenge/MortuaryPole**	Kake	Unknown
Bear with Salmon	Ridicule Pole**	Shaken Bay	Unknown
Secretary of State Pole	Ridicule	Saxman	Unknown
Three Frogs	Ridicule	Wrangell	C. Ukas
Dog Salmon People*	Shame	Shaken Bay	Unknown

* Depicted in drawing form.

** Poles no longer exist.

GLOSSARY OF TLINGIT WORDS

Tlingit language for many years has been transposed into English by people of varying academic status ranging from scholars to traders. Gradually the extreme variations narrowed to a more modified approach, and in the last quarter of the century the University of Alaska has developed a program to study and document not only Tlingit but all the aboriginal languages spoken in Alaska. As a result of this program and Sealaska's efforts there are three individuals in Alaska and one in Canada who are considered to be the authorities in the lexical and linguistic interpretation and transposition of Tlingit into English. They are Dr. Richard and Nora Dauenhauer of Juneau, Alaska, Dr. Jeff Leer at the University of Alaska in Fairbanks and Bessie Cooley of Teslin, Yukon Territory.

There is, however, a slight academic difference in their methods of diacritical analysis and lexical rendition of Tlingit into English. Nora Dauenhauer is a Tlingit and a fluent speaker of her language, and her husband Dr. Richard Dauenhauer is a scholar trained in classical languages and etymology. Dr. Jeff Leer is a fluent Tlingit speaker and a linguist. Bessie Cooley is a Tlingit and fluent in her language. She received degrees from Yukon College in Yukon Territory and from the University of Alaska in Fairbanks. In 2003 she received the Golden Jubilee Medal from Queen Elizabeth II for her significant contributions to the nation of Canada.

In this book we have mainly relied on the Tlingit lexicon of Dr. Leer. This is not to imply that we have a preference of one authority over the other, but at the time of the writing of this book Dr. Leer was gathering material for his book on the Tlingit geography of Atlin, British Columbia, and my great Aunt Elizabeth Nyman was his informant. This gave us the opportunity to be in frequent contact with him regarding exchange of photos and other materials. It was simply more convenient to work with him and my Aunt Elizabeth than trying to rely on calls, emails and faxes within the very busy lecture schedule of the Dauenhauers in Juneau.

The discerning reader will note, however that different spelling of Tlingit words occur in the text. These are not errors, but simply our efforts to maintain the integrity of the source quoted. As a result the glossary includes Dr. Leer's lexicon of Tlingit, the lexical contributions of individual Tlingits, Dr. John Swanton's clan names and glossary, as well as, Tlingits words from the many sources quoted.

We beg the reader to bear with the symbols of pronunciation and strange sounding words and share with us aspects of the Tlingit language. It was not easy task for us either, and often frustrating at times to use the exact Tlingit word with the source quoted in this book. For example, there are six ways in which the Tlingit clan name Kîksa 'dî can be written! Dr. Leer writes the word hít while Dr. Swanton records it as hît. The name Dukkt!uli is often written as Ducktoulh. The Dauenhauers use the word Chookaneidi clan, and Dr. Swanton writes it as Tcūkane'dî clan. The possibilities often seemed endless.

We continuingly had to remind ourselves that language is our most valuable resource and deserves our great respect. All languages are formed over a long series of time, and have been shaped and directed by man's mind, his culture and his vocal ability. They all are rich in different ways in meaning, detail and phonetics, and they are only limited by the extent of man's creativity. Learning another language or even reading a well documented translation of it can open doors to other realities. With this in mind, perhaps the reader may discover his forbearance was worth the effort and has led him/her to capture an essence of Tlingit!

DR. JEFF LEER'S LEXICON

ahunè t kanàyi'	member of the opposite clan
at la.ùx'ú	gifts distributed at a feast
at.óow	crest, regalia that has deep metaphysical meaning
at ỳedí	tied on prow of a boat (price paid for something)
at wunà khâwn	mediator or arbitrator
dag' anḵu	land of the dead
gâs'	post
ghaxhdà shìyí	funeral song
hít	house
hít s'atí	master of clan house
hít yìgâs'i	house post (in particular)
Ḵaa	human being
khà dakèdí	wooden box containing the remains of a person
khà datì yí	memorial feast for a person
khà' khunígu	public event sponsored by a clan
khà kanîxh'i`	tombstone
khà nêx'i	inheritance, possessions of deceased distributed at a feast
khà shuká	crest
khà xh' eyi	language reserved for use by a certain clan
khà nàwiwèdí	price paid for his/her death
kùtîyà	totem pole
khuwakàn	deer or peace hostage
khû.ix'	feast or potlatch
ligaās	taboo or contrary to moral law
ḵ wāan	tribe or local group
naa	clan
ne x ae shi'	the entrance song
nà kâni	master of ceremonies at a feast
nâtxh	wealth
shagóon	ancestor or can refer to parents
shuká	ancestor and can refer to the past or to the future and fate or destiny
su	rain
su'xh'in	rain wall screen
tinâ	copper (form of wealth)
wás' tî yi	wooden clan emblem
woot'sagâs'	ceremonial staff
yéik	shaman's spirit helper
yéik utee	spirit song
xh'in	wall screen
yà'na.át dàshìyí	procession song
yù at kutik	memorial feast

DIRECT SOURCE OF TLINGIT LEXICON

ak	to weave
Awei'x̲	Tlingit name means patience (Literal translation 'the setting trap')
dēq!	to be ashamed
dex	two
gax	to weep
he'oy̲k	shaman (wizard) who practiced both good and bad medicine
Ix̲t	shaman who were healers and prophets
lax	red cedar
leq!	one
L!ēx	to dance
nak'satie	shaman (sorcerer) who practiced bad medicine
q!âl!	eagle down
t'á	King Salmon
thlīngi't	the people
xēl!	to be afraid of
yāk	medicine

DR. JOHN SWANTON'S MOIETY/CLAN/HOUSE LEXICON USED IN THIS TEXT

Dē'citān	(People of the beaver) Raven or Crow Moiety
Gānaxa'dî	(People of the Ga-nax)
Kasq!ague'dî	(People of a camp called Kaq!e'k)
Kiksa'dî	(People of the Island Kiks)
K!uxine'dî	(Martin People)
Tak^u ane'dî	(Winter People)
Te'nedî	(Bark House People)

WOLF OR EAGLE MOIETY

Kā 'gwantān	(Burnt House)
Daq!!awe'dî	(Killer Whale)
Nāste'dî	(People of the Nass)
Nanyaā'yî	(People of Na'aya)
Nēxa'dî	(People of the Nex)
Te'qoedî	(People of the Island from Teq)
Tcūkane'dî	(Bush or Grass people)
Wucketā'n	(People with House on top of one another)
Xēl quan	(People of the Foam)
Yênyē'dî	(Hemlock People)

DR JOHN SWANTON'S CLAN HOUSES

RAVEN MOIETY	WOLF MOIETY
(S!gē 'di xā' î hît) Beaver House house)	Nēxa'dî
Tcāk!q!ō'si hît (Eagle's Foot house)	Nēxa'dî
Kats!s (Xits!hît/Grizzly Bear) House	Kā'gwantān
Kidjū'k hît (Golden Eagle House)	Gānaxa'dî
S!ax hît (Starfish House)	Gānaxa'dî
Q!A´tgu hît (Shark House)	Nanyaā'yî
Tcāk! Hît (Eagle House)	Nexa'dî
Tc!it hît (Murrelet House)	Nāste'dî

DR JOHN SWANTON'S LEXICON

yēl	Raven
gux	slave
tēq	heart
qea	daylight
xā'l	yellow cedar
axa'	paddle
gei	bay
xāt	salmon
ēl!	seawater
cu	to drink
hīn	fresh water

TLINGIT WORDS FROM SOURCES QUOTED

Chapter I

Te'q e'di Laguna (according to Dr. Swanton: Te'qoedî)

Chapter II

Sukheen	Emmons (according to Dr. Leer: su'xh'in)
Kik.sette	Wrangell Totem Park (according to Dr. Swanton Kîksa'dî
X'atgu hit	Keithahn (according to Dr. Swanton the name is Q!A´tgu hît)
Kudanake	Keithahn name for Tlingit elder
Sun House	Wrangell Park (according to Dr. Swanton Gagā'n hît)
Na-chee-su-nu	Joe Thomas, Tlingit elder name for pole in front of Sun House, 1940

Chapter III

Kadjuk House	Garfield (according to Dr.Swanton Kidjū k house refers to Chief Johnson's pole
Eagle's Foot House	Garfield (according to Dr. Swanton Tcāk!q!ō'si hît)
Beaver Dam	Garfield (according to Dr. Swanton Beaver house- house)
Beaver's Tail House	S!ig ē'di xā' î hît
Kit.setti	Wrangell Totem Park (according to Dr. Swanton Kîksa'd î)
Tcūkane'dî	Dr. Swanton's word for Sitka clan (National Park Service in Sitka and the Dauenhauers record this as Chookaneidi)
Wucketā'n	Dr. Swanton's name for Sitka clan (National Park Service in Sitka records this as Wooshkitaan)

Chapter IV

Teikweidî Clan	Dauenhauer (according to Dr. Swanton Te'qoedî)
Chookaneidî Clan	Dauenhauer (according to Dr.Swanton Tcūkane'dî)
Kaat's	Dauenhauer (according to Dr. Leer Kats!s)

Chapter V

Gaanaxteidi	Emmons (usually Gānaxa'dî)
Thlingit	Grygla, Federal Land Officer in Gov. Brady meeting (now spelled Tlingit)

BIBLIOGRAPHY

Barbeau, Marius, *Totem Poles*, 2 Volumes, National Museum of Canada Bulletin 119, Anthropological Series No, 30, Ottawa: National Museum of Canada, 1951.

Bates, Marion, *The Forest and the Sea*, New York: Vintage Press, 1960.

Boas, Franz, *Primitive Art*, New York: Dover Publishing Company, 1955.

Boyd, Robert, *Demographic History 1774-1874 Handbook of the North American Indian*, Vol. 7: Northwest Coast, Washington: Smithsonian Institution, 1990.

Bureau of Indian Affairs, *Planning Support Groups, Angoon — Its History, Population and Economy*, Billings, Montana: United States Department of Interior, 1975.

Brennan, Louis, *Artifacts of Prehistoric America*, New York: Stackpole Books, 1975.

Brown, Steven, *Native Visions, Evolution in Northwest Coast Art from the Eighteenth through the Twentieth Century*, Seattle and London; Univeristy of Washington Press in association with the Seattle Art Museum, 1998.

Campbell, Joséph, *Renewal Myths and Rites of the Primitive Hunters and Planters*, Eranos Year Book, Zurich: Rhein Verlag, 1959.

Carpenter, Edmond, *The Far North: 2000 Years of American Eskimo and Indian Art*, Washington, D.C.: The National Gallery of Art, 1973.

Cole, Douglas, *Captured Heritage: The Scramble for Northwest Coast Artifacts*, Norman: University of Oklahoma Press, 1985.

Cole, Douglas and Ira Chaikin, *An Iron Hand upon the People*, Vancouver/Toronto: Douglas & McIntyre and Seattle: University of Washington Press, 1990.

Cole, Douglas and David Darling, *History of the Early Period. Handbook of the North American Indian*, Vol. 7: Northwest Coast, Washington: Smithsonian Institution, 1990.

Cook, Captain James A., *A Voyage to the Pacific Ocean, 1776-1778*, London, 1785.

Cornell, Stephen, *The Return of the Native American Indian Poliitical Resurgence*, New York: Oxford University Press, 1990.

Corser, H. P,. *Totem Lore of the Alaskan Indians*, Wrangell: Bear Totem Store, 1932.

Dauenhauer, Nora Marks, *The Spirit Within: Northwest Coast Art from the John Hauberg Collection*, Seattle: The University of Washington Press, 1995.

Dauenhauer, Nora and Richard, *Haa Shuká: Our Ancestors -Tlingit Oral Narratives*, Seattle and London: University of Washington Press and Sealaska Heritage Foundation, l987.

Dauenhauer, Nora and Richard, *Haa Tuwunaagu Yís, for Healing Our Spirit*, Seattle and London: University of Washington Press and Sealaska Heritage Foundation, 1990.

Davydov, G. I., *Two Voyages to Russian America, 1802-1805*, Kingston, Ontario: Limestone Press, 1977.

de Laguna, Frederica, *The Story of a Tlingit Community*, Bureau of American Ethnology: Bulletin 172, Washington, D.C., 1960.

de Laguna, Frederica; *Under Mt, Saint Elias: The History and Culture of the Yakutat Tlingit*; Smithsonian Institution, Vol 1 and Vol 11; 1972.

De Menil, Adelaide and Reid, William, *Out of Silence*, New York: Amon Carter Museum/Harper Rowe, 1971.

Dixon, Captain George, *A Voyage Around the World, 1784-1788*, London, 1789.

Drucker, Phillip, *Indians of the Northwest Coast*, American Museum of Natural History, New York: National History Press, 1955.

Drucker, Phillip, *"The Native Brotherhood: Modern Intertribal Organization on the Northwest Coast,"* Bureau of American Ethnology, Bulletin 168, Washington: Smithsonian Institute, 1958.

Drucker, Philip, *Cultures of the Pacific Coast*, Pennsylvania: Chandler Publishing Company, 1965.

Eliade, Mircea, *Shamanism*, Translated by Willart R, Trustk, Princeton: Princeton University Press, 1964.

Emmons, Lt. George T., *The Whale House of the Chilkat*, New York: American Museum of Natural History, 1916.

Emmons, Lt. George T., *Correspondence, Itemization Notebooks and Invoices, Assession Numbers 28072, 41512, 42081*, United States National Museum, Washington, D.C.: Smithsonian Institute.

Emmons, Lt. George T., *The Tlingit Indians*, Edited by Frederica de Laguna. Seattle: University of Washington Press, 1991.

Enge, Marilee, A series of five articles in *"We Alaskans: Treasures of the Tlingit Battle Over a Birthright"*, Anchorage Daily News, April 4-8, 1993.

Garfield, Viola and Linn Forrest, *The Wolf and the Raven*, Seattle and London: University of Washington Press, 1948.

Goddard, Pliny, *Indians of the Northwest Coast*, Lancaster, Pennsylvania: Lancaster Press, 1945.

Goldshmidt, Walter R., and Theodore Haas, *Haa Aani Our Land; Tlingit and Haida Land Use Rights*, Edited by Thomas Thornton. Seattle and London: University of Washington Press and Sealaska Heritage Foundation, 1998.

Gruening, Ernest, *The State of Alaska*, New York: Random House, 1954.

Hawthorn, Audrey, *The People of the Potlatch*, Vancouver Art Gallery, Vancouver: University of British Columbia Press, 1956.

Heller, Christine, *Edible and Poisonous Plants of Alaska*, College, Alaska: University of Alaska Press, 1953.

Holm, Bill, *Northwest Coast Indian Art: An Analysis of Form*, Seattle and London: University of Washington Press, 1965.

Holm, Bill, *Art: Handbook of the North American Indians*, Vol. 7: Northwest Coast, Washington: Smithsonian Institution, 1990.

Hope, Andrew, Map of Traditional Tlingit Country-circa Nineteenth Century, Juneau, Alaska: Tlingit Readers Inc., 1998.

Howay, Frederick W., *A List of Sailing Vessels in Maritime Fur Trade 1785-1825*, Transactions, Royal Society of Canada, Volumes XXIV to XXVIII, Ottawa, 1930-34.

Hully, Clarence C., *Alaska, Past and Present*, Portland: Binford and Mort, 1970.

Inverarity, Robert Bruce, *Art of the Northwest Coast Indians*, Berkeley: University of California Press, 1950.

Jenness, D., *The Carrier Indians of Bulkley River*, Bulletin No, 133, Bureau of American Ethnology, Washington, D.C., 1943.

Jung, Carl, G, *Archetypes of the Collective Unconscious*, Vol, 9, Part 1, Bollingen Series XX, New York: Pantheon Books, 1959.

Jung, Carl, G, *Psychic and Symbol: A Selection from the Writings of C. G. Jung*. Edited by Violet Lazalo. New York: Doubleday-Anchor Books, 1958.

Kan, Sergei, *Symbolic Immortality: The Tlingit Potlatch of the Nineteenth Century*, Washington and London: Smithsonian Institution Press, 1989.

Keithahn, Edward L., *Monuments in Cedar*, Seattle: Superior Publishing Company, Bonanza Books, 1963.

Keithahn, Edward L., *Authentic History of Shakes Island and Clan*, Wrangell, Alaska: Wrangell Museum Publication, 1950.

Knapp, Marilyn and Mary Meyer, *Carved History — Totem Poles and House Posts of Sitka*: Anchorage: National Park Service and U.S. Department of Interior, 1979.

Krause, Aurel, *The Tlingit Indians*. Translated by Erna Gunther. Seattle and London: University of Washington Press, 1956.

Kuh, Katherine, *"Alaska's Vanishing Art"* in Saturday Review, October 1966.

Langdon, Steve, *Native People of Alaska*, Anchorage: Greatland Graphics, 1993.

La Perouse, Comte de Jean Francios de Galaup de, *A Voyage Round the World 1803-06*, London, 1798.

Lévi-Strauss, Claude, *The Savage Mind*, Chicago: University of Chicago Press, 1966.

Lisiansky, Urey, *A Voyage Round the World in the Ship Neva 1803-1806*, London: John Boothe, 1914.

Malaspina, Don Alejandro, *La Expedición 1789-1794, Diario General del Viaje por Alejandro Malaspina, Tomo II – Vol, I*, Ministerio de Defensa; Museo Naval; Madrid, 1885.

Marchand, Capt, Etienne, *A Voyage Round the World 1790-92*, London, 1801.

Miller, Polly and Leon, *Lost Heritage of Alaska*, Cleveland: World Book Publishing Company, 1967.

Morgan, Lael, *"The Klukwan War: A Painful Return of the Past,"* Alaska Magazine, October 1977.

Oberg, Kalervo, *The Social Economy of Tlingit Indians*, Ph.D Dissertation, University of Chicago, 1937.

Oswalt, Wendall K., *This Land Was Theirs: A Study of Northern Indians*, New York: John Wiley and Sons, 1966.

Paul, Francis, *Spruce Root Basketry of the Tlingit Indians*, Bureau of Indian Affairs, U.S. Department of Interior, Kansas: Haskell Institute, 1944.

Progroff, Ira, *Jung's Psychology and Social Meaning*, New York: Anchor Press-Doubleday, 1973.

Rey, Arsenio Tejerina, *Tomás de Suria a l'expedició Malaspina en Alaska 1791*, Generalitat Valencia, España: University of Valencia Press, 1996.

Rasmussen Library, *Photograph Collection*, University of Alaska, Fairbanks.

Rhinelander, Phillip, *"Is Man Incomprehensible to Man"* in Portable Stanford, Stanford: Stanford University Press, 1977.

Salisbury, O. M., *The Customs and Legends of the Tlingit Indians of Alaska*, New York: Bonanza Books, 1957.

Singer, June, *Boundaries of the Soul*, New York: Anchor Press-Doubleday, 1972.

Spencer and Jennings, *The Northwest Coast Native Americans*, Philadelphia: University of Pennsylvania, 1940.

Stirling, Matthew W., *"Indians of Our North Pacific Coast,"* The National Geographic Magazine: Volume lXXXVIII, January, 1945.

Strehlow, T. G. H., *Aranda Traditions*, Melbourne University Press, Melbourne, Austria, 1968.

Suttles, Wayne, Volume Editor; *Handbook of North American Indians Northwest Coast*, Vol. 7, Washington D.C., Smithsonian Institute, 1990.

Swanton, John R., *"Social Conditions, Beliefs, and Linguistic Relationships of the Tlingit Indians,"* 26th Annual Report of the Bureau of American Ethnology, Washington, D.C., 1908.

Swanton, John, R, *Tlingit Myths and Texts*, Bureau of American Ethnology, Bulletin 39, Washington, D.C.: Smithsonian Institute, 1909.

Wardwell, Allen, *Tangible Visions; Northwest Coast Indian Shamanism and Its Art*, New York, Monicelli Press, 1995.

Wherry, Joséph, *The Totem Pole Indians*, Funk and Wagnalls, Division of Readers Digest, New York, 1964.

Williams, Maria, *Alaska Native Music and Dance: The Spirit of Survival*, Ph.D. Dissertation, University of California ,1996.

Young, S. Hall, *Alaska Days with John Muir*, New York: Fleming H. Revell Company, 1915.

INDEX